meadow

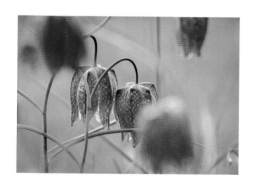

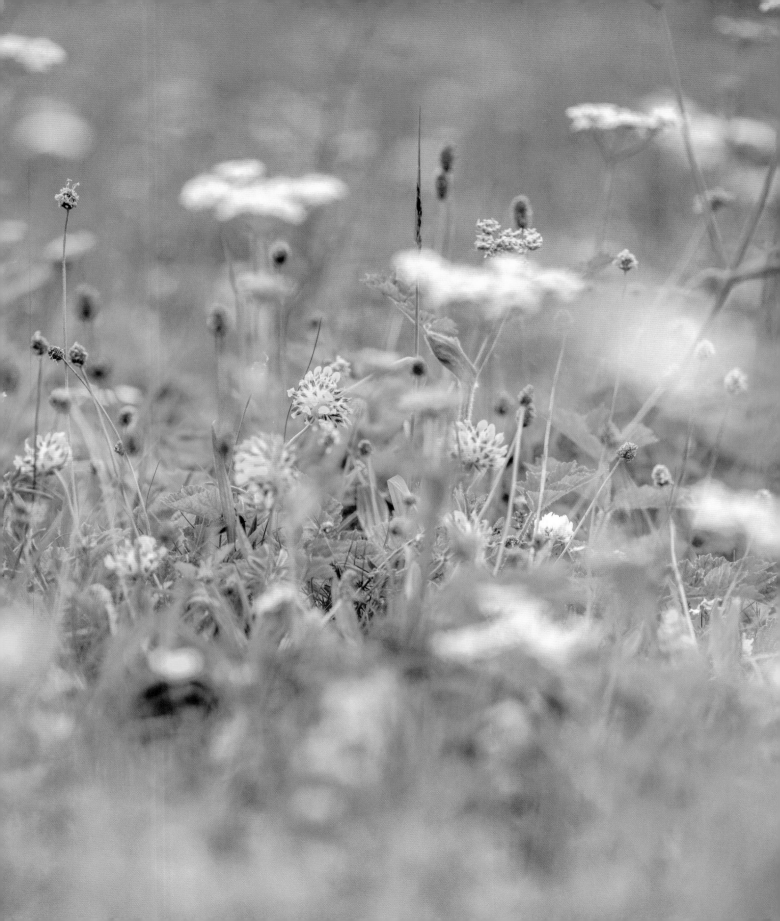

meadow

The intimate bond between people, place and plants

IAIN PARKINSON

Photography by
JIM HOLDEN

Kew Publishing
Royal Botanic Gardens, Kew

First published in 2022 by
Royal Botanic Gardens, Kew,
Richmond, Surrey, TW9 3AB, UK
www.kew.org

ISBN 978 1 84246 747 3

Distributed on behalf of the Royal Botanic Gardens, Kew in North America by the University of Chicago Press, 1427 East 60th St, Chicago, IL 60637, USA.

British Library Cataloguing in Publication Data
A catalogue record for this book is available from the British Library

DESIGN: Ocky Murray
TYPESETTING AND PAGE LAYOUT: Kevin Knight
PROJECT MANAGER: Lydia White
PRODUCTION MANAGER: Jo Pillai
COPY-EDITING: Amanda Harman
PROOFREADING: Catherine Bradley

For information or to purchase all Kew titles please visit shop.kew.org/kewbooksonline or email publishing@kew.org

Kew's mission is to be the global resource in plant and fungal knowledge and the world's leading botanic garden.

Kew receives approximately one third of its funding from Government through the Department for Environment, Food and Rural Affairs (Defra). All other funding needed to support Kew's vital work comes from members, foundations, donors and commercial activities, including book sales.

Printed and bound in Italy by Printer Trento srl

Contents

Foreword

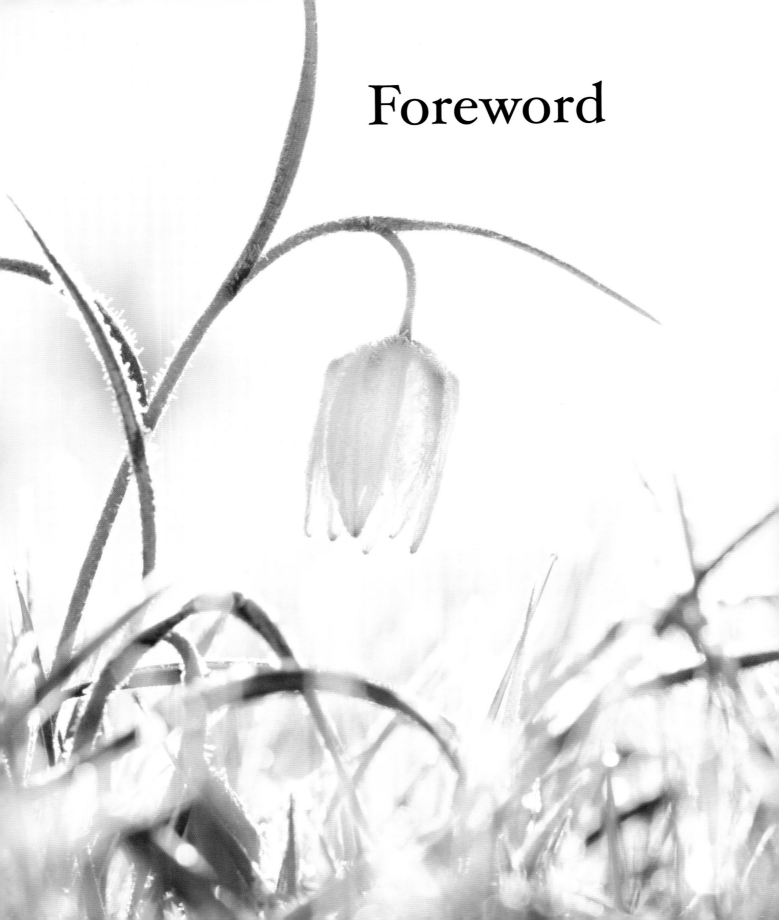

CLARENCE HOUSE

"Meadow" explores the intimate and complex relationship between people, place and plants which, over many centuries, has shaped the colour and character of the classic hay meadows of the British Isles.

These biodiversity hotspots are intrinsic to our cultural heritage, and in this book the author, Iain Parkinson, has carefully curated a fascinating collection of personal and evocative accounts shared by notable meadow experts from the world of science, conservation and the arts. Over thirty first-person accounts touch on everything from wildflower and grassland restoration, basketmaking and weaving, pollinators and birdlife, water and soil, to hedgelaying, grazing and archaeology. It is here where the stunning photography by Jim Holden brings these fascinating stories to life.

At Wakehurst, Kew's wild botanic garden in Sussex, the Coronation Meadow – which was established as part of an initiative I launched to mark the sixtieth anniversary of The Queen's Coronation and designed to establish a whole series of new wildflower meadows throughout the British Isles – acts as an important 'living laboratory' which provides a unique testing ground to gather crucial data that can be used to inform solutions to challenges such as climate change, mental health and food security.

In 2019, when I visited the meadow at Wakehurst for myself, I was particularly taken with a number of wildflower species, including tufted vetch and sneezewort, which I later planted in the meadows at Highgrove in 2020.

This publication, aligned with Kew's 'manifesto for change', aims to inspire and encourage people to explore and protect the natural world – something that is now more important than ever. "Meadow" highlights these natural havens and their vital role in offering sanctuary to flora and fauna, as well as to the people who visit and benefit from them.

'Landscapes have a language of their own, expressing the soul of the things, lofty or humble, which constitute them, from the mighty peaks to the smallest of the tiny flowers hidden in the meadow's grass.'

ALEXANDRA DAVID-NEEL

Preface

Imagine, for a moment, the enchanting form of a classic hay meadow, where the abstract designs of nature repeat over and over again at varying degrees of complexity and regularity in countless expressions of natural beauty. A meadow that sparkles with an ever-changing palette of colours, from shimmering golds and emerald greens to pastels of pink, purple and magenta. Now imagine a time when fields full of wildflowers covered the countryside in a patchwork pattern of colour and sound. A time long before the damaging forces of intensive agriculture robbed our grasslands of all their botanical treasures.

Surviving hay meadows, much like the one we have just conjured to mind, embody a time when farming worked in harmony with nature. But sadly, with every passing generation, the beauty of these once ubiquitous grasslands has been tarnished by a patina of harmful herbicides and chemical fertilisers. It is not just the loss of wildflowers that is cause for concern but also the devastating impact this has on the complex, and mutually beneficial, relationships they

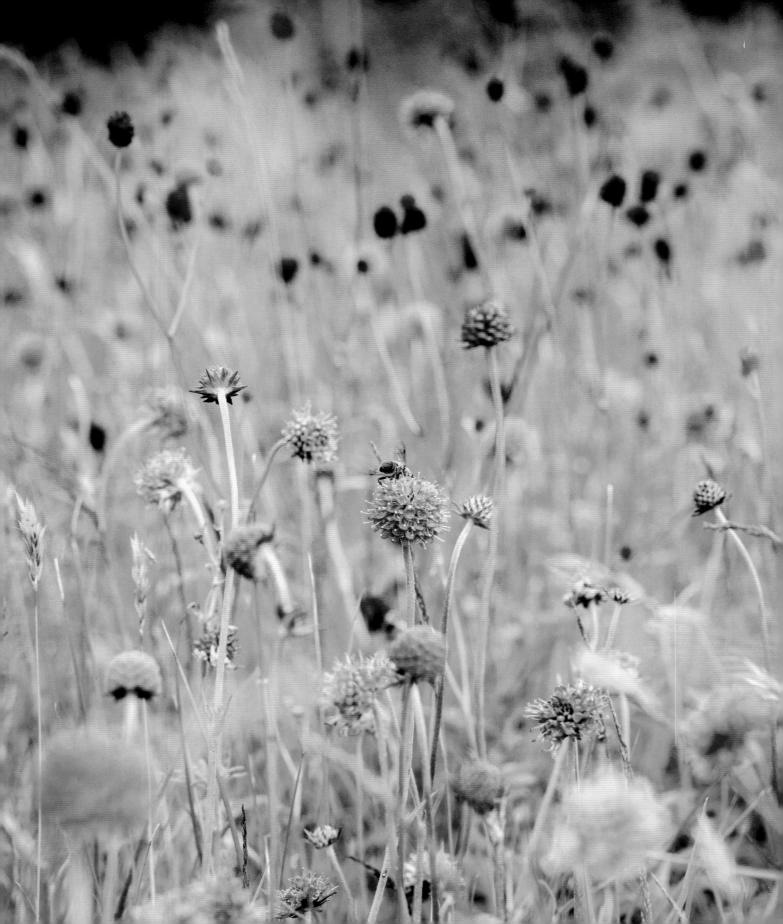

share with other species. When hay meadows vanish from the landscape, populations of butterflies, bees and other pollinating insects are dramatically affected, alongside the animals that predate those insects, such as birds, badgers and our beleaguered bats.

Traditionally managed hay meadows are now exceptionally rare, but, by virtue of their enduring character, surviving examples demonstrate a resilience to change that is worth celebrating. It is not just serendipitous that a scattering of meadows survive today, but an achievement mainly due to the heroic actions of the conservation community: a community of people just as specialised and colourful in character as the community of plants found within the sward. The secret life of a hay meadow is a fascinating story which is best told by the people whose own lives, and livelihoods, are deeply entangled within its complex web.

> Traditionally managed hay meadows are now exceptionally rare, but, by virtue of their enduring character, surviving examples demonstrate a resilience to change that is worth celebrating.

Acknowledgements

First and foremost, I would like to thank the myriad 'meadow folk' who contributed to the writing of this book. I hope you agree that the content is all the richer for the insight they generously share. It has been a fascinating experience to work with so many meadow experts.

I am very grateful to the many erudite mentors who have encouraged my interest in meadows over the years, including Margaret Pilkington, Keith Datchler, Dawn Brickwood, Richard Scott, Ruth Starr-Keddle, Helen Proctor and Gerry Sherwin. A special thank you also goes to my colleagues Jo Wenham, Harriet Fermor, Steven Robinson, Eliana Van Der Schraft, Ted Chapman and Kate Hardwick. Many kind people have provided comments on ideas, draft chapters and text, but in particular my thanks go to Rebecca Holden for her gentle critique of the manuscript, Christina Harrison for giving me opportunities over the years to put pen to paper and to Lydia White for her patient guidance.

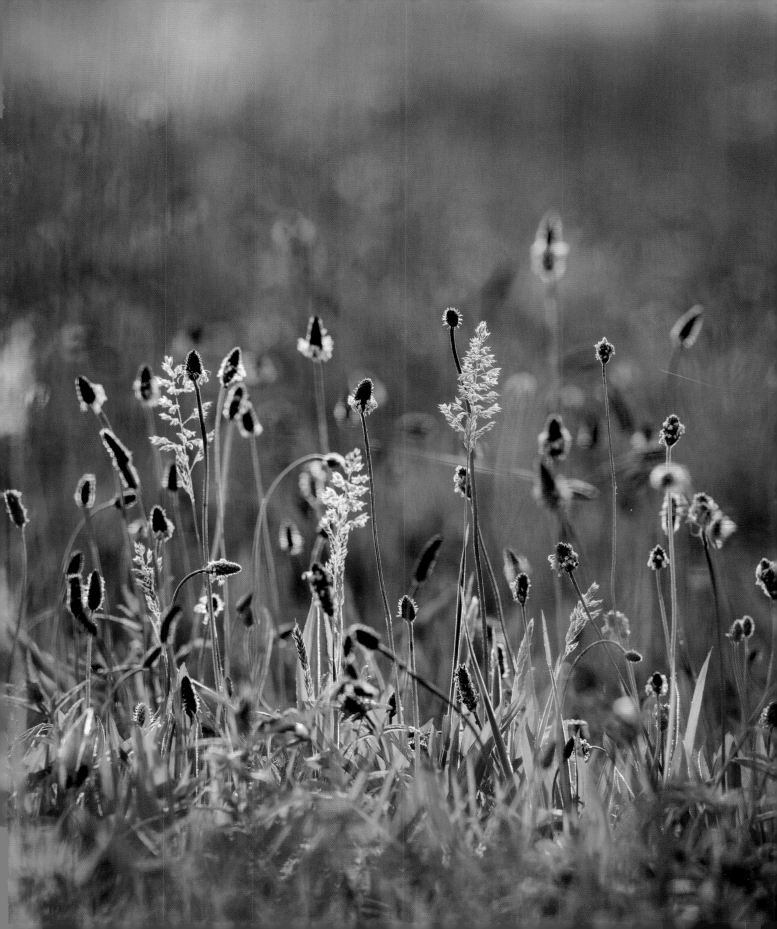

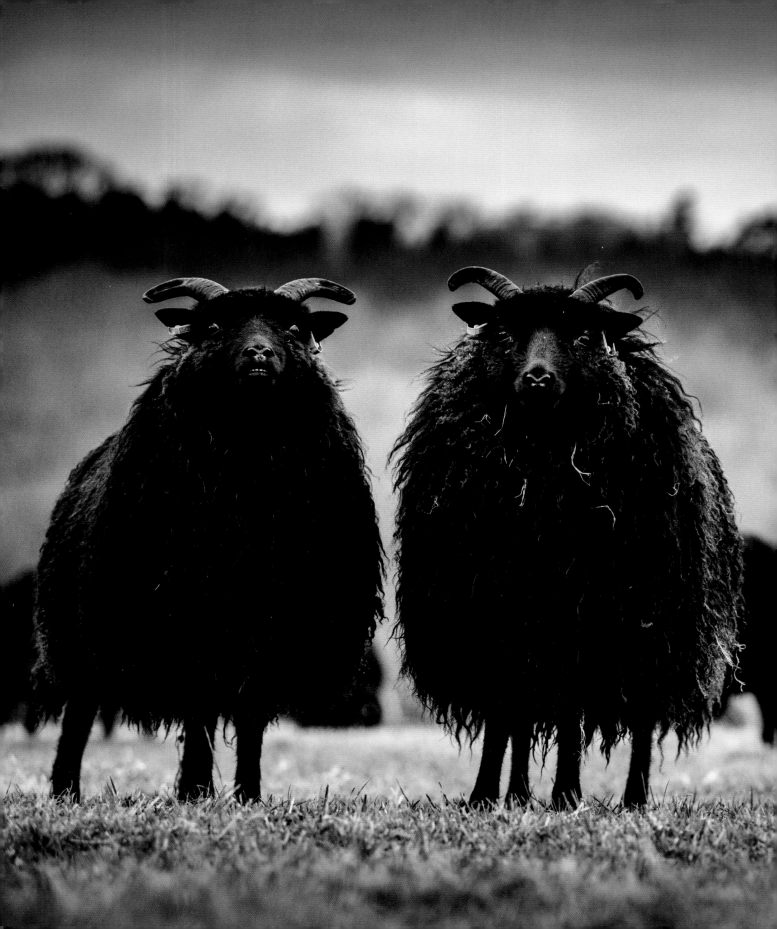

Meadows have an abstract beauty of colour and form which is difficult to put into words, so I would like to pause for a moment to reflect on the contribution made by Jim Holden, photographer, co-author and friend. I'm sure that Jim will remember the ones that got away, but the images that grace the pages of this book demonstrate his unique ability to capture beautiful moments in time. We enjoyed many adventures together.

It is important to me that I make a special mention of Andy Jackson, who took a particular interest in my early career and with endless patience steered me onto a path which has enriched my professional life beyond all measure. Also to Sophie Smith, who has kept a watchful eye. Lastly, I would like to thank innumerable friends, colleagues and family, especially Jane, Adam and Thomas, for the support, patience and encouragement they gave me during the writing of this book.

[1] Hebridean sheep have established a reputation as being one of the best breeds for the management of delicate ecosystems such as traditional hay meadows.

[OVERLEAF] The character of upland pastures and meadows in the Pennines and Yorkshire Dales is enhanced by an ancient network of drystone walls.

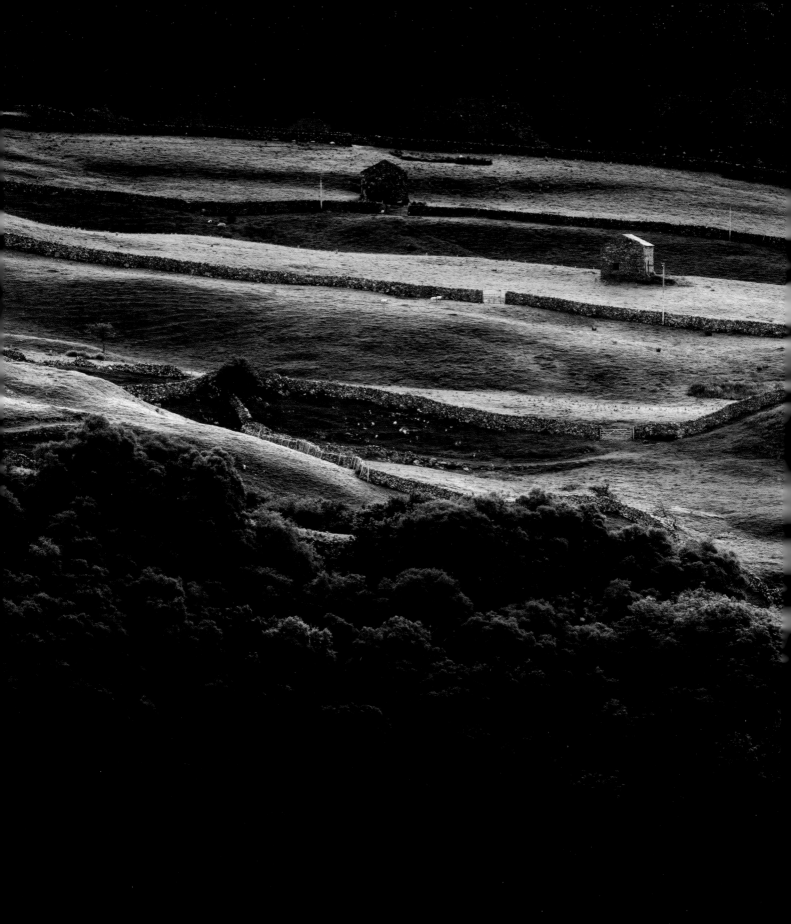

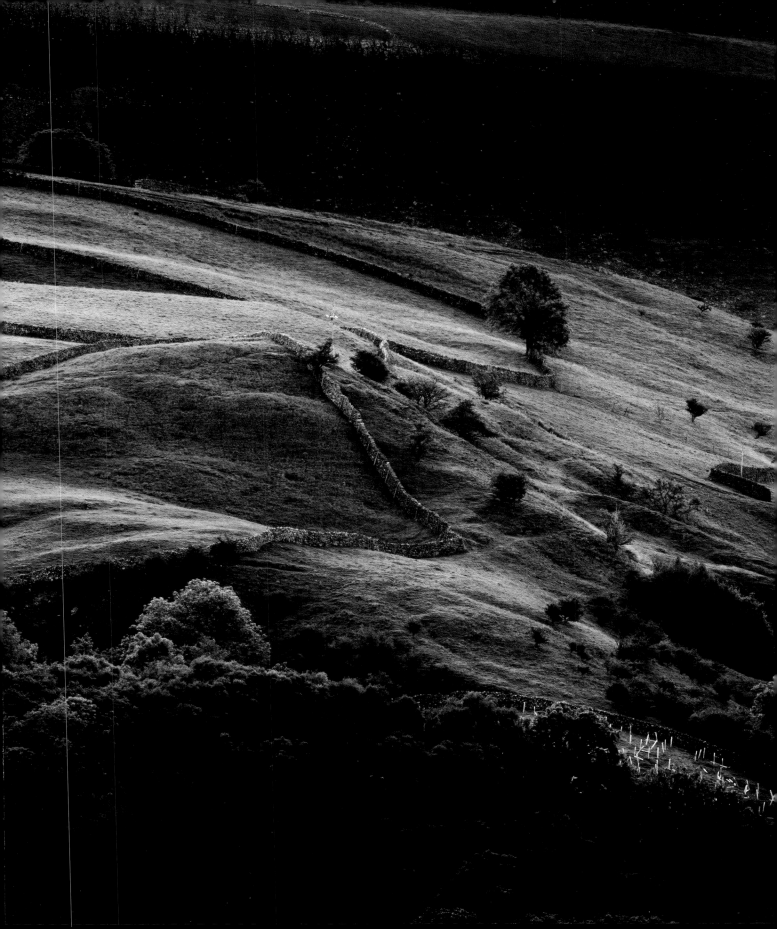

'Nature is an endless
combination and repetition
of a very few laws. She hums
the old well-known air through
innumerable variations.'

RALPH WALDO EMERSON

Introduction

The origins of this book can be traced back to one summer some years ago, when I spent many days sharing in the company of seasoned botanists while exploring the classic hay meadows of the British Isles. The opportunity to immerse myself in the wonderful world of wildflowers arrived in the guise of a generous bursary, which not only subsidised my bed and board but also gave me the precious gift of time. I decided to travel light that summer, packing my rucksack with just a few field guides, a hand lens and my hopes and dreams of finding a wildflower utopia.

My botanical adventures began with a trip to Clattinger Farm in Wiltshire, a stunning mosaic of ancient landscapes and home to some of the finest examples of species-rich meadow in the country. From early spring to late summer the meadows light up with the colourful designs of wildflowers, including many rare and threatened species. When I arrived the potential and promise of spring was in full flow. Lengthening days and warming soils had

breathed vitality back into the meadow and the ground crackled with energy. My senses were alive with the visible and audible patterns of meadow life.

The meadows at Clattinger are interwoven with myriad species of wildflowers, native grasses and all manner of other plants and fungi which provide interest throughout the year. But each spring aspiring botanists make a special pilgrimage to pay their respects to just one species of flower, the charismatic snake's head fritillary. Appearing in countless thousands, the instantly recognisable pink-and-purple chequered flowers of this most enigmatic of plants jostle with other early spring arrivals such as lady's smock and the much-maligned dandelion. My heart sunk, therefore, when I realised that the timing of my visit was poorly judged and I was too late to witness the beauty of this flowering spectacle.

To avoid missing any more 'must see' moments I resolved to quicken my step. What had started out as a gentle study tour had now, by necessity, turned into an exercise requiring military precision. I turned to the reconnaissance of specialists in grassland phenology to help synchronise my meadow manoeuvres. The advice they shared was uncannily accurate and invariably included a useful contact for the person who watched over the meadow I hoped to visit. Listening to the stories of people who had a special bond with a particular meadow added an unexpected depth of meaning to my experience. I soon realised that behind every fascinating meadow was an even more fascinating person.

Over the years my memory of the meadows I visited during the course of that summer has faded, yet my recollection of the people who greeted me at the meadow gate has stood the test of time. While I marvelled at many rare and fascinating plants on my travels, it is the stories of the people who I met along the way that has left a lasting impression. Whether the bond they shared with a meadow

was professional in nature or simply a labour of love, it was not only a privilege to spend time in their company but also an education.

The pages of this book are bound together with the fascinating stories of people who keep a watchful eye over our surviving meadows. From the world of science we meet ecologists, botanists and seed researchers, while archaeologists and landscape historians take us on a journey into the past, back to a time when meadows were ubiquitous features of the farming landscape. We also explore the practical side of meadow management, meeting practitioners involved in haymaking, grazing, scything and hedgelaying. We are even invited to a private viewing of meadow-inspired arts and crafts.

The evocative accounts that unfold with the turn of each page are peppered with insightful observations revealing the pattern of seasonal change in the life of a hay meadow. Each personal commentary takes us on a compelling journey through time and space to explore the past, present and future of wildflower meadows in the British Isles. Along the way, we have an audience with many rare and threatened plants and learn about the wildlife they support. By placing people right at the very heart of the narrative, this book celebrates, above all, the intimate and enduring bond that connects people with place through the power of plants.

[1 AND OVERLEAF] Marden Meadow is one of the best remaining examples of an unimproved hay meadow in Kent.

[2] Now a Site of Special Scientific Interest, Hannah's Meadow is considered to be one of the least improved and most species-rich meadows in upland Durham.

[1]

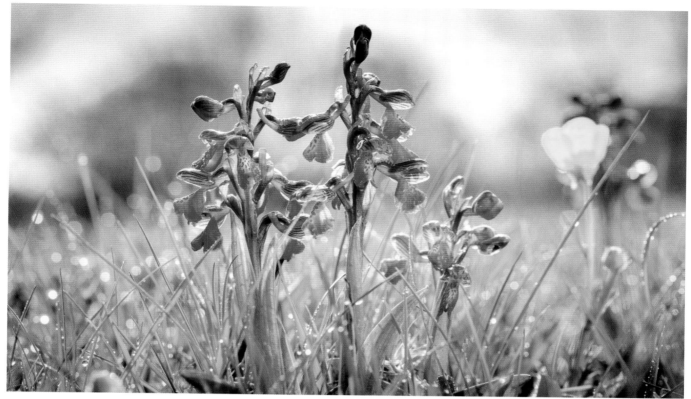

[2]

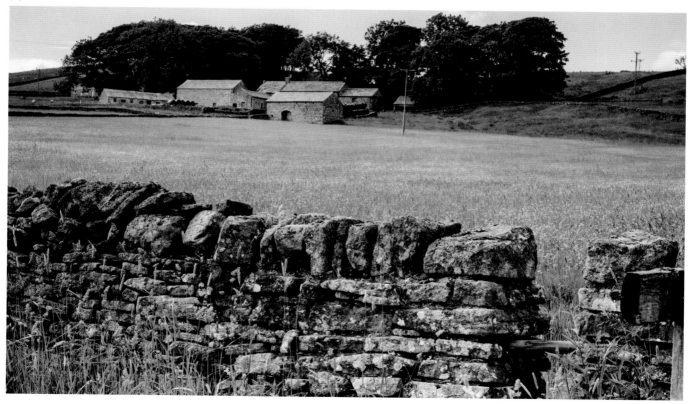

'How does the Meadow
flower its bloom unfold?
Because the lovely little flower
is free down to its root, and
in that freedom bold.'

WILLIAM WORDSWORTH

Variety

Hay meadows are tightly-woven landscapes interlaced with an intricate mix of plants, including wildflowers, grasses, some sedges and rushes, and even a couple of tiny yet fascinating ferns. In the public imagination meadows are synonymous with the colourful forms of wildflowers, but the important role that native grasses play should not be overlooked. The vertical and wiry-stemmed world of grasses gives structure to a meadow, providing forage and shelter for small insects, including the caterpillars of butterflies and moths, as well as offering valuable cover for ground-nesting birds such as the lapwing, curlew and the shy and retiring corncrake.

With such a richly layered flora, it should be no surprise to learn that hay meadows also support an astonishing range of fauna. Above the grassland canopy, for example, countless insects dart, bumble and flutter in search of nectar-laden flowers, while a quick census of cobwebs hints at an incalcuable number of spiders lurking in the depths of the meadow understorey. Amazingly, the number

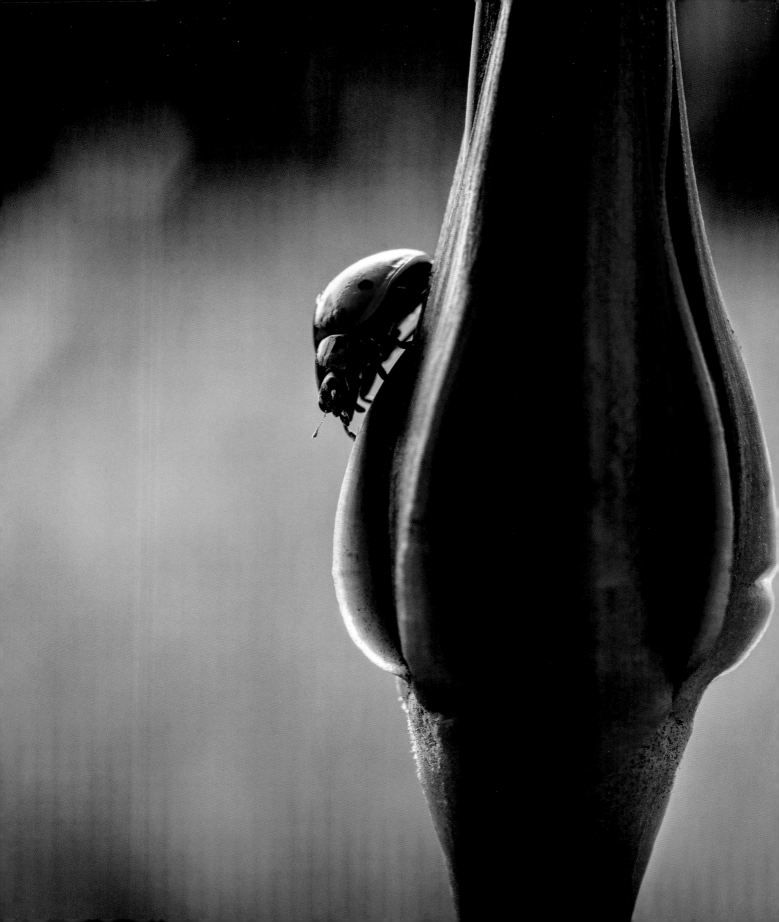

of species above ground is eclipsed by billions of micro-organisms, including bacteria and fungi, that are busy below the surface, working hard to keep the subterranean world of soils in a healthy and sustainable condition.

Meadows are undeniably a metropolis of life, but we need to be careful not to rhapsodise too enthusiastically about the opportunities they provide for nature. They may well be full of wildflowers and teeming with insects, but, working in isolation, meadows are not a panacea for biodiversity loss. In a landscape increasingly fragmented by human activity and vulnerable to a rapidly changing climate, we need to focus on building a more resilient network for nature. Meadows, along with other sustainably managed grasslands, are an important part of this equation because they have the potential to bring together not just communities of plants, but also communities of people.

Meadows may well be full of wildflowers and teeming with insects, but, working in isolation they are not a panacea for biodiversity loss.

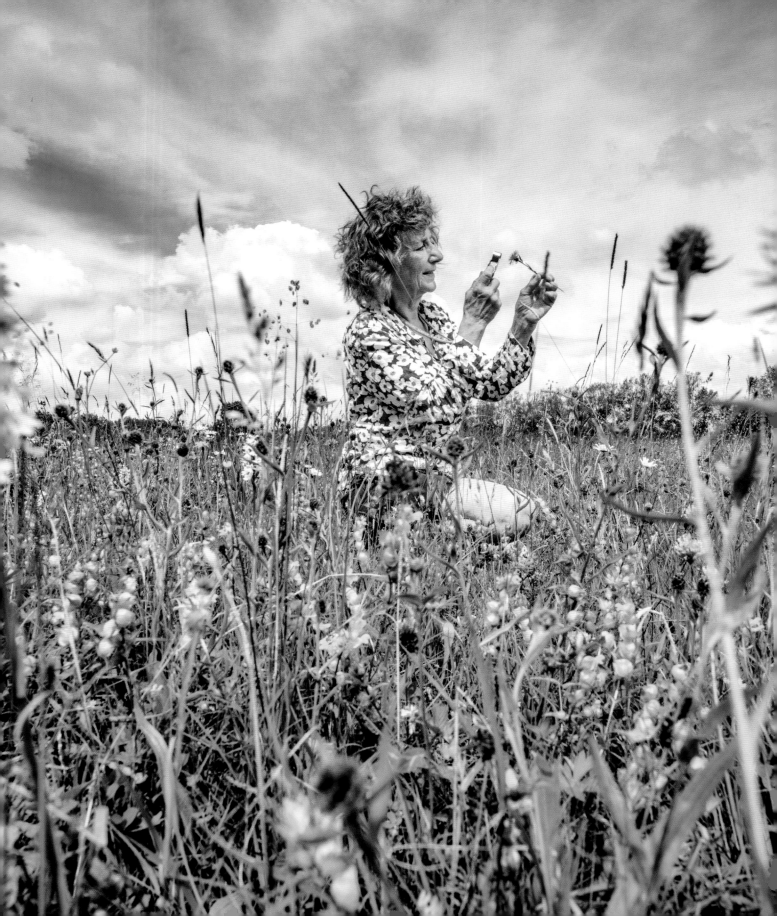

Beauty and utility

ANN SKINNER, FCIEEM, CEcol AND CEnv
CONSERVATION ADVISOR

I fell in love with flower-rich meadows nearly 40 years ago while coordinating a county-wide survey of this beautiful but threatened habitat. The few remaining meadows were mostly in floodplains or on heavy clay soils that would have been difficult to plough, and all were owned by remarkable people who continued to farm the land in a traditional way for a variety of reasons. These farmers are the real unsung heroes in the evolving story of meadows in the British Isles. Stoically they stood their ground during the most damaging period of agricultural intensification, when modern methods of farming caused irreversible damage to our precious native grasslands. When we lament the loss of meadows, it is all too easy to lay the blame at the feet of the farmers, but over the years I have met many who were motivated not by money but by a deep affinity with and love for the land.

Meadows are grasslands that are 'shut up' in spring so they can be mown for hay in summer, then grazed by animals into the autumn until the soils become too wet. They have been created by centuries of traditional farming methods – annual cutting and grazing are essential to maintain the rich community of grasses, sedges and rushes, herbs and mosses that make up the sward. The diversity of plants yields sustainable hay and grazing of excellent nutritional value to livestock; it supports a rich and intricate web of life, including pollinating insects, butterflies, dragonflies and birds.

Every meadow is different because of factors such as geology and soils, topography and hydrology, history and management, all of which affect the competitive abilities of plants. As a result there will often be an intimate mosaic of different plant communities within a single field. The dominant plants in flower change through the seasons and in response to the vagaries of the prevailing weather.

Wildflowers are symbols of regionality. Botanists use their presence and abundance to classify different types of meadow. Upland meadows have a late and short growing season. They are characterised by glorious displays from the luminous yellow of globe flower (*Trollius europaeus*), the blue and purple flowers of meadow crane's-bill (*Geranium pratense*) and wood crane's-bill (*Geranium sylvaticum*), the pinks of water avens (*Geum rivale*) and ragged robin (*Lychnis flos-cuculi*), sweet smelling meadowsweet (*Filipendula ulmaria*) and stands of regal melancholy thistle (*Cirsium heterophyllum*).

Floodplain meadows are perfectly adapted to regular flooding, which deposits fine river silts that build deep, fertile soils and promotes rapid grass growth. Some have spectacular displays of snake's head fritillary (*Fritillaria meleagris*) in April; others are wetter with welcome early colour provided by the egg-yolk yellow flowers of marsh marigold (*Caltha palustris*) and pale lilac lady's smock (*Cardamine pratensis*), on which the orange tip butterfly (*Anthocharis cardamines*) lays her eggs. Later on the burgundy flowers of great burnet (*Sanguisorba officinalis*) are accompanied by the ivory of pepper saxifrage (*Silaum silaus*) and meadow rue (*Thalictrum flavum*), giving way to golden grasses punctuated by the dazzling blue globes of devil's bit scabious (*Succisa pratensis*) and the purple jewels of saw-wort (*Serratula tinctoria*) buds.

Lowland meadows may have spectacular spring displays of cowslips (*Primula veris*), their velvety yellow flowers contrasting superbly with the different colour forms of the green-winged orchid (*Anacamptis morio*), which can grow in such profusion that they tinge the field with a haze of purple. Some of these meadows have special plants such as the diminutive adder's tongue fern

[1]

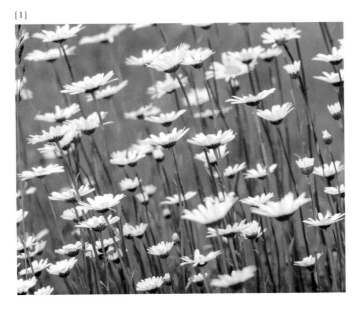

[2]

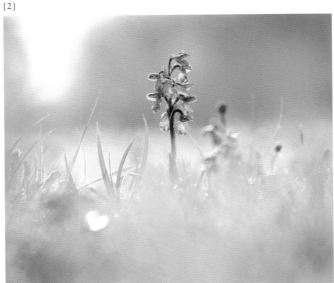

[3]

[4]

[5]

[6]

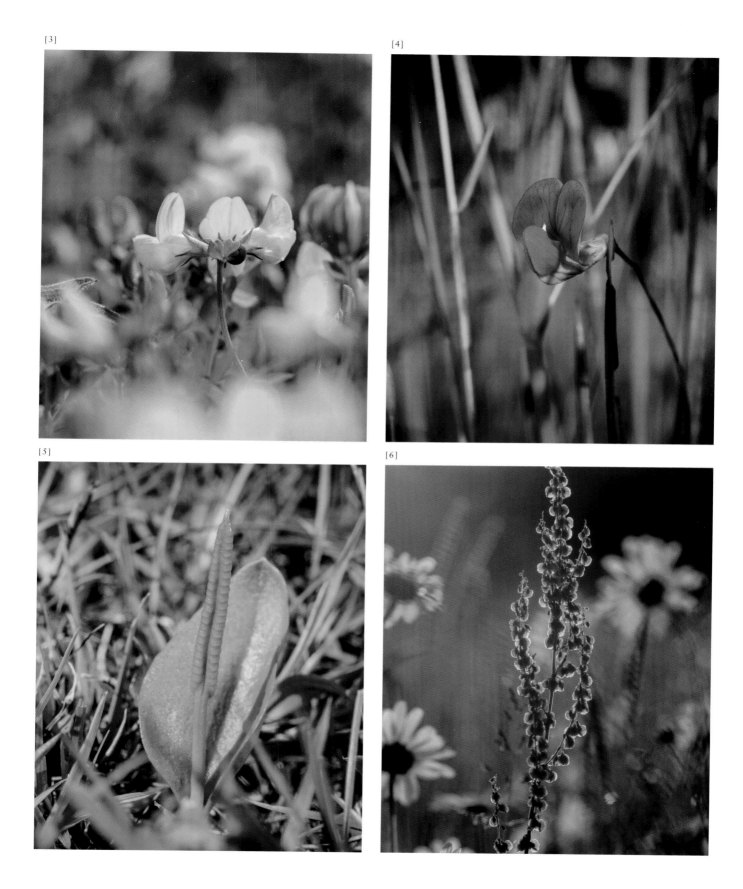

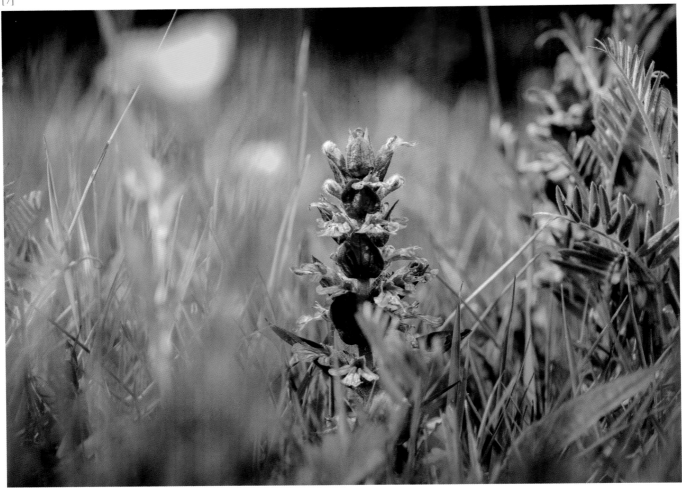

Every meadow is different because of factors such as geology and soils, topography and hydrology, history and management, all of which affect the competitive abilities of plants.

(*Ophioglossum vulgatum*), which is always a joy to find. Dyer's greenweed (*Genista tinctoria*), meadow vetchling (*Lathyrus pratensis*) and bird's foot trefoil (*Lotus corniculatus*) provide long-lasting displays of yellow.

Some of my favourites are the machair grasslands on the shelly coastal sands of the north and west coasts of Scotland and western Ireland. Red and white clovers (*Trifolium* spp.), kidney vetch (*Anthyllis vulneraria*) and eyebright (*Euphrasia officinalis*) are abundant, with lady's bedstraw (*Galium verum*) and sometimes diminutive frog orchids (*Dactylorhiza viridis*), hard to find but well worth the effort.

Many meadows support plants that are fairly widespread such as ox-eye daisy (*Leucanthemum vulgare*), knapweed (*Centaurea nigra*), clovers (*Trifolium*

[1] There is more than meets the eye to the humble ox-eye daisy (*Leucanthemum vulgare*); in days gone by it was more commonly known as the 'moon daisy' as its unashamedly bold flower heads welcome in the summer solstice.

[2] The green-winged orchid (*Anacamptis morio*) is a short orchid of unimproved grasslands. The Latin name *morio* means 'fool' and refers to the jester-like variegated pattern of its green-and-purple flowers.

[3] Common names for bird's-foot-trefoil (*Lotus corniculatus*) include 'butter and eggs', 'eggs and bacon' and 'hen and chickens', which all describe the egg-yolk yellow flowers and reddish buds.

[4] Grass vetchling (*Lathyrus nissolia*) is a tall, erect annual plant. It is easy to identify when in flower due its piercing pink colour, but blends in with the surrounding grass at other times.

[5] Adder's tongue ferns (*Ophioglossum vulgatum*) are plants of unimproved grassland and are usually very difficult to find as they blend into the similarly coloured grassland.

[6] Common sorrel (*Rumex acetosa*) is found in a wide variety of habitats across the British Isles but, is particularly characteristic of meadows and pastures.

[7] The blue flower spikes of bugle (*Ajuga reptans*) is often found carpeting the swards in damp meadows.

[8] Globeflower (*Trollius europaeus*) prefers damp soil and provides a splash of colour in wet meadows, particularly in classic upland hay meadows.

spp.) and vetches (*Vicia* spp.) but nevertheless produce spectacular displays. Others may have drifts of common, heath spotted and marsh orchids (*Dactylorhiza* spp.), elegant moth-pollinated butterfly orchids *(Platanthera* spp.) and the curious green-flowered common twayblade (*Neottia ovata*).

As traditional flower-rich meadows produce less 'grass' and can sustain fewer animals than intensive pasture, there have been significant challenges for those wishing to farm them profitably, or even make enough to money live on. It is now more important than ever to ensure that any new agricultural policy supports the management of this vitally important part of our cultural heritage for the many benefits they bring to us all. Valued throughout history for their natural productivity

and essential hay crops, today we value meadows more for their ability to lock up significant amounts of carbon deep within their soils; to slow, store and filter the flow of water off the land; to recharge aquifers and support rivers during drought – helping us to withstand the extremes caused by our changing climate.

Flower-rich meadows are perhaps our most under-appreciated habitat, and the one we are in greatest danger of losing altogether. Thanks to determined individuals who love their ancient meadows, those fragments that remain are an integral component of many quintessentially British landscapes, an important part of our history and culture, and a fantastic source of inspiration and happiness. We need to rebuild them at a landscape scale to restore resilience for future generations ❧

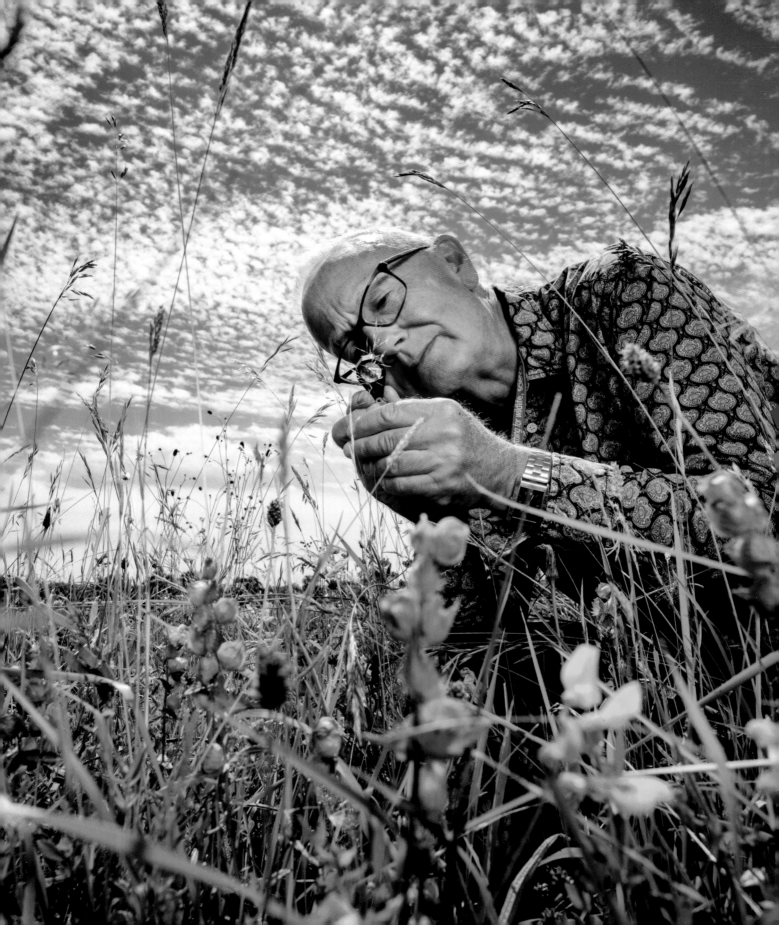

Wild grasses

DR RICHARD G. JEFFERSON
GRASSLANDS SPECIALIST

In the British Isles there are 105 species of native grass, depending on whose taxonomy and interpretation of 'native' you follow. For a further five grasses, their status is unclear – that is, they are classed as native or alien. A large number of alien grasses have also found their way to our shores, especially since the Industrial Revolution around 240 years ago, with around 447 species recorded since 1930. These latter grasses have not established populations in hay meadows, however.

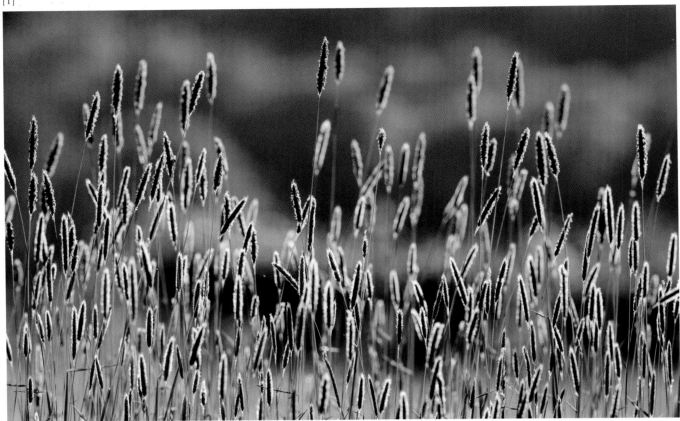

Of the 110 species, there are 46 species (42 per cent) of grass that can occur in hay meadows, of which 28 might be considered as 'core' hay meadow species. The sterile hybrid between meadow fescue (*Festuca pratensis*) and perennial ryegrass (*Lolium perenne*), known as hybrid fescue (*Festulolium*), is included in the meadow species list, as it is widespread in this habitat across much of England and Wales.

Using a variety of published and unpublished sources, including quadrats and species lists that I and colleagues sampled from a range of English meadows over the last 30 years, I assembled some grass statistics. The range in number of grasses per 2 m x 2 m quadrat (4 m²) from old meadows is 5–14, with an average of 8 species per 4 m². The most grass-rich quadrat of this sample contained a staggering 14 species and was recorded by the author at Stockwood meadows in Worcestershire.

The richness of grasses in old meadows contrasts markedly with agricultural sown leys, which now dominate our lowland landscapes. These are normally dominated by one or two grasses – usually cultivars of perennial ryegrass (*Lolium perenne*) and Timothy grass (*Phleum pratense*).

At the meadow site level, the number of grasses is strongly influenced by site size, management and the extent of small-scale variability in soils and hydrology. However, the visually stunning and botanically diverse Thames flood meadows near Oxford, known as Pixey and Yarnton Meads, topped my sample sites with 25 of the 46 grasses, followed closely by Mottey Meadows, Staffordshire, with 24 grasses.

Most of the core meadow species have wide distributions in Europe, spanning the major climate zones, from the boreal in the north to the temperate in the south but rarely reaching the Mediterranean. Some meadow species occur in a wide range of British habitats – red fescue (*Festuca rubra*), for example, occurs in 125 National Vegetation Classification plant communities.

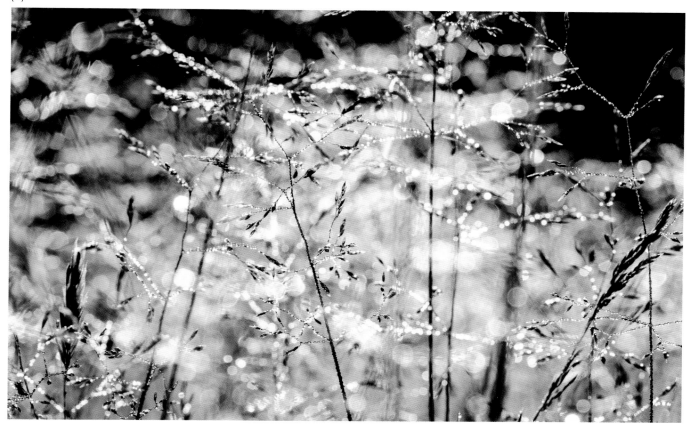

The richness of grasses
in old meadows
contrasts markedly with
agricultural sown leys,
which now dominate our
lowland landscapes.

Grasses are clearly important, prominent and intrinsic features of our wildlife-rich grasslands, including hay meadows. These grasslands have been well studied and documented, and the National Ecosystem Assessment (2011) concluded that ecological research into semi-natural grasslands has probably contributed more than any other ecosystem to the development of the UK's ecological knowledge.

Despite this, at the level of individual species, it seems that grasses have not captured the same level of interest, at least to botanists and ecologists, as other flowering plants. This is perhaps reflected in the paucity of illustrated identification guides to grasses in Britain and Europe.

From an aesthetic point of view, individual species of wild grass have arguably been somewhat under-appreciated. There is some evidence that humans tend to have a strong preference for brightly coloured flowers, which might help to explain this. However, grasses both

individually and collectively undoubtedly have their own subtle beauty, some species more than others. Perhaps the growth in popularity and availability of grasses in horticulture is a sign that this perspective is starting to change. Dutch landscape designer Piet Oudolf, for example, has pioneered the use of ornamental grasses in garden design.

From a sensory perspective, many commentators such as Richard Mabey have remarked on the pleasure of experiencing the heavy scent of newly mown hay from wildflower-rich meadows.

Grasses are a very important family in terms of the number of associated plant-feeding insects and other invertebrates. They rank third in a list of the top seven British plant families for insects and mites, with over 800 species. Many grass-feeding species are small and inconspicuous; they mine the leaves, bore into stems, form galls on leaves, stems, roots and flowers or feed on the roots. Examples include the larva of a fly that mines the leaves of many grasses, including cereals, a couple of chalcid wasps whose larvae form galls in the stems of Timothy and tufted hair grass, and a grain aphid that feeds on a wide range of meadow and cereal grasses. The larvae of eight species of British butterfly also feed on grasses. Of these, there are five species that feed on one or more of the core meadow grasses and that could potentially use meadow habitats for all or part of their life cycle. These include the meadow brown (*Maniola jurtina*) and ringlet (*Aphantopus hyperantus*), both familiar and widespread species.

Traditionally managed species-rich hay meadows do not yield as much volume of cut herbage as re-sown agricultural grasslands, and the livestock feed value of the former is also lower. Despite this, they can still be readily integrated into, and provide value for, beef and sheep farming enterprises.

There is increasing evidence of the value of species-rich grasslands for maintaining the health of domestic livestock through the supply of vital minerals and via the antibiotic and medicinal properties of specific component plants.

Hay made from species-rich grasslands can often find a market among horse owners, who often prefer to feed their animals hay rather than forage from intensively managed grasslands. This is because wild grasses and certain herbs are lower in sugars, which may help to lower the risk of obesity or diseases such as laminitis.

There is emerging evidence that livestock fed on forage from species-rich grasslands may produce better quality meat than agriculturally improved grasslands. The former tastes better and is healthier due to higher concentrations of omega-3 fatty acids. Also, there is good evidence that the sensory characteristics of cheese (taste, aroma and texture) is improved by higher botanical diversity of pasture or forage fed to livestock. ❦

Grasses are a very important family in terms of the number of associated plant-feeding insects and other invertebrates.

[1] The tall upright nature of meadow foxtail (*Alopecurus pratensis*) provides food and habitats for a variety of invertebrates, including the caterpillars of the Essex skipper butterfly (*Thymelicus lineola*).

[2] The glistening early morning dew gives the delicate whorled branches of common bent grass (*Agrostis capillaris*) a crystal-like appearance.

[3] A close look at the neatly braided flower heads of crested dog's-tail (*Cynosurus cristatus*) brings the beauty of this wiry stemmed grass into sharp focus.

[4] Crested dog's-tail (*Cynosurus cristatus*) grass is the food plant of the larvae of several species of butterfly, including the brown butterflies (Satyridae) and skipper butterflies (Hesperiidae).

[5] The empty seed head of sweet vernal grass (*Anthoxanthum odoratum*) take on a translucent appearance when backlit by the sun. This heavily scented grass is one of the first meadow grasses to flower and when cut gives hay its sweet aroma.

[6] Quaking grass (*Briza media*) grows equally well on chalk and clay soils. Dangling from delicately thin stalks, the purple-tinted flowerheads respond with a quiver to even the gentlest of breezes.

[3]

[4]

[5]

[6]

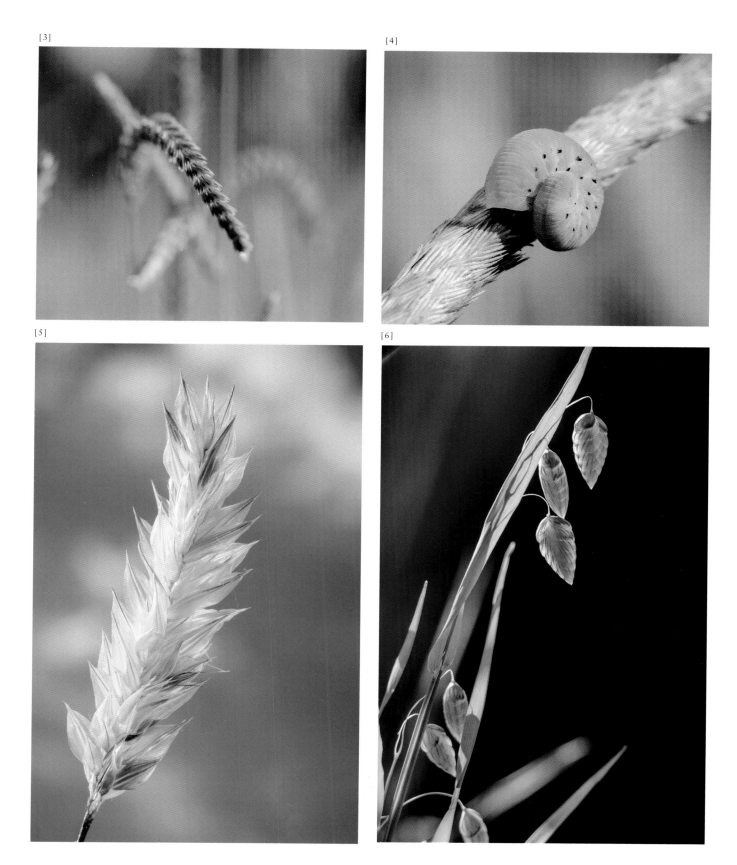

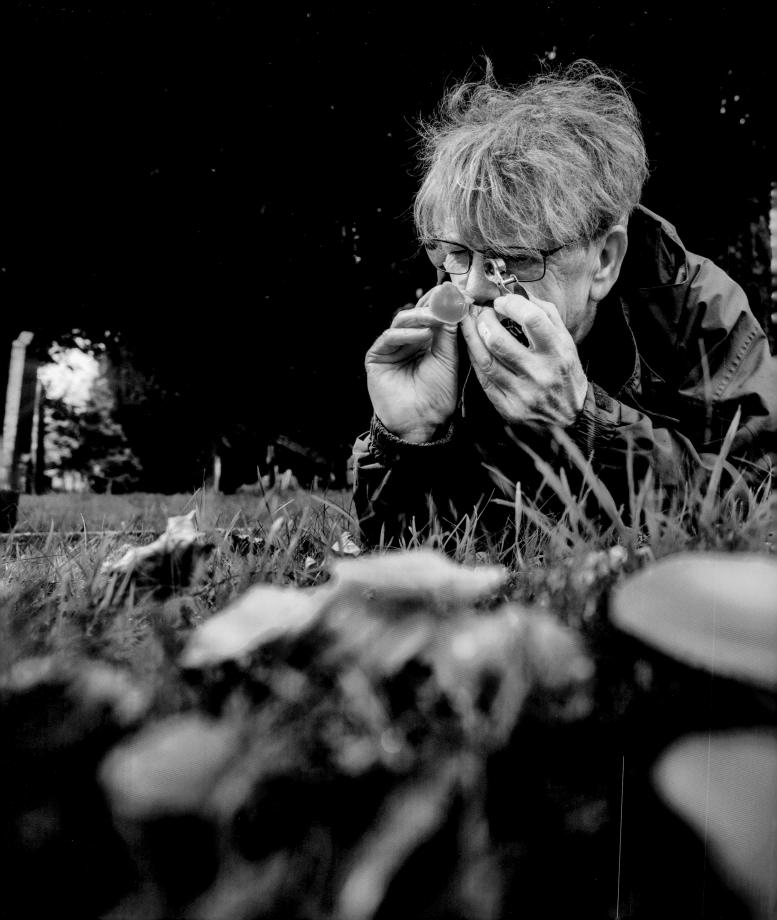

Grassland jewels

MARTIN ALLISON
ECOLOGICAL CONSULTANT

Waxcap fungi (*Hygrocybe*) come in rainbow colours: reds, yellows, oranges, pinks, greens and violets. They have wacky names: spangle, slimy, butter, parrot, oily, date, toasted, goblet, ballerina. They may smell of honey, or Russian leather, or even bed bugs. They may appear in huge numbers one season, only to be absent the following year. To me they are verging on the magical. But, above all, the waxcap grassland community plays a vital role in helping us to assess the quality of old meadows and lawns, as they represent long periods of undisturbed ecological continuity.

Fungi have held a lifelong fascination for me. As a cash-strapped student I wandered the countryside armed with my bible of that time – Richard Mabey's *Food for Free* – the original still on my shelf today. I very soon realised that there was much more to mushrooms than just providing a free meal, or conversely having the potential to do me serious harm. From there I began to learn to differentiate the species found on my local patch from a more scientific viewpoint, eventually building a knowledge that now allows me to offer mycological survey and management advice to a range of organisations and private landowners, and even the occasional planning enquiry.

Waxcaps are the archetypal grassland mushrooms. As well as their superb colouration, many species literally feel cold and waxy to the touch, more so than other genera of fungi. But there are other textures, the most entertaining being the lubricious species. Try holding a fresh glutinous waxcap between your fingers and it will squirt out of your grasp and go flying. They are truly slimy.

The growth mode of these grassland species is still poorly understood. They were long considered saprotrophic, feeding on dead organic material. Waxcap hyphae (branching, root-like structures) are now known to inhabit the roots of grasses, but which processes are being played out needs further study. A potential waxcap lawn will almost always support bryophytes (mosses and liverworts), particularly springy turf-moss (*Rhytidiadelphus squarrosus*), although again the relationship between mushroom and moss is unclear. No doubt the moss clumps retain moisture, which possibly helps the mushrooms to survive during dry periods. What is known is that these fungi will struggle to compete with tall and vigorous vascular plant growth, whether mosses are present or not.

[1]

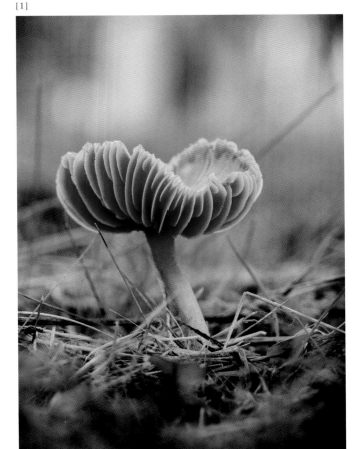

[2]

[3]

Prime waxcap grasslands are those which are unfertilised, and either short grazed or mown with clippings removed. Suitably grazed sites are scarce in southern England, more prominent on the sheep-grazed slopes of the western and northern hills. In the south and east, the more frequent habitats are found on old lawns and in cemeteries. Old estates and historic gardens can be outstanding, but only if the correct management regime is in place. The same can be said regarding Victorian cemeteries and churchyards, all with the potential to support good waxcap populations.

Damaging management can be devastating to these mycological communities, as even minor disturbance can mean a loss of the bulk of the species present, with a recovery window, if at all, of up to 50 years. Local damage can include ploughing, compaction and fertilisation. It may sound counter-intuitive, but the creation of flower-rich meadows, often championed

in conservation circles, should be avoided on those grasslands supporting waxcap communities. But many old established meadows are havens for grassland fungi, including waxcaps, and these should continue to be managed in the traditional way.

Although waxcaps stand out on a survey visit due to their array of dazzling colours, often aptly described as grassland jewels, other associates are equally important. There are three further groups of fungi to consider. These are the pinkgills (Entolomataceae), corals and clubs (Clavariaceae) and the rather spooky black fingers of the earthtongues (Geoglossaceae). The latter often have an uncanny penchant for appearing on the tops of actual graves.

Meadow fungi are taxonomically challenging. When I began studying mycology there were just one or two field guides, illustrating a handful of species. Today there are readily available monographs on waxcaps and

pinkgills, but species concepts are still being challenged. DNA sequencing has come partly to the rescue, and now there is even a portable device called a Bento Lab, described as a DNA analysis laboratory, where extraction can take place at home. However, this is not for the faint-hearted, and to a traditional mycologist it might feel like cheating.

For the last three autumns I have been involved in a joint Natural England and High Weald Area of Outstanding Natural Beauty (AONB) survey of existing and potentially new waxcap communities across the High Weald. The purpose of this exercise is to document and map priority grasslands across the region, preparing a catalogue of potential Sites of Special Scientific Interest

The waxcap grassland community plays a vital role in helping us to assess the quality of old meadows and lawns, as they represent long periods of undisturbed ecological continuity.

[5]

(SSSI) quality sites, while encouraging site owners to manage their land in a sympathetic manner for these charismatic fungi.

Waxcap grasslands in the UK are among the last European strongholds for these rapidly declining habitats and species, lost through agricultural improvements, atmospheric pollution and relentless development. Some species present here, such as the pink waxcap (*Porpolomopsis calyptriformis*), are vanishingly rare in Continental Europe. The onus is therefore on us to protect and conserve our mycological heritage so that the colourful and enigmatic waxcaps and associated fungi continue to make a glorious addition to the biodiversity of old grasslands and meadows into the future. ◑

[1,2 AND 3] The scarlet waxcap (*Hygrocybe coccinea*) is one of the smaller red waxcaps and, like all hygrocybes, it has its best seasons in frost-free late autumn months.

[4] The golden waxcap (*Hygrocybe chlorophana*) is an infrequent, but far from rare, species of unimproved grasslands.

[5] The parrot waxcap (*Gliophorus psittacinus*) favours unimproved acid or neutral grassland and is most plentiful in western Britain.

[6 AND 7] The crimson waxcap (*Hygrocybe punicea*) is one of the largest of the waxcaps. It is often confused with the far more common scarlet waxcap.

(8) Waxcaps are distinguished by well-spaced, thick waxy gills on the underside of the fruiting body.

[6]

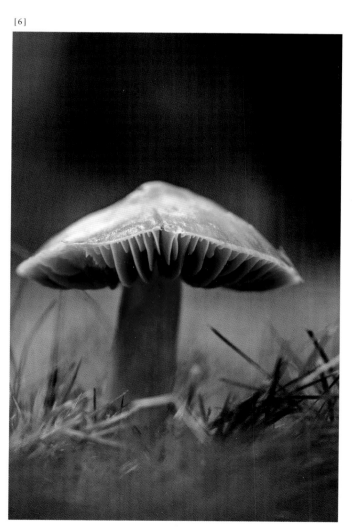

[7]

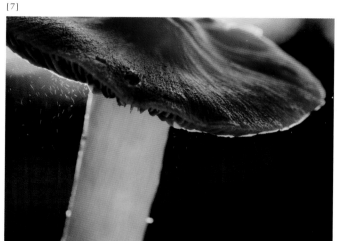

[8]

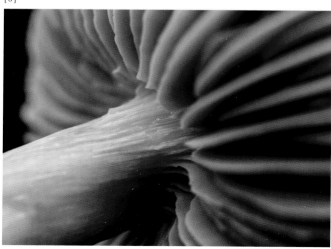

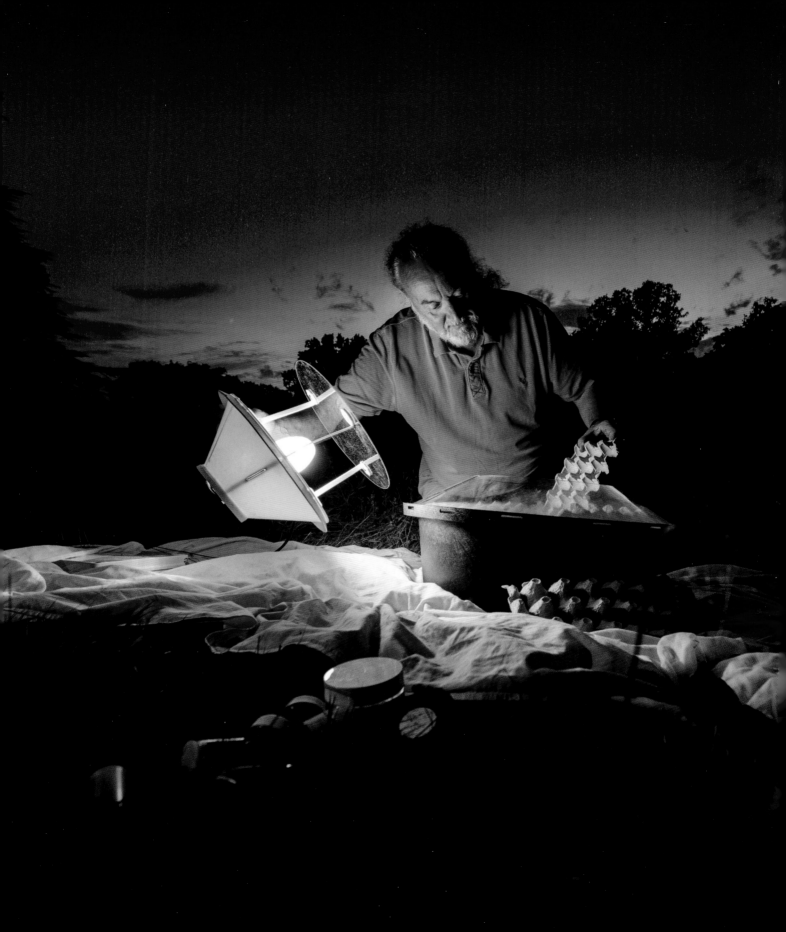

Moths matter

BOB FOREMAN
BIODIVERSITY DATA LEAD
SUSSEX BIODIVERSITY RECORD CENTRE

There is not a specific event, that I can remember, that triggered my lifelong fascination for moths and butterflies, but I do know for sure that it happened sometime prior to the long hot summer of 1976. I lived by the coast in South Devon and we were lucky enough to have an almost endless array of glorious cliff-top meadows right on our doorstep. I would spend my summer holidays scampering about, butterfly net in hand, looking for new species to add to my ever-growing, and at the time entirely uncontroversial, collection.

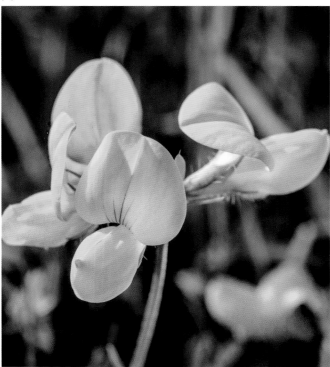

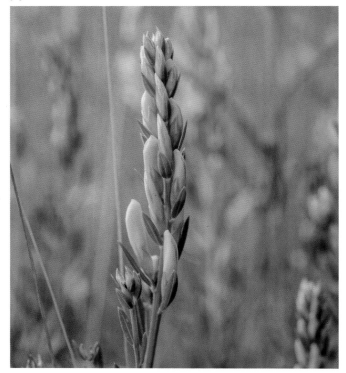

Undoubtedly the person that I hold responsible for this obsession was my elderly next-door neighbour. Mr Laidlaw was an extremely knowledgeable entomologist and taught me a great deal of what I now know. These days his study of moths and butterflies would be characterised as 'old school' in that his interest was in collecting, identifying and cataloguing rather than understanding the ecology of these species, but in reality he was just as knowledgeable about their habitat requirements and life histories as any 'modern' ecologist, and much of this he passed on to me.

It becomes rapidly apparent when you start studying moths (and butterflies or any other insect order, for that matter) that while many are so-called generalists and are likely to be encountered in a broad spectrum of habitats, there are those that are very particular about their surroundings. Meadows are the chosen habitat for many species. The enormous diversity of plant species that are found in the best meadows supports a similar diversity of moth species.

Around the edges of meadows in May or June you will sometimes see what at first glance appear to be little more than dark specks in buttercup flowers; on closer inspection you will find that these are tiny *Micropterix calthella* moths. No bigger than a few millimetres in size, they congregate in the flowers to eat the pollen (unlike almost all other moth species, they have mandibles rather than a proboscis). Studies have found that solar tracking increases the ambient temperature within a buttercup flower by up to 3 °C higher than the surroundings, so they are probably there for the warmth too.

More common in the north but a rare treat in Sussex is the chimney sweeper (*Odezia atrata*) – occupying a few damp meadows in the county, these could easily be mistaken for small, jet-black butterflies. Elusive and rarely settling for long, these delightful little moths are about the size of a small copper butterfly (*Lycaena phlaeas*) and their wings, when fresh, are completely black and plain except for a pure white fringe at the tips of the forewings. The caterpillars feed on pignut

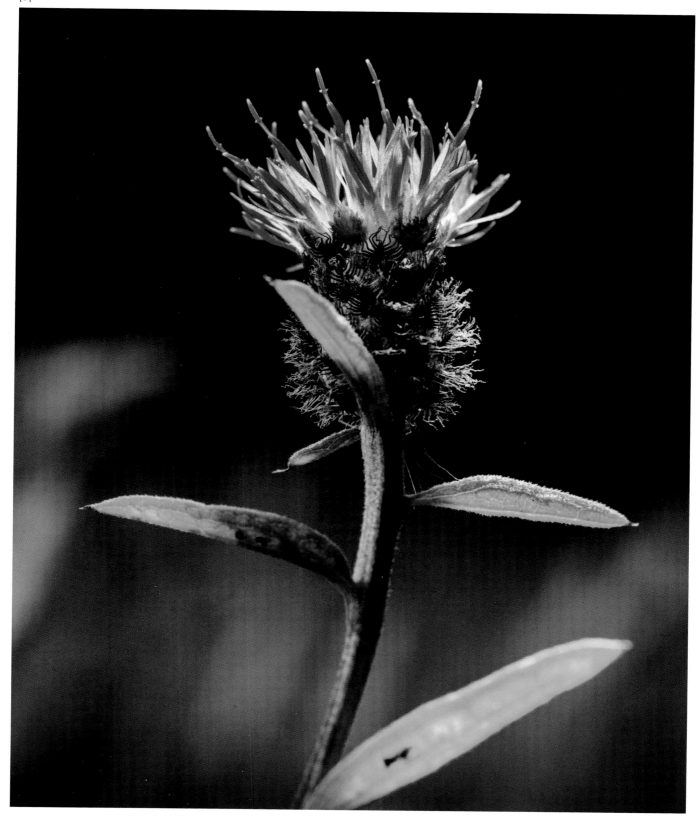

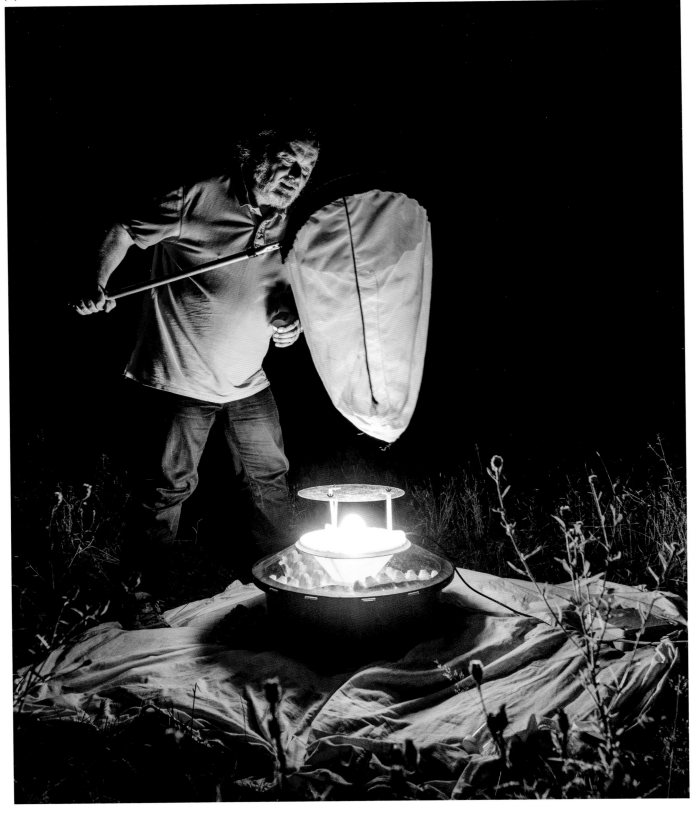

(*Conopodium majus*), which is much more common than the moth itself, so why it should only be found in beautiful ancient meadows rather than being more widely distributed is a mystery.

A common sight in a summer meadow is the strange elongated and tapered papery cocoons of burnet moths (zygaenids) aligned along flowering stems of tall grasses, exactly the same colour as the grass and looking almost like some sort of growth from within the stem. The caterpillars, which feed on common bird's-foot trefoil (*Lotus corniculatus*), pupate in May or June. After the adult moths have emerged, a month or so later, the cocoons can still be seen but with the empty case of the chrysalis protruding from the top, through the hole made by the emerging adult.

Most commonly it is the six-spot burnet (*Zygaena filipendulae*) that we see flying in meadows in high summer, their flight a high-speed whirring of wings, reminiscent of extremely alarming large red-and-black hornets (*Vespa crabro*). When they settle, however, usually on the flowers of creeping thistle (*Cirsium arvense*) or knapweed (*Centaurea nigra*), they reveal themselves to be beautiful iridescent, almost metallic black moths with bright scarlet blotches and (less obviously) scarlet hindwings. Completely harmless.

Without doubt, when one conjures thoughts of a wildflower meadow and its invertebrate inhabitants in high-summer, the first thing that most people would think of is the sound of stridulating grasshoppers or of clouds of butterflies, but not many would necessarily think of the enormous variety of moths that are to be found there too. Whether it is dusky sallows (*Eremobia ochroleuca*) feeding on knapweed flowers or tiny speckled fanners (*Glyphipterix thrasonella*) flying in swarms in damp, rushy corners, the diversity of moths is as great and extraordinary as anything to be found there. ☙

The enormous diversity of plant species that are found in the best meadows supports a similar diversity of moth species.

[1] Common bird's-foot-trefoil (*Lotus corniculatus*) is a very versatile meadow plant. It is an important source of nectar for many kinds of species including moths.

[2] Dyer's greenweed (*Genista tinctoria*) is a member of the pea family and has bright yellow flowers that appear from June to August. It is an important food plant for a range of scarce micro-moths and other pollinators.

[3] Common knapweed (*Centaurea nigra*) is not just a big favourite of all kinds of butterflies, including common blues, marbled whites and meadow browns, but is also the food plant for a myriad of moths.

[4] Being primarily nocturnal creatures, moths evolved to travel by the glimmer of the moon. To do this they use a method called transverse orientation which is why they are attracted to artificial light, although many can be seen on the wing during the day.

[5] Common wainscot (*Mythimna pallens*) is a species normally associated with grassland habitats. Adults appear frequently at light but the larvae are nocturnal, hiding among grassy tussocks during the day.

Tangled web

LAURIE JACKSON
ENTOMOLOGIST

Daydream of a summer meadow and I will bet there is the buzz of a passing bumblebee, a colourful flash of butterfly wing and the hypnotic chorus of crickets. And rightly so. Insects are the beating heart of a meadow, providing the soundtrack and magnifying its vibrancy. While our scythes may now lie quiet, meadows remain hubs of activity for insects. Industrious bees are joined by deliciously chunky flies, clumsy beetles and elegant wasps. Just as we do, different pollinators have their preferred blooms. Long-tongued bumblebees often choose the protein-packed pollen of clovers and vetches, while knapweeds and scabiouses provide an irresistible draw for butterflies.

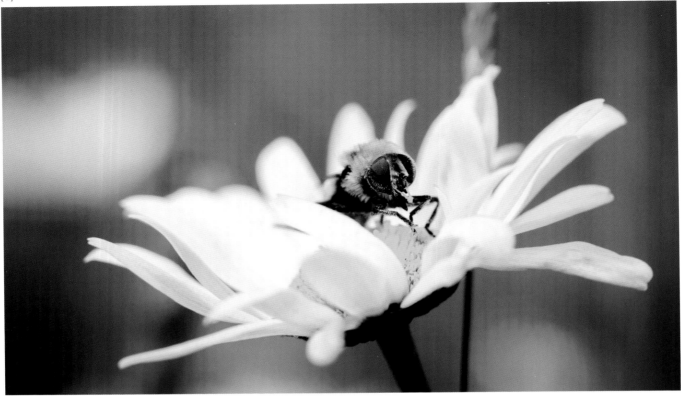

As with the flowers, the insect community waxes and wanes through a seasonal sequence, the variety of wildflowers having a direct impact upon the species present. Some, such as the red bartsia bee (*Melitta tricincta*), rely on pollen from a single species of plant and many others, including the charismatic long-horned bee (*Eucera longicornis*), survive only where the flowering community is rich and diverse. While pollinators may race to the front of our minds when we think of insects, meadows also contain rich communities of herbivores, predators and decomposers, and are the scenes of untold numbers of micro-dramas as their lives unfold.

Meadows are a key part of the patchwork of our landscapes, combining with woodland, wetlands and other wild places. The abundant feeding opportunities entice species from adjacent habitat, including the colourful longhorn beetles (Cerambycidae). While their larvae develop in decaying wood, adults can flock to the meadow edge to feast on umbellifers and other open-fronted flowers. But meadows provide more than just food. Although the subtlety can be lost on us, meadows are complex and provide an intricate mix of microhabitats that are much in demand among insects: the scuff of a passing cow's hoof, a grassy tussock, an anthill or a scrubby edge. All add structure and diversity, providing new opportunities to the insect inhabitants. Hollow stems and seed heads offer the perfect nooks to hide from predators or to while away the worst of the winter weather, emphasising the importance of varied vegetation height in and around meadows.

Meadows are important for insects, but insects are important for meadows too. A diligent community of decomposers break down plant and animal material, returning nutrients once again to the plants. Elaborately patterned bugs join beetles and the larvae of many moths and butterflies in grazing the vegetation, contributing to the structural diversity, while the soil dwellers distribute nutrients, aerate the soil and help to disperse plant seeds.

Insect communities can be studied by combining techniques, including sweeping of vegetation and

[2]

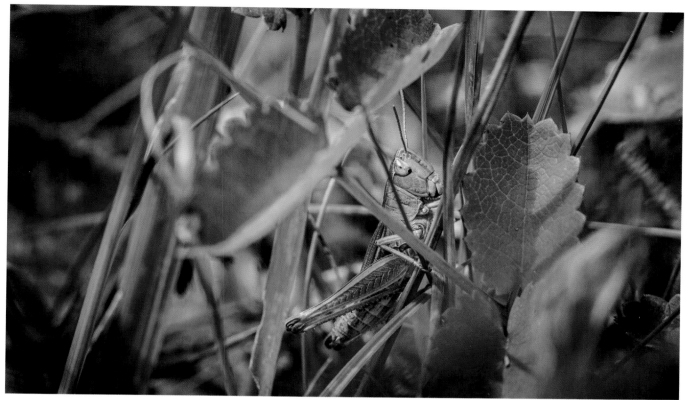

[3]

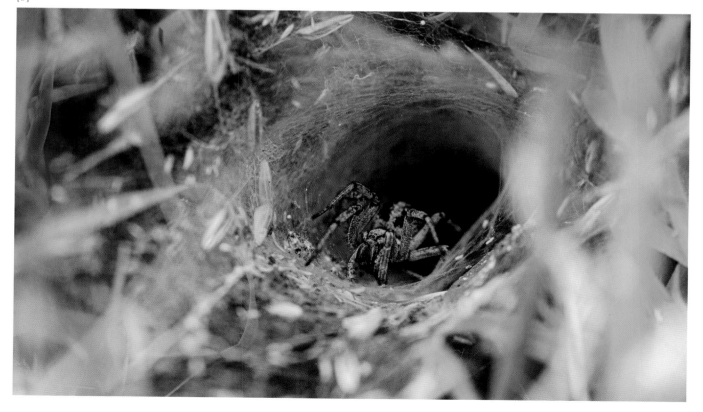

searching flowering plants. Fixed-route transects can be used for airborne species including butterflies and bumblebees, while beating surrounding woody vegetation can tell you about the species around the meadow edge that are likely to interact with it. Monitoring flowering resources at different times of year provides a useful insight into the availability of foraging opportunities. Whichever methods are used, it is important that they are standardised so they are easy to repeat and data gathered are comparable.

The loss of meadows in recent decades presents many species with a lack of stability. Insects are often adapted to the subtleties of their particular meadow type: its hydrology, its soil type, even its history of management. It is a sad fact that today's meadows are a more thinly dispersed part of our landscape; their breaking apart into ever smaller fragments can be an insurmountable barrier to many, making individual populations much more vulnerable, especially for those species that have specialist requirements. Meadows may be the last refuges for some insects within a countryside that is getting ever-less flowery and increasingly similar in terms of its plant composition.

We have lost so much of these species-rich habitats, but it is not too late to atone for this. By restoring meadows, we enable insects once again to flow through our landscapes, allowing them to move and mate and increasing the resilience of their populations. We need to see beyond any misconceptions of meadows being unkempt and start to listen to and feel all they have to tell us. The richness of insect communities is tied to the richness of the communities they support. This colourful cast are a key part of our meadows and our lives would be all the poorer without them. ∞

Meadows are important for insects, but insects are important for meadows too.

[4]

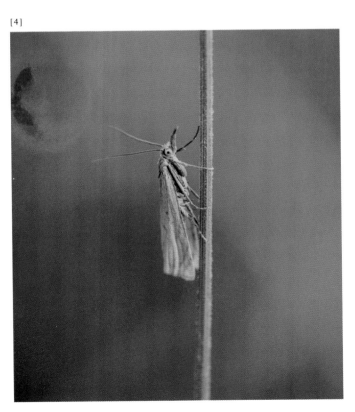

[1] Ox-eye daisy attracts various pollinating insects including many different species of hoverfly and beetle.

[2] The meadow grasshopper (*Chorthippus parallelus*) is a resident of damp, unimproved pastures and meadows. This common species is the only flightless grasshopper in the UK.

[3] The funnel-shaped webs that suddenly seem to appear in meadows on dew-laden mornings are not the lairs of some poisonous funnel-web spider. Instead they are the homes of labyrinth spiders (*Agelena labyrinthica*), which feed on grasshoppers and crickets.

[4] Wildflower-rich meadows provide forage and shelter for myriad insects.

[5] Particularly active on hot and sunny days, the swollen-thighed beetle (*Oedemera nobilis*) feeds on pollen and so is easy to spot. Its iridescent, coppery green hue contrasts strikingly with open-structured flowers such as the ox-eye daisy (*Leucanthemum vulgare*).

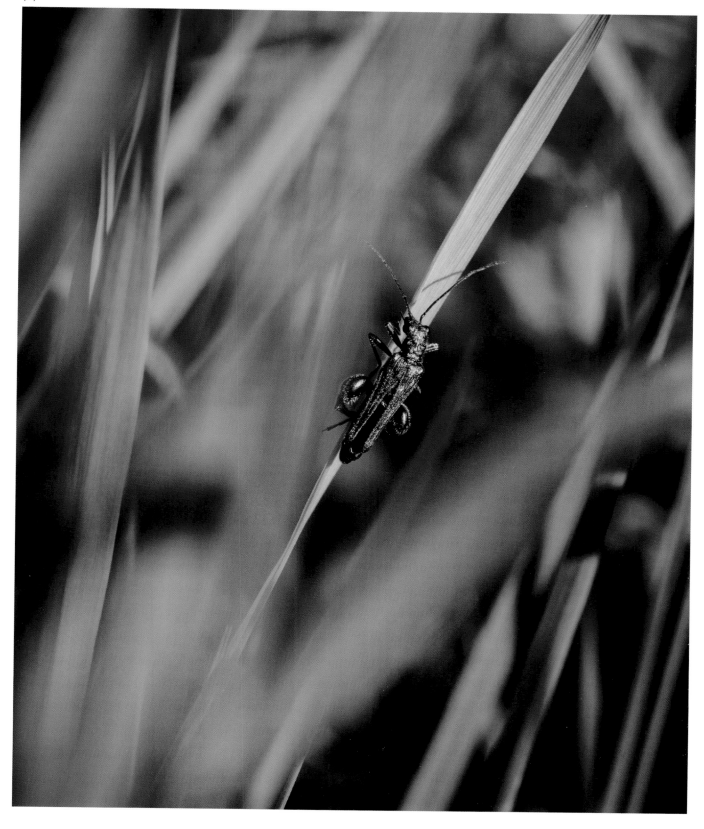

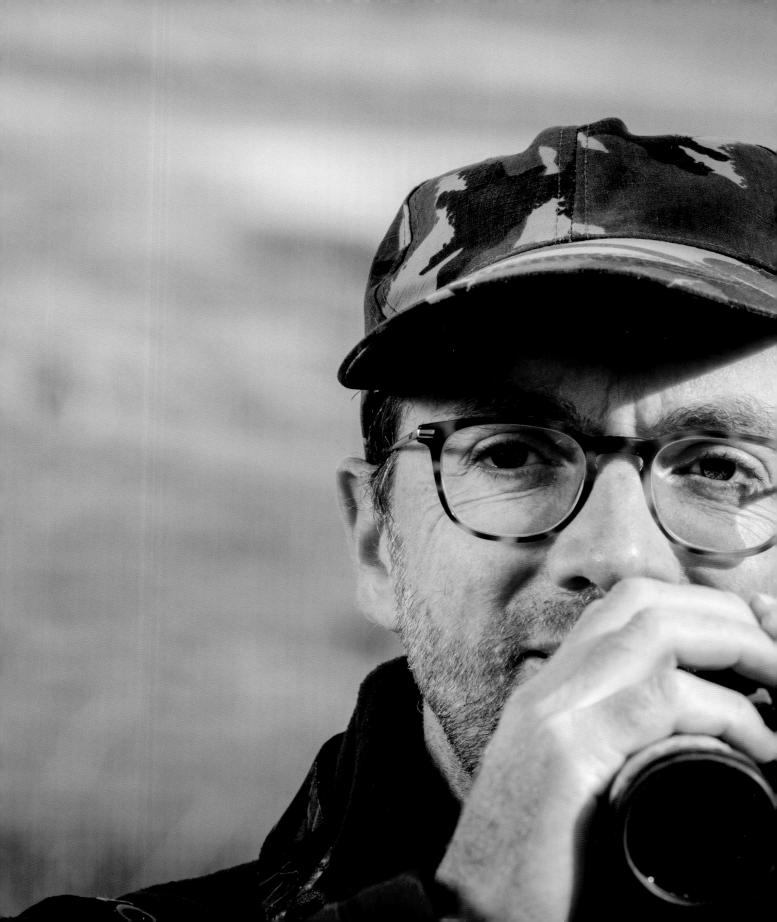

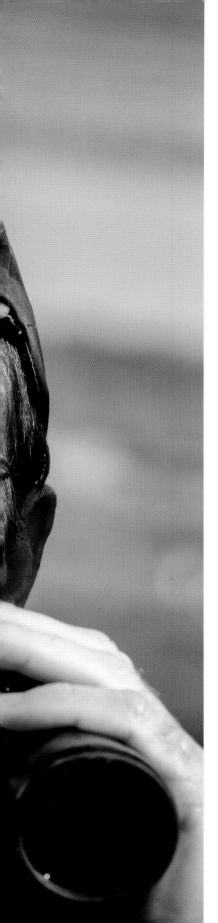

Meadow song

ADRIAN THOMAS
PROJECT DEVELOPMENT MANAGER
RSPB

Think of meadow wildlife and maybe you imagine butterflies bobbing over waving grasses and meadow flowers. However, there are also many birds – special birds – that rely on such habitats as a place to feed and breed. Much of my work with the RSPB has been involved with meadows and their birdlife, whether it be setting up new nature reserves, encouraging people to make their own garden meadows or making recordings of the rich soundscape of bird songs and calls.

The exact suite of species varies with place and meadow type. For example, on the Outer Hebrides the seaside meadows growing out of the white shell sand – the 'machair' – are the last stronghold in Britain of the secretive corncrake (*Crex crex*), its rasping call the essence of summer nights. The meadows of the machair beat a rhythm beneath a piping throng of breeding wading birds such as oystercatchers, dunlins, redshanks and lapwings.

Come south a little into the mainland uplands and you find what is called in-bye land, just below the open moorland. These hay meadows are home to nesting curlew (*Numenius arquata*), one of the UK's most threatened breeding species. In a few places male black grouse (*Lyrurus tetrix*) gather at leks, which are traditional sparring grounds, where they bubble and hiss at each other.

Into the lowlands, the meadows in the river valleys often lie as a myriad of shallow floodwater pools for much of the winter. These water meadows, ings and levels are perfect for whistling flocks of wigeon (*Mareca penelope*), a grazing duck from Scandinavia and Russia. Here too are plentiful teal (*Anas crecca*) and mallard (*Anas platyrhynchos*) and the scarce pintail (*Anas acuta*), plus wild swans and geese, while the damp soil in spring allows wading birds to probe for worms.

The sun-baked grasslands up on chalk and limestone downland provide yet another meadow habitat for birds, where stone-curlews (*Burhinus oedicnemus*) run across the short, orchid-dotted turf and skylarks (*Alauda arvensis*) rise in endless verse above. I should make clear that in all of this I am using the term 'meadow' in its broadest sense. Technically a meadow is a grassland that is mown for hay while pasture is grassland that is grazed, but the distinctions are fuzzy. When grasslands are managed with birds and other wildlife in mind, the feel is rather the same, whether cut or grazed or both.

What further links these habitats is how much their birdlife has struggled over the last few decades. In many places meadows have been ploughed up; in others fertiliser has been repeatedly applied, boosting the grass growth for greater yields but creating a dense monoculture that ousts wildlife. Damage can also be inflicted by overgrazing, which reduces the diverse, tussocky sward that ground-nesting birds need, while wet meadows have been drained, becoming too dry for wading birds. Changes to the hay cropping regime have also been devastating, first as it became mechanised, which can destroy nests and nestlings, and then the shift from hay to silage, with grass cut repeatedly over a season.

But with the right management, such as you find not only on nature reserves but also in the hands of sympathetic farmers, the perfect conditions can be re-established and the birdlife can return.

As the RSPB's wildlife gardener, I also know that you can even create a little of the meadow magic in your own garden. Your lawn (back or front) may not be extensive, but allowing it to take on a meadowy feel is easy. Just sideline the mower for a month or two in summer and let any wildflowers that are lurking there seize their chance to flower. You will not get great herds of wildfowl or displaying lapwings, but that doesn't matter. Your reward may be tinkling flocks of goldfinches (*Carduelis carduelis*), feeding on the seed heads as they set.

Even better, mow your lawn as tight as possible in autumn, give it a firm rake and sprinkle on a wildflower meadow seed mix containing yellow rattle. Its roots will tap into those of the grasses, reducing their vigour and allowing ever greater floral diversity, with all the benefits to the food chain above. Together, our combined efforts across the landscape, whether in the countryside, city parks or gardens, can put back some of the meadows we have lost, and with it the birdsong that forms their natural soundtrack. ❧

[1] The secretive corncrake (*Crex crex*) is listed in the IUCN Red List of birds of high conservation concern because of major population declines, both historically and recently. © David Kjaer (RSPB-images.com)

[2] The striking red crown, golden back and bright yellow wings of the goldfinch (*Carduelis carduelis*) make it one of the prettiest avian visitors to wildflower meadows. In late summer large flocks can be seen feeding on the seed heads of common knapweed (*Centaurea nigra*). © Tim Hunt (RSPB-Images.com)

[3] The song of the skylark (*Alauda arvensis*) has inspired many works of literature and music, but the spectacle of watching the male birds hover effortlessly, singing from a great height before parachuting back down to earth, is not as common as it used to be due to the decline in their favoured grassland habitats. © Paul Sawer (RSPB-images.com).

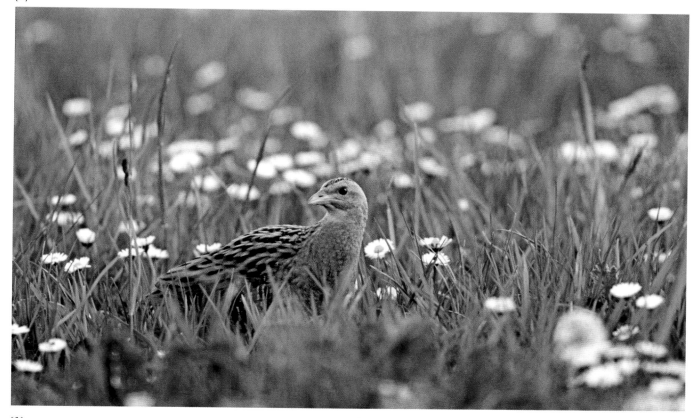

[1]

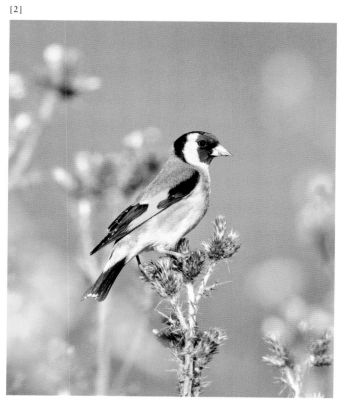

[2]

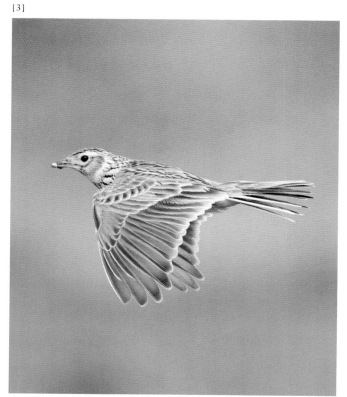

[3]

'Nature uses only the longest
threads to weave her patterns,
so each small piece of her fabric
reveals the organisation of the
entire tapestry.'

RICHARD FEYNMAN

Restore

Surrendering your senses to the sights and sounds of a classic hay meadow is an intoxicating experience. This is particularly true in the height of summer when the artistry of nature has reached a peak of perfection. It is a sobering thought, however, when you consider that virtually all traditionally managed hay meadows in the British Isles have vanished without trace. Meadows have been marginalised for a number of reasons. Conversion to intensively managed grasslands by ploughing and reseeding, along with heavy inputs of chemical fertiliser, are the main culprits. But under-management and overgrazing, combined with a loss of expertise, have all played a part.

The scale and speed of decline already represents a conservation catastrophe, but sadly meadows and the wildlife they support continue to be lost at an alarming rate. It is important that we act now to avoid losing the colour and character of our ancient grasslands forever. Meadows urgently need our help to maintain, restore

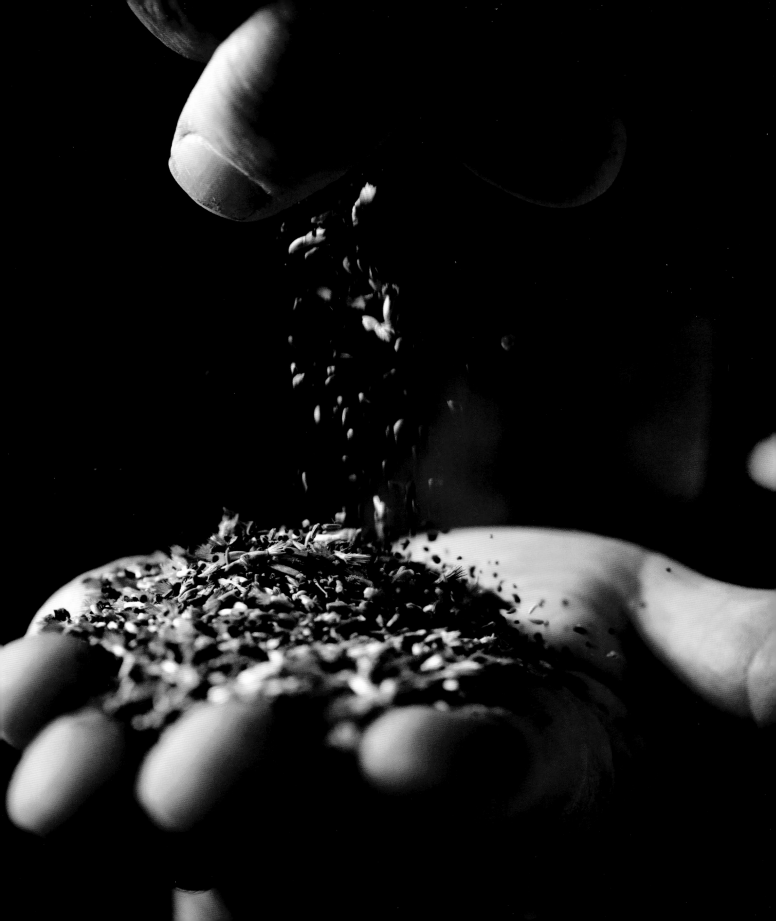

and most importantly, expand and connect them to other sustainably managed habitats. Restoring ancient grassland once it has been damaged though is neither quick nor easy to achieve, but a study of surviving examples can help by offering a sense of what is possible.

Reinstating time-honoured patterns of management, such as hay making and grazing, is sometimes enough to trigger a recovery. More often than not, however, the deterioration in the condition of the sward is such that additional measures are required. In these cases, nature needs a helping hand. There are a number of ways to increase the species-richness of grassland including sowing wild harvested seed, transferring seed-laden green hay and planting nursery-grown wildflower plugs. No matter what tried-and-tested techniques are used, however, experience shows that attempting to breathe biodiversity back into our forgotten grasslands is not an exact science, but more of a labour of love.

Breathing the biodiversity
back into our forgotten
grasslands is not an exact
science, but more
of a labour of love.

Hay time

VICKY BOWSKILL
PHD RESEARCHER
OPEN UNIVERSITY

Meadows are a fantastic place to see an abundance of wildflowers, insects, birds and other wildlife. However, they are not as wild as you might think; they are an ancient part of our farming landscape that has evolved from the need to produce hay to feed to livestock. Haymaking is the reason that meadows exist – but, as the saying goes, they do not make it like they used to.

My love of meadow plants began as a child, with my mother teaching me the common names of local wildflowers. She grew up on a Sussex family farm in the 1950s and learned from her mother, making wildflowers a golden thread of family culture. The sweet scent of good hay is evocative of my childhood, spent around farm and stable. So it was a natural choice to opt for haymaking on floodplain meadows as the focus for my PhD research. Working with the Open University and the Floodplain Meadows Partnership has provided a wealth of expertise to explore this important and fascinating topic.

Modern haymaking has a very different impact on sensitive meadow species from pre-industrial methods, with hay often cut later to protect ground-nesting birds and modern machinery allowing large areas to be covered much more quickly. With many farm businesses tied into the date-based restrictions imposed by agri-environmental schemes, large areas of adjoining farmland are now cut for hay at the same time. This creates a landscape-scale impact on meadow life, with little refuge for insects and other mobile species.

There is controversy over the timing of hay cutting, with the date-based restrictions designed for conservation gains often conflicting with agricultural management goals. A later cut hay is perceived to make a lower quality crop, with nutrients thought to decline as the summer goes by, while missed hay cuts can mean rising soil nutrients and falling botanical diversity.

With a better understanding of how the nutritional content of hay changes during the growing season, the production of a valuable hay crop can be brought back into balance with biodiversity conservation.

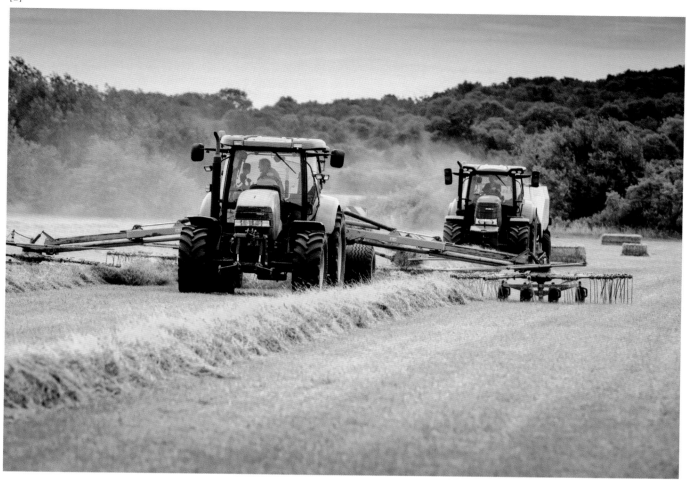

Haymaking is the reason that meadows exist – but, as the saying goes, they do not make it like they used to.

The most common way that the quality of hay is assessed is sensory.

My research began with a questionnaire to find out what was most important to those people making and using hay from floodplain meadows across the UK. With over one hundred responses, one clear message is that the division between 'farmer' and 'conservationist', so often portrayed in the media, is a false one. While farming goals and conservation goals may sometimes conflict, the people working hard to maintain our precious meadows are involved in both to varying degrees.

The most common way that the quality of hay is assessed is sensory. It should be well dried, but soft and not dusty or brittle, and have a good range of different species, lending soft shades of gold and gentle green, with accents of dried petals. A good sniff should bring that sweet, heady aroma of species such as sweet vernal grass (*Anthoxanthum odoratum*) and meadowsweet (*Filipendula ulmaria*) blossoms that can transport many

back to halcyon days around animals and nature. While some businesses may have access to lab analyses, giving objective data on the nutritional content of the hay crop, for most farmers haymaking is more of an art than a science and is based purely on experience.

Many hay meadow wildflowers are deep rooted and have a good store of underground resources; while they can reproduce by seed, they primarily reproduce vegetatively via underground shoots that form large clones. So, although some wildflowers may look delicate, they can actually be over a hundred years old, only needing to set seed in those occasional years when haymaking is prevented or delayed by summer rain or flooding. Other species, such as meadowsweet (*Filipendula ulmaria*), black knapweed (*Centaurea nigra*), ribwort plantain (*Plantago lanceolata*) and a host of others, contain medicinal compounds that have been shown to be effective against gut parasites in livestock.

My research is focusing primarily on the range of nutritional minerals present within hay and when they peak and fall during the growing season in our botanically diverse floodplain meadows. I have three stunning meadow sites in Oxfordshire and Buckinghamshire where I am collecting hay samples to see how the mineral profile evolves through the summer. I will also be looking at how this can be measured against accumulated heat during the growing season, as opposed to calendar date, to take account of advancing seasons and regional variation.

There are many and varied considerations for practitioners in deciding when to make their hay – such as weather, availability of farm labour or machinery, presence of target bird or invertebrate species and date-based restrictions in agri-environment schemes. The information I am gathering will provide greater clarity on the implications of cutting date for nutrient cycling and crop quality, and I will be exploring how this may affect perceptions of when hay should be made and its value as a fodder crop.

With a changing policy landscape and focus on sustainable food production, it is more important than ever to see how our heritage hay meadows can continue as part of a sustainable, nature-friendly farming future. ☙

[1] Windrows of hay are allowed to dry before baling. Red kites (*Milvus milvus*) are known to follow the hay cut around different farms in search of forage.

[2] Mechanisation has made haymaking too efficient at the expense of biodiversity.

[3] The presence of the rounded magenta heads of great burnet (*Sanguisorba officinalis*) is an indication of a rare group of plants found flourishing together in the fertile soils of floodplain meadows.

[4] Species-rich hay benefits grazing livestock, providing a wider range of minerals and nutrients than intensive pasture, resulting in healthier animals and healthier food.

[5] The densely packed frothy white flower heads of meadowsweet (*Filipendula ulmaria*) bloom in damp meadows from June to September.

[6] The aromatic hints of vanilla in freshly cut hay comes from the fragrance of sweet vernal grass.

[3]

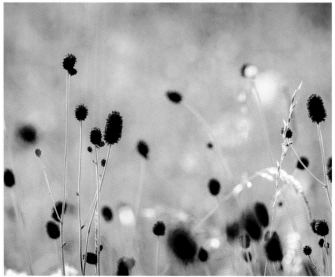

[4]

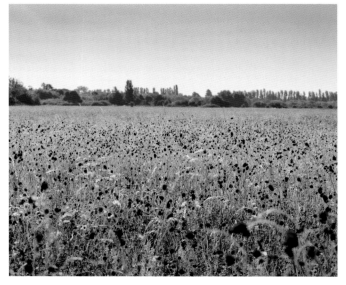

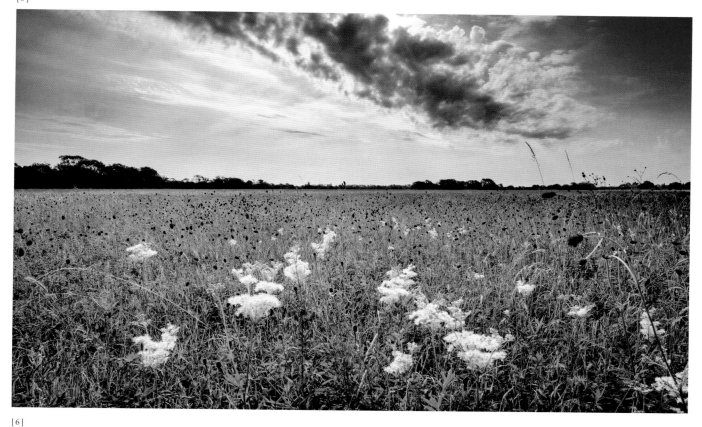

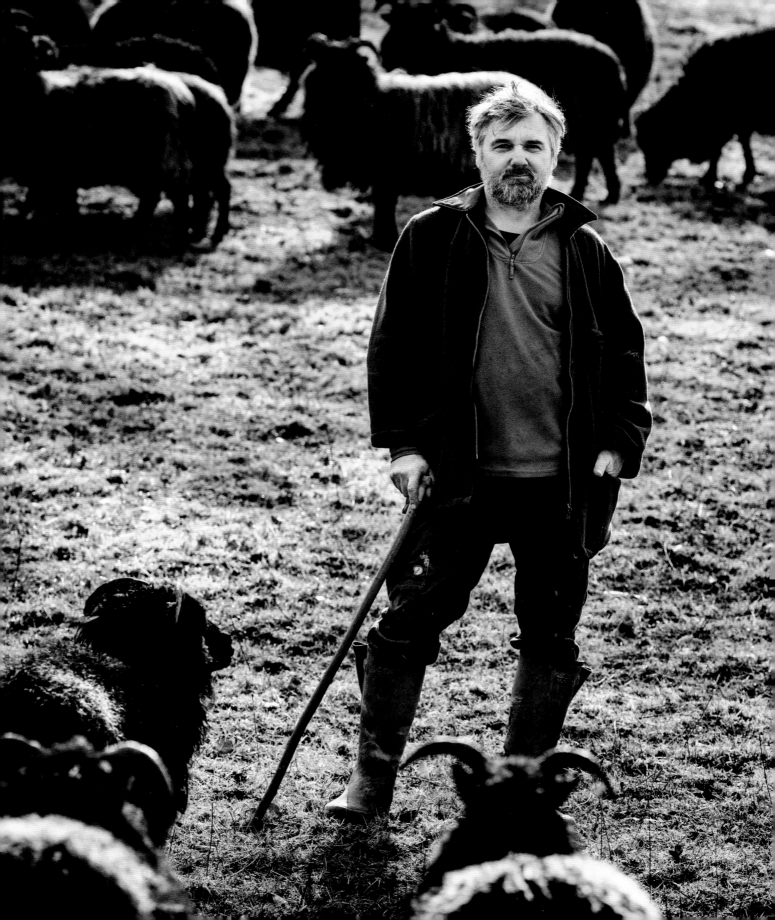

Conservation grazing

STEVEN ROBINSON
WILDLIFE WARDEN
WAKEHURST, KEW'S WILD BOTANIC GARDEN

Grazing is an essential part of the annual management of a meadow. The process helps to keep the structure of the sward open, resulting in a wider variety of plants and insects. We graze the meadows on our nature reserves with sheep, and sometimes cattle, to perpetuate a very traditional pattern of management. This helps to control vigorous grasses while providing the more delicate wild plants with light and space to establish a permanent residence. Conservation grazing seeks to bring a balance back to our meadowlands.

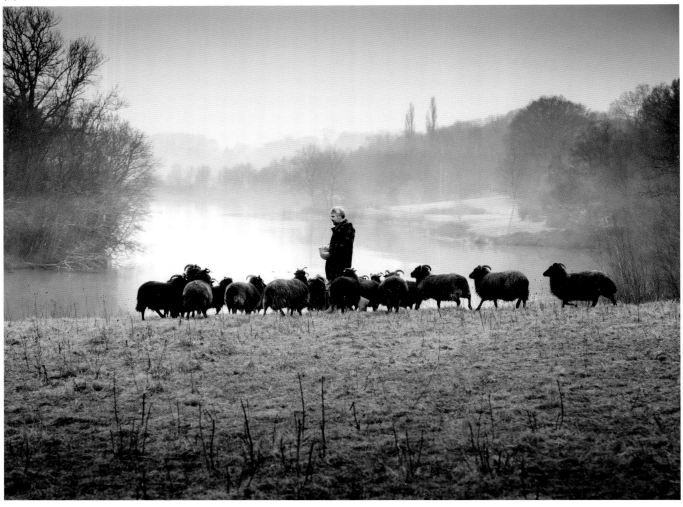

We borrow the livestock we use in our reserves from the Ranger Team at Ashdown Forest, an area of lowland heath occupying the highest sandy ridge-top of the High Weald Area of Outstanding Natural Beauty and the setting for the *Winnie-the-Pooh* stories. Here the animals spend the spring and summer months grazing the heathland habitat to prevent natural regeneration of woodland. In the autumn, the sheep and cattle make the short journey to Wakehurst, Kew's wild botanic garden, where they are immediately brought into action to graze our meadows and parklands.

When considering the use of livestock in habitat management it is important carefully to select the right animal and breed for the conservation aims and conditions of the site. We use a combination of cattle and sheep, which helps to create a diverse sward structure. Cattle, for example, use their tongues to wrap around vegetation to pull grass into their mouths, whereas sheep use just their front teeth to 'cut' the grass, which creates a uniform height often just above ground level. By 'mixing it up', the animals create a range of niche microhabitats that include areas of bare ground where wild seed can settle and germinate free from competition.

The sheep we use are Hebridean, which have established a reputation as the breed for the management of delicate habitats, just like meadow ecosystems.

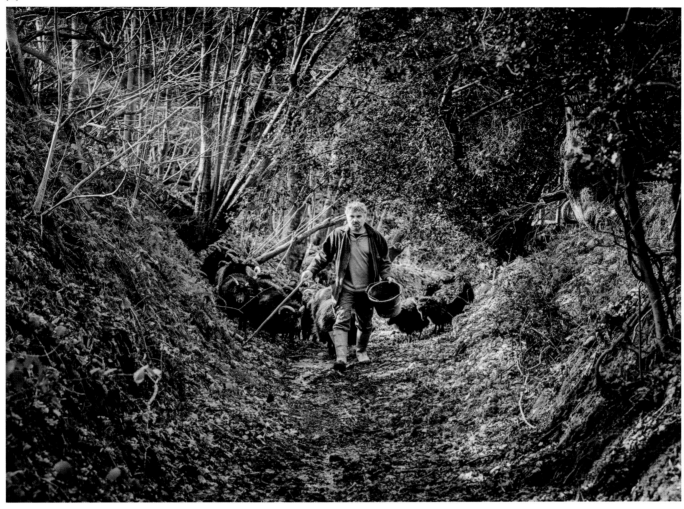

Despite their wild charm, meadows are just as domesticated as the animals that graze on their fine-leaved grasses.

Hebridean sheep are relatively small and light-footed, which means that more animals can be kept per hectare than a larger breed. Being light on their feet, they cause minimal damage to our meadows, which are prone to lying very wet through the autumn and winter due to the underlying clay soils. The cattle are Belted Galloways, which originate from the lowlands of Scotland but do not look too out of place in the wilds of the High Weald. Like other breeds of cattle, these hardy animals do not graze as selectively as sheep, which helps to create a greater variety of structure within the meadow habitat.

Overgrazing and undergrazing can be damaging to meadows. Striking the right balance is not an exact

science; it requires skill and experience to get it right, both for the condition of the meadow and the health and well-being of the animals. Having spent time travelling around Romania, where centuries of traditional land management has shaped a rich mosaic of old-growth woodland, wildlife-rich pastures and flowery meadows, I have seen at first hand the value of a well-managed grazing regime.

While I do not have to endure the same level of hardship as the shepherds in that part of the world, who spend nights sleeping outside with the livestock to prevent attack from wolves and bears, as I move the flock from one meadow to another, travelling along ancient droving lanes, I do get a sense of being a part of the natural rhythm of meadow life that has existed for millennia. Despite their wild charm, meadows are just as domesticated as the animals that graze on their fine-leaved grasses. Grazing is the most effective and natural way to maintain meadow habitats; after all, this is how these diverse ecosystems evolved in the first place. ∝

[1] Conservation grazing aims to continue a traditional system of land management to help maintain habitats which have evolved over many centuries.

[2] Old drove ways were used to move livestock through the countryside to new pasture. In some cases, centuries of use by many trotters, feet and hooves have eroded the ground, creating sunken lanes.

[3] Hebridean sheep are a tough breed which seem to thrive in a range of conditions including harsh winters.

[4] Riggit Galloway cattle are docile cows that calve easily and are good mothers. They thrive in all conditions on unimproved pasture and in hill country, making them ideal conservation graziers.

[5] Although regular hay cutting depletes the soil fertility, a natural balance is maintained when grazing animals return nutrients to the soil via their droppings.

[6] Grazing helps to maintain an open sward structure where seeds can settle, germinate and flourish free from competition.

The relationship between shepherd, sheep and sward is a special one.

[3]

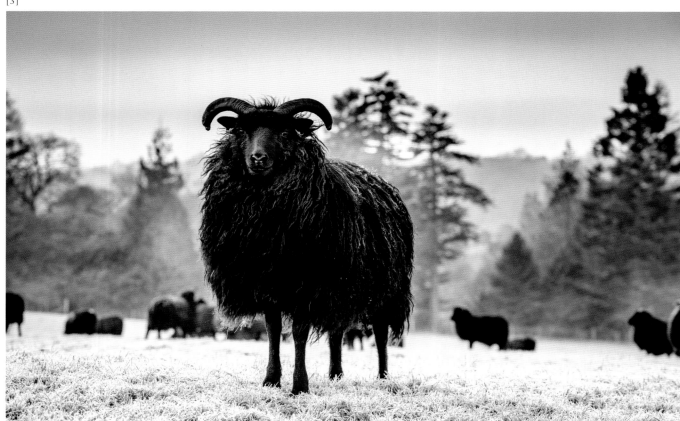

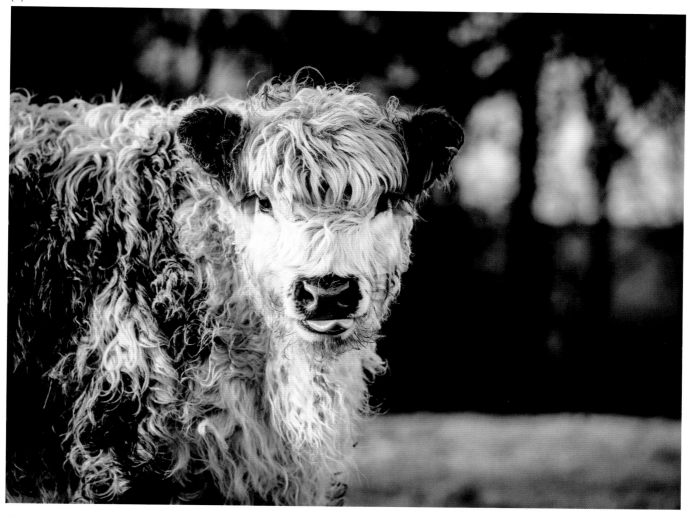

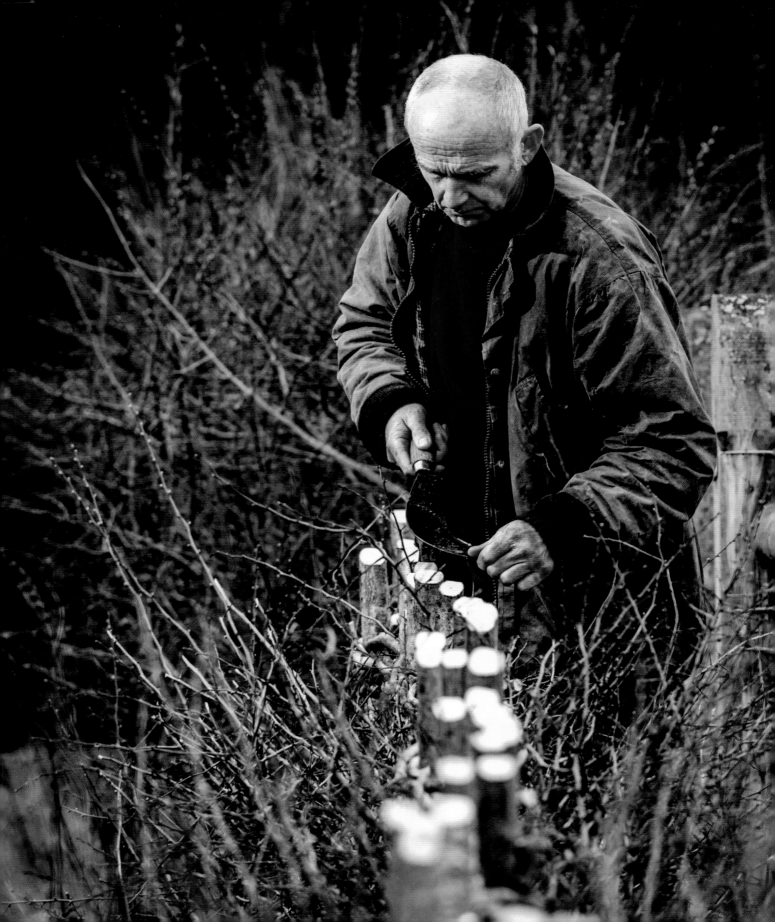

Hedgerow husbandry

DOMINIC PARRETTE
HEDGELAYER

I was taught the art of hedgelaying over 30 years ago by two 'old boys'-turned-tutors at my local agricultural college. I am predominantly a basket maker these days, but it was hedgelaying that introduced me to the possibilities of working with our native trees in a creative way. I have since learned how hedgerows have helped to shape our landscape. The wild and tangled hedgerows that separate meadowland and pasture into their familiar patchwork pattern are in effect linear woodland ecosystems of great diversity.

The craft of hedgelaying has evolved hand-in-hand with the management of grasslands. Hedges not only help to contain livestock, but also provide shelter from biting winds and driving rain as well as an alternative food source, not to mention being an intrinsic part of our ancient landscapes. As with many grasslands, a hedge can contain a diverse range of plant species and the older the hedge the more diverse it is likely to be. Some of our most ancient hedgerows are actually the remnants of ancient woodland once cleared to make way for agriculture.

Hedgelaying is an ancient craft, its origins dating back thousands of years to a time when humans began to settle, and the need to pen animals in an enclosed area for grazing led to the planting and laying of native tree species. Hedges often surround and frame ancient meadows and are important wildlife corridors for plants, birds, invertebrates and other animals,

[1]

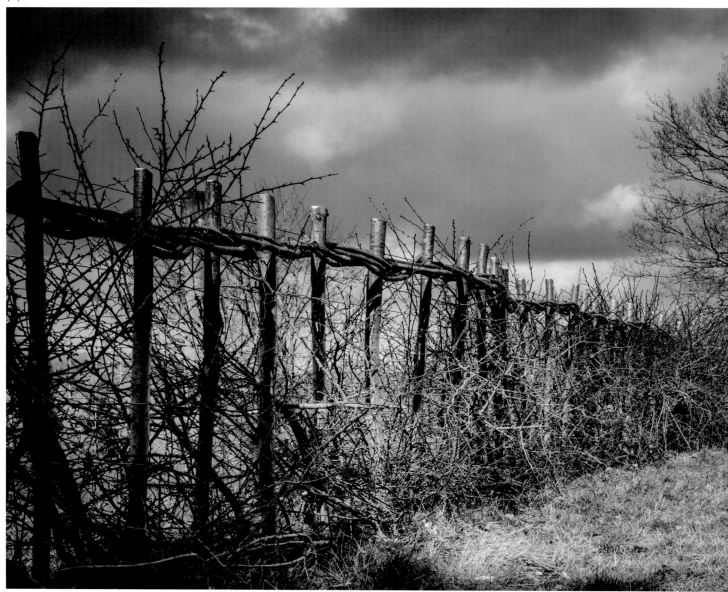

allowing movement and therefore colonisation of other dispersed habitats.

Traditionally, a hedge that needs to keep livestock in (described as a stockproof hedge) would be layed around every 15 years or so. By this point the hedge plants have become very robust and tall, with the top growth in the plants shading out any emergent lower growth. As a result, a hedge can become 'gappy' and therefore no longer stockproof. In order to lay a hedge, you have to plan a way of creating a growing barrier from a wild confusion of growth. The initial task is to identify the direction to lay – always uphill if there is an incline and with any smaller offshoots and twigs (the brash) positioned towards the livestock to make it harder for them to break through the hedge.

Pleachers (cut stems) are layed by thinning the base of the trunk with a billhook or axe. Pleachers are cut at a long, shallow angle until the stem is pliable enough

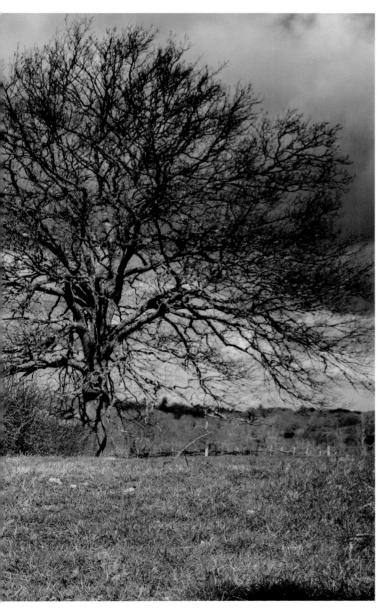

[2]

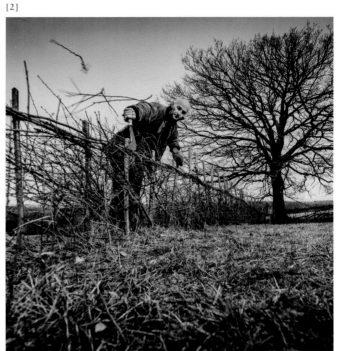

[3]

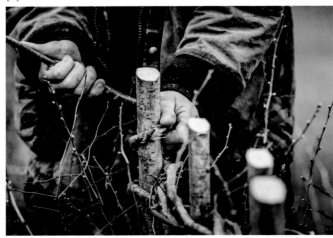

to bend without breaking and laid down at an angle. A section of the actively growing cell layer (the cambium) is always left intact so the plant can continue to regrow. Successive stems are laid on top of each other, creating a thick woody barrier; these are then secured by upright stakes bound together by weaving long lengths of wood known as hazel (*Corylus avellana*) and sometimes cut directly from the hedge.

From the spring through to early summer an old hedge line is bedecked with the flowers of blackthorn (*Prunus spinosa*) and hawthorn (*Crataegus monogyna*). This provides sustenance for the early emerging queen bumble bees, followed later by nectar-rich maple flowers that hum with the beat of honeybee wings and sweet-smelling May blossom that can be crowded with gatekeeper butterflies (*Pyronia tithonus*) as midsummer approaches. You may also find the nests of several species of birds, feeding stations for voles and mice on an old stump covered with hawthorn husks and hazel shells. Just like the meadows they frame, old hedges are a tangled jigsaw of wild growth containing a whole web of life. ❧

[1] A newly laid hedge combines form and function to create an attractive boundary that also acts as a living fence.

[2] Trimming the hedge helps it to thicken up and creates an even shape.

[3] The top weave helps to keep the laid hedge in place. The technique reflects different regional styles, in this case showing the 'Midlands' style.

[4] Hedgerows are an important part of the meadow habitat, providing forage and shelter for all manner of wildlife.

The wild and tangled hedgerows that separate meadowland and pasture into their familiar patchwork pattern are in effect linear woodland ecosystems of great diversity.

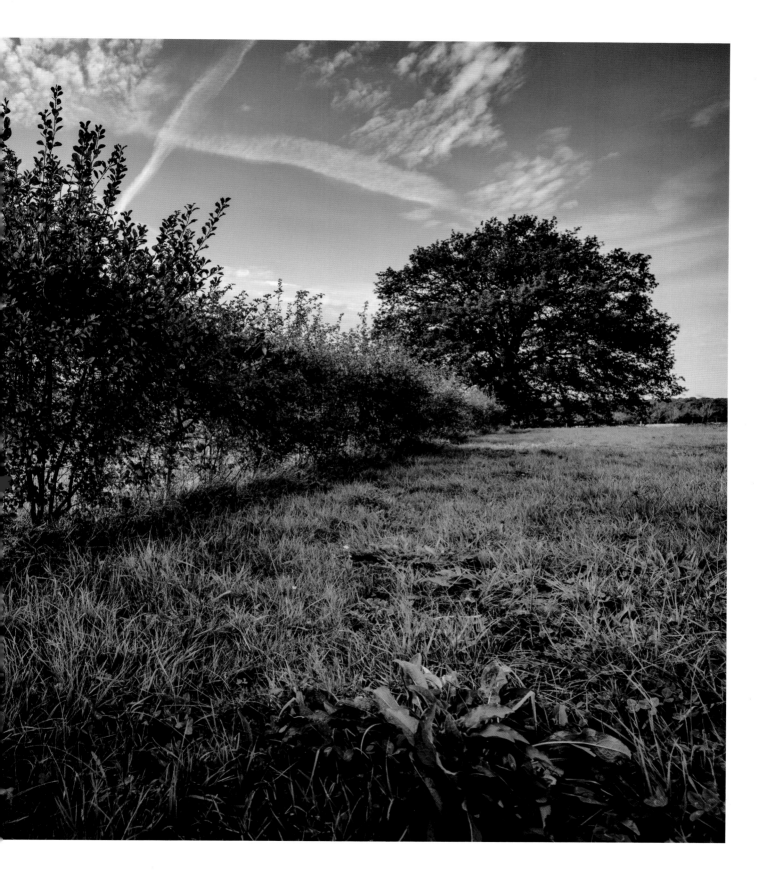

Art of scything

MATTHEW MURGATROYD
DEPUTY HEAD GARDENER
HIGHGROVE GARDENS

Well before meadows became in vogue, His Royal Highness The Prince of Wales created an individual garden meadow. Spanning four acres, the meadow dominates Highgrove and runs right through the middle of the garden. In the spring there are ornamental bulbs such as *Narcissi* species and *Camassia*. Once summer has arrived, however, the bulbs make way for our native species which take over the show. They include dainty white cow parsley (*Anthriscus sylvestris*) and ox-eye daisies (*Leucanthemum vulgare*), delicate drifts of colonised orchids followed by large swathes of purple scabious (*Knautia arvensis*) and knapweed (*Centaurea nigra*). As the flowers begin to fade, the work begins. Cutting the hay, whether by tractor or the humble scythe, is essential to maintaining the diversity of plants that have adapted to this form of traditional management.

If you see the garden team at Highgrove during the latter weeks of summer, you may spot us darting around collecting the seed of HRH's favourite species or moving green hay from some colourful parts of the meadow in order to improve the biodiversity in other areas. The focus in late summer is the annual hay cut. If left the grasses will take over, smothering the flowers. By cutting and removing the hay we remove nutrients, allowing wildflowers to flourish.

Within the meadow we have several diverse habitats: dry shade, damper areas and ground that is baked in full sun. Within each of these differing situations individual species thrive, each going to seed at various times. A solitary gardener with a simple hand scythe can hop into an area inaccessible by tractor. Heavy rank grass can be cut down tight to the ground so that the soil is exposed, providing opportunities for more desirable flowers. When individual areas requiring early cuts have been picked off, it is time to start thinking about cutting the remainder of the meadow.

We always try to gather a team of master scythers to join the gardeners. Each comes with their own scythe and an individual approach, from botanists and students to countryside managers and rural skills tutors. The team will line out across the width of the meadow and mow in unison, stopping from time to time to catch their breath or observe the plants at their feet while they sharpen their lightweight Austrian scythes. Within

[1]

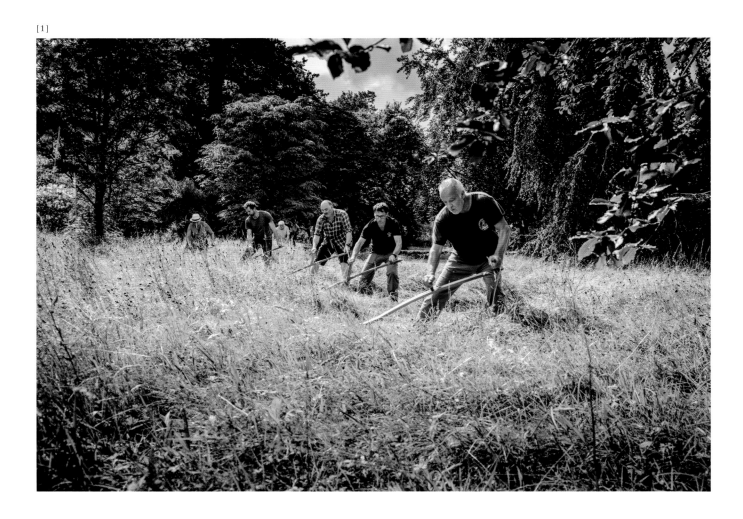

Although scything is no longer seen as commercially viable, it has a place in bringing people together, and helping us tune in to nature.

a couple of days we have cut four acres. Great care and joy is taken in this simple task.

As the scything team works through the meadow, we identify where little parcels of wetter ground sit; later in the season we will return to sow, plant or encourage more suitable species here. Areas of heavy sward are noted for a hard scarification and sowing of the Prince's home-grown seed in the autumn. Mowing with a scythe has a gentle rhythm that allows animals the time to take refuge in the uncut margins. Areas with later flowering species, more suited to a delayed cut, will be left as refuges for the wildlife to shelter in.

Just as I imagine meadow folk of years gone by would have done, the team gathers, sharing food and

[2]

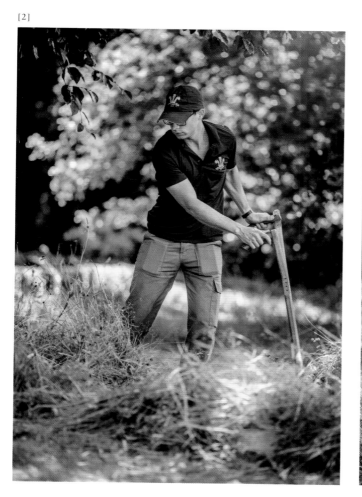

[3]

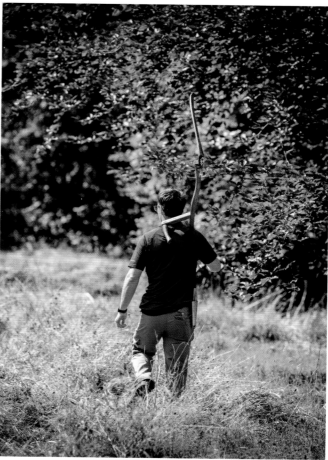

drink around a fire. Bats fly from their roosts and farmers return to the yard in tractors. Everyone comes together: gardeners, farmers and scythers. We catch up on stories and experiences of our shared interests in nature, folklore and rural skills, which are slipping from our collective knowledge.

The most memorable times I have had in wildflower meadows have been those spent sharing in the company of other like-minded people. Although scything is no longer seen as commercially viable, it has a place in bringing people together, helping us tune in to nature. In a more curated meadow, such as the garden meadow at Highgrove, scythes have become important tools. ∝

[1] For many reasons, scything a meadow is best carried out as a cooperative effort.

[2] The correct scything technique has a slicing action, where the blade is kept parallel and very close to the ground. This leaves behind a uniform cut with the grass arranged into a regular windrow.

[3] Even the most experienced scythers look forward to the end of the day.

[4] Peening the scythe's blade by hammering the edge helps to draw it out and restore the ideal cutting profile.

[5] An Austrian-style scythe is a precision instrument that in the right hands becomes an economical and efficient tool for mowing small areas of grassland.

[6] The unhurried action of scything a meadow allows other residents the time to escape to pastures new.

[7] Regular honing not only helps to keep a razor-sharp edge, but also provides a moment for a well-earned breather.

[4]

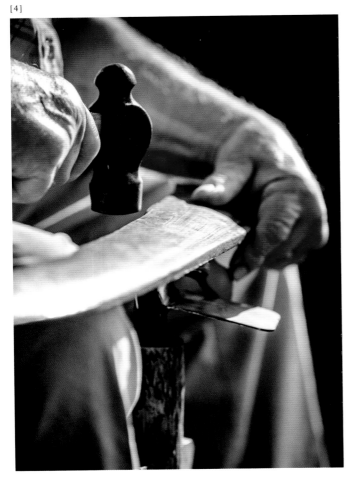

[5]

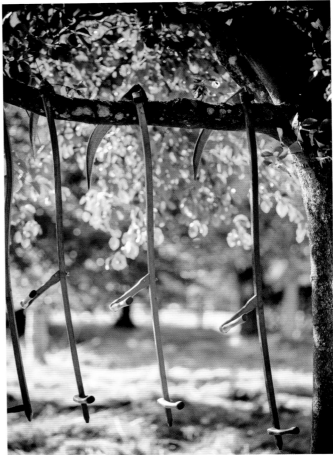

Mowing with a scythe
has a gentle rhythm that
allows animals the time
to take refuge in the
uncut margins.

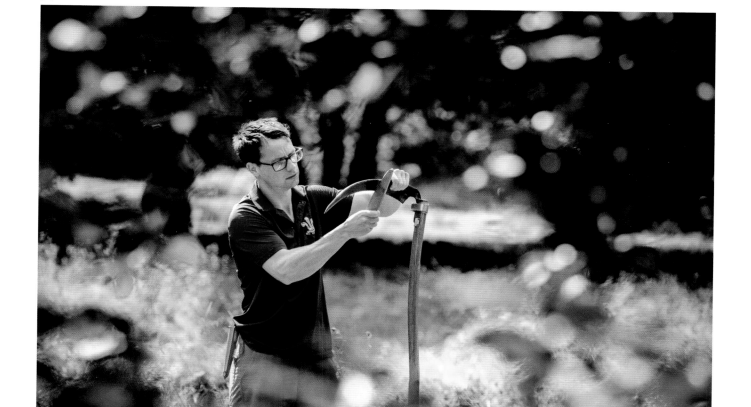

Seeds
of success

TED CHAPMAN
UK CONSERVATION PARTNERSHIPS COORDINATOR
WAKEHURST, KEW'S WILD BOTANIC GARDEN

I have sown, grown, collected or studied
seeds since childhood, but remain astonished
by their ability to hold the potential for
new life in such small packages and to
transport this through time and space to
emerge months or years later and, perhaps,
many miles away. Close examination with
a magnifying glass or hand lens reveals a
small-scale world of intricate design and
beauty, where form is carefully interwoven
with function.

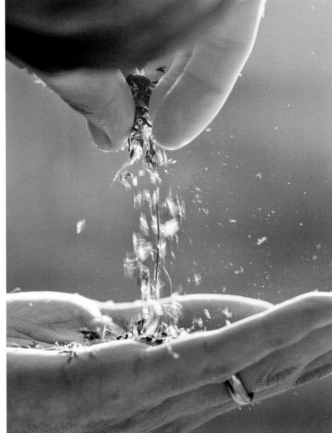

Consider, for example, the feathery parachutes of dandelion (*Taraxacum officinale*) or, more impressively, goat's beard (*Tragopogon pratensis*), which allow the seed to be carried on the breeze to find new ground away from competitive parents and siblings. Agrimony (*Agrimonia eupatoria*) seeds are topped by rings of hooked bristles, one of many species adapted to move with the passage of animals – an important means of seed dispersal in the past, though increasingly threatened in our fragmented and highly mechanised landscapes. Clovers, vetches, trefoils and other members of the pea family (Fabaceae) lack these obvious adaptations, but are characterised instead by hard seed coats in shades of yellow, green, brown and black. These are impervious to water and durable in the soil, staggering germination – and therefore increasing the seeds' chance of success – over many seasons.

Seeds also conceal less obvious mechanisms to control when and how they germinate and grow. Some give up their secrets easily. Ox-eye daisies (*Leucanthemum vulgare*), knapweed (*Centaurea nigra*), yarrow (*Achillea millefolium*) and many grasses will germinate whenever warmth and moisture allow, making these the backbone of many meadows and the first to appear where new seed is sown. Others require more careful observation to understand what is happening beneath the surface. Cowslip (*Primula veris*), yellow rattle (*Rhinanthus minor*) and betony (*Stachys officinalis*) seeds are dispersed in midsummer, but remain dormant until they have experienced several weeks of cold and damp, delaying germination until the improving conditions of spring. Orchids rely on symbiotic fungi to supply essential nutrients to the tiny seed, taking many years to form a recognisable plant

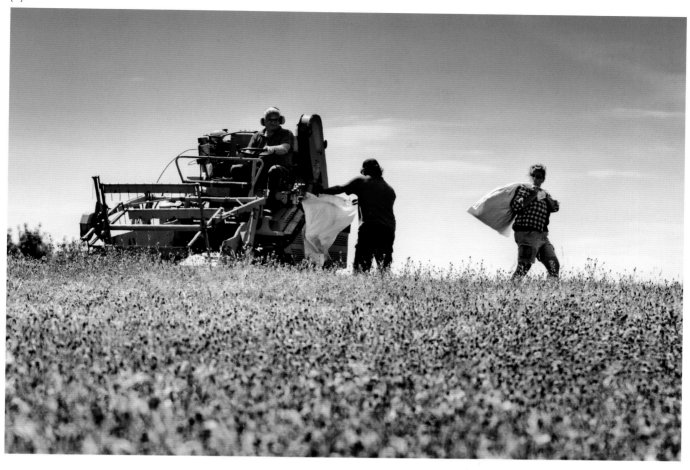

and, for me, increasing the sense of triumph when these are found in a meadow for the first time.

A study of seed can therefore provide valuable clues to help understand why some plants appear and others do not. Cowslip and yellow rattle will germinate when sown in the autumn but not the spring – cowslip seeds are tough and can survive to germinate the following year, but yellow rattle seeds are more delicate and likely to disappear without a trace. It can also explain the apparently miraculous appearance of plants where none were expected. A flush of poppy (*Papaver rhoeas*) or goosefoot (*Chenopodium*) after heavy cultivation may speak of a forgotten arable past, while grass vetchling (*Lathyrus nissolia*), wild carrot (*Daucus carota*) or bee orchid (*Ophrys apifera*) wander in from plants growing nearby. In places where meadows existed recently or still survive nearby, it may be wise to hold off sowing for a few years, allowing time and good management to reveal what is already there.

In many cases, however, opportunities for this natural recolonisation are limited and seeds must be introduced to kickstart a meadow into life. As a living resource, seed must be thoughtfully chosen and carefully handled to avoid wasting time, money and – perhaps most importantly – the motivation and good will of the people involved. The process starts by considering which species are likely to thrive. Time going through books and online resources is well spent, but finding a nearby meadow you can use as a reference and direct source of inspiration is invaluable, particularly where it provides links to local expertise and support.

Whether collected directly from a local meadow or grown as a crop by specialist producers, seed must be viable – capable of germinating – to produce a plant.

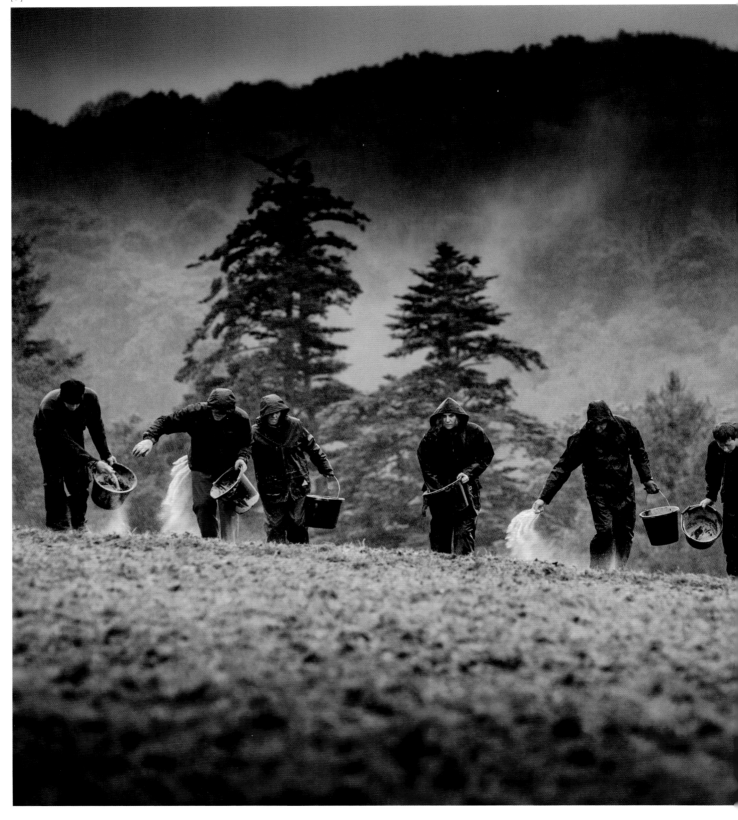

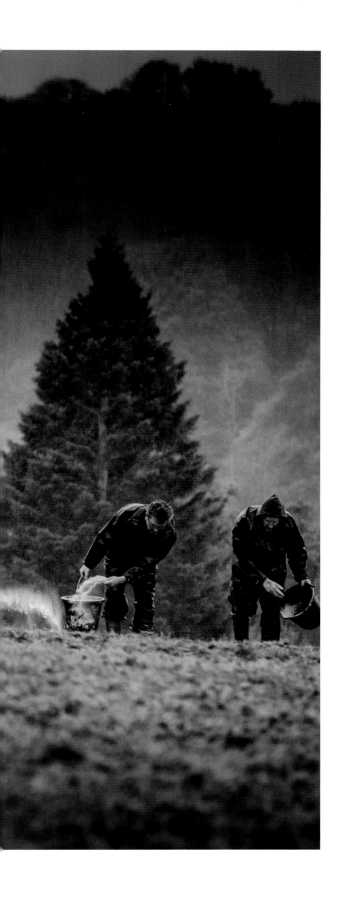

Viability is influenced by a host of factors, including the weather during flowering and seed development, the maturity of the seed when it is harvested and the conditions under which the seed is processed and stored. Good harvesting and processing practices seek to maximise viability by harvesting seed just before it is naturally dispersed by the plant, followed by careful drying, cleaning and storage in cool, dry conditions.

Several techniques have been developed to assess viability, the simplest being a germination test. High quality seed is available, but I would always recommend making enquiries about production, storage and testing practices when sourcing seed, or to consider carrying out simple germination tests of your own. ∞

[1] Brush through a wildflower meadow at the height of summer and you can hear the tiny seeds of yellow rattle (*Rhinanthus minor*), rattling in their brown pods. This is a sign that the seed is ripe.

[2] The seeds of wildflowers come in all shapes, sizes and colours, from the microscopic, dust-like seed of orchids to the hard-shelled cases of tufted vetch (*Vicia cracca*) and common bird's-foot-trefoil (*Lotus corniculatus*).

[3] A simple method for checking seed viability is to cut open a few examples with a scalpel.

[4] Harvesting wild meadow seed on a commercial scale requires specialist machinery and a period of warm and dry weather.

[5] Sowing wild origin native seeds helps to breathe biodiversity back into our nature-depleted grasslands, even on the wettest of days.

Close examination with a magnifying glass or hand lens reveals a small-scale world of intricate design and beauty, where form is carefully interwoven with function.

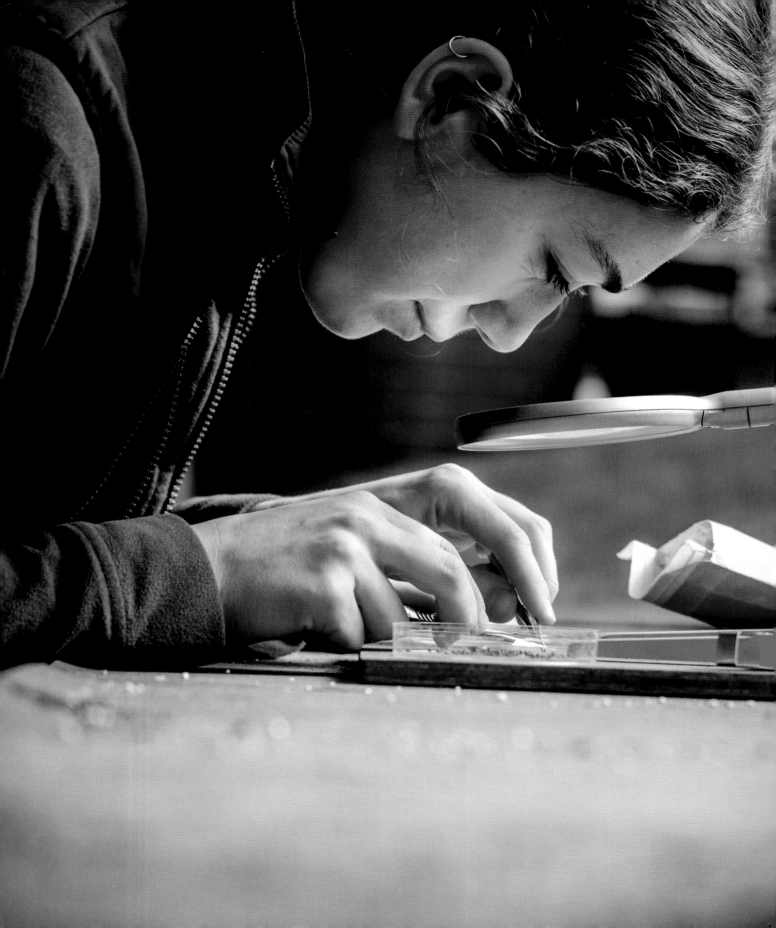

Perfecting
propagation

ELIANA VAN DER SCHRAFT
BOTANICAL PROPAGATOR
WAKEHURST, KEW'S WILD BOTANIC GARDEN

When propagating native meadow plants there are some species that establish quite easily, while others need a little more encouragement. Certain species require specific conditions to germinate successfully, conditions that do not always occur naturally every year in a meadow. These recalcitrant species require special pretreatments to aid germination. This is not to say that without additional special care and attention germination would not occur, but propagation rates are significantly more successful when these treatments are applied.

Scarification, stratification and soaking are all types of pretreatment. The process of scarification involves partially removing a small part of the outer coating of the seed with abrasion or, if you are feeling patient, a scalpel. This enables water to enter the seed, which triggers germination. A faster technique, but one that is not always as accurate as a scalpel, is using sandpaper on a firm surface. By placing the seed underneath the sandpaper and lightly sanding, the hard outer coat is worn away, replicating the natural weathering that would occur in the field. In practice, I have found the scalpel yields more success due to the accuracy and control over the amount of damage you need to bring to bear on the seed coating.

Following this treatment, some seeds, such as those of red clover (*Trifolium pratense*) or tufted vetch (*Vicia cracca*), require no more treatments and can be sown directly on to plug trays. Others require further persuasion. Seeds that are broadcast sown in the autumn run the risk of being predated by animals or of failing to thrive through the winter months. So instead of sowing these seeds directly in the meadow they can be kept in an artificial environment created by special, temperature-controlled growth chambers. Having this cold period breaks the dormancy of the seed while shielding them from other external elements, in the process helping them get through a vulnerable stage in their journey from seed to flower.

A species that responds well to this treatment is dyer's greenweed (*Genista tinctoria*). We have had very little success direct sowing this species, and it has also proved difficult to propagate under nursery conditions, but after some trial and error with pretreatments we have been able to crack the propagation code. It is very

[1]

[2]

[3]

satisfying to give this handsome plant a helping hand. As an important foodplant for many species of moth, it is a valuable addition to any meadow. Once these seeds have been scarified, they are put into cold stratification for three months, then sown and moved to warm glasshouses to germinate and grow. With enough root growth they can be transplanted into individual plugs. Growth chambers can also be used to aid germination of some species after being sown, as they allow for more consistent light levels.

After scarification, some seeds need higher quantities of water to imbibe properly and germinate. The bright yellow pea-like flower of meadow vetchling *(Lathyrus pratensis)* is surpassed in looks by its beautifully mottled seeds. After scarification the seeds are soaked, typically submerged in cold water for 24 hours. The small, hard little seeds are now swollen and fat with water, which aids their germination. Once the seedlings get going they quickly turn into resilient little plug plants that when planted out into the meadow are far more likely to be able to fend for themselves.

Establishing species in a meadow by following these processes is a costly and time-consuming business. Fortunately, the majority of meadow plants do fairly well when sown directly onto an area of grassland that is being enhanced or restored. But the hard-to-establish species add colour and regional character to a meadow and so are well worth the extra effort. Wild plant propagation is not an exact science; finding the right combination to unlock each species is a challenging yet fascinating journey. ❧

[4]

[1] Growth chambers help to create and control temperature, humidity and many other environmental conditions that aid seed germination.

[2] A magnifying glass helps to bring the tiny seeds into sharp focus, which is particularly important when trying to 'chip' tiny seeds to aid germination.

[3] Having the right tools of the trade to hand will massively increase your chances of success.

[4] When seedlings have two or more sets of leaves and are large enough to handle, it is time to prick them out into a plug plant tray.

[5] Establishing saw-wort *(Serratula tinctoria)* by seed is not always successful. Planting saw-wort in the meadow as nursery grown plug plants often gets better results.

[5]

Wild plant propagation is not an exact science; finding the right combination to unlock each species is a challenging yet fascinating journey.

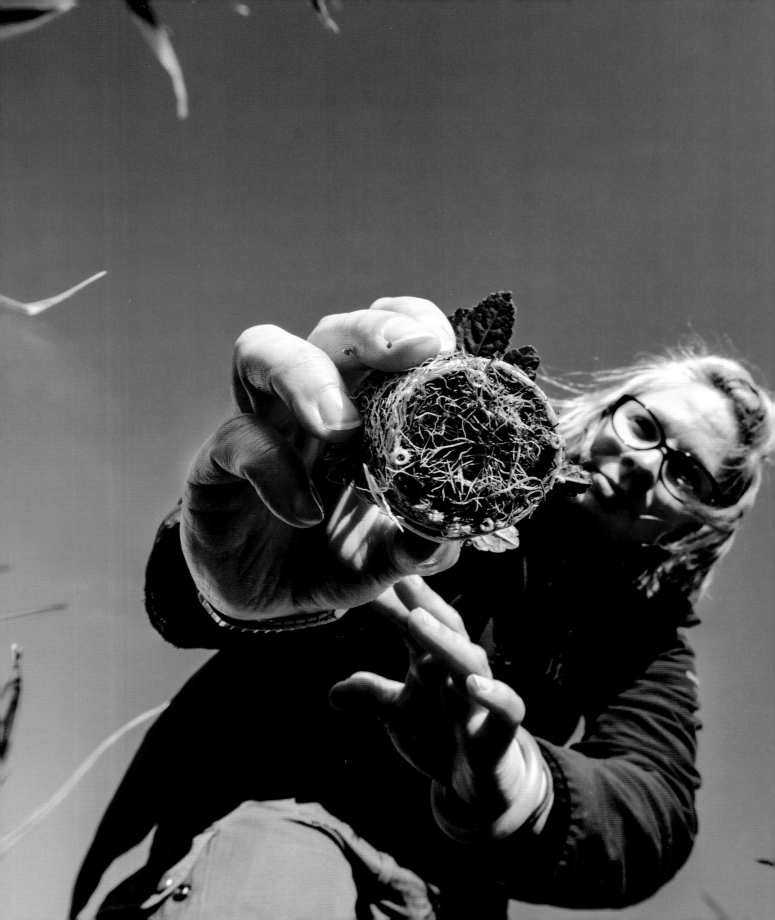

Plugging the gap

HARRIET FERMOR
BOTANICAL HORTICULTURIST
WAKEHURST, KEW'S WILD BOTANIC GARDEN

Establishing most species of wildflowers when creating or restoring a meadow is relatively easy – throw the seed in the general direction of the ground and allow gravity and the forces of nature to do the rest. But there are some species that can be more challenging. Very often it is these plants that add regional character to a meadow, so it becomes important to find another way to establish them. By growing these 'hard-to-establish' species into plug plants under nursery conditions and then placing them with a real sense of purpose into the meadow, they are far more likely to survive. This is certainly time-consuming and costly, but I think the wildflowers are worth it.

There is something very exciting about walking to a meadow holding a tray of wildflowers to plant. When deciding where to plant them I try to mimic the way that species would naturally grow, creating drifts and swathes or speckling the plants through the meadow. Taking a lead from nature results in a more naturalistic appearance. I often plant a little patch at the entrance to a meadow or where a path splits or beside a bench, wherever I think people will enjoy seeing them – after all, it is not all about the butterflies and the bees. A meadow appeals mostly to our sense of sight, so I try to make sure that the colour palette and pattern of planting catches the eye.

There is a whole range of specialist planting tools on the market, from bulb planters and dibbers to trowels and spades, but I have found that the radius of an old scaffold pole makes a perfectly sized hole for a plug plant. The weight of the pole does not so much cut a hole in the ground as make an indentation, so it is important to remove the grassy matter that inevitably gets pushed to the bottom of the hole. This allows the roots to make contact with the soil, enabling more successful establishment. I leave the pole discreetly propped up against a gate post all through the year, not something I could do with a branded tool, and although at first I was worried that someone might pinch it, that has never happened. There is something quite interesting about planting beautiful wildflowers by using a hard metallic cylinder that is more associated with building sites, and if the tool is fit for purpose then it is good enough for the job.

When planting wildflower plugs, it is vitally important to press the plant firmly into the ground so it is secure. There are a number of reasons for this, but it is mainly to prevent other meadow residents, such as badgers, rabbits or birds of various descriptions, from pecking or grubbing them out. While I suspect there is no malice in their actions, it can be frustrating when revisiting a planting

Over the years I have planted tens of thousands of wildflower plug plants, and each one is placed into the ground with care, attention and a wheelbarrow full of affection.

[2]

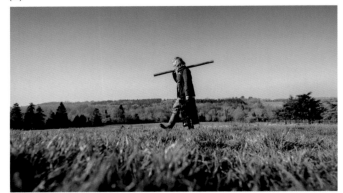

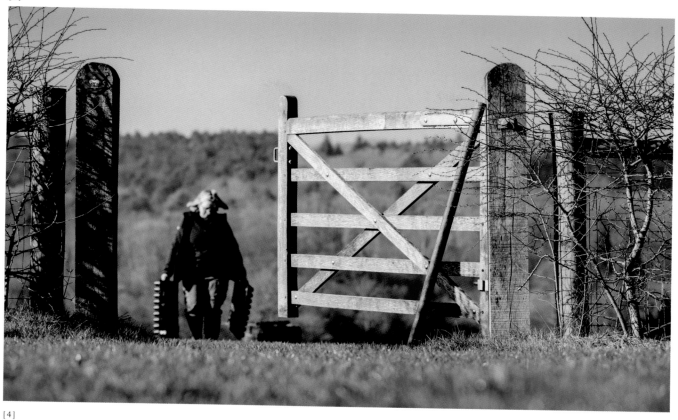

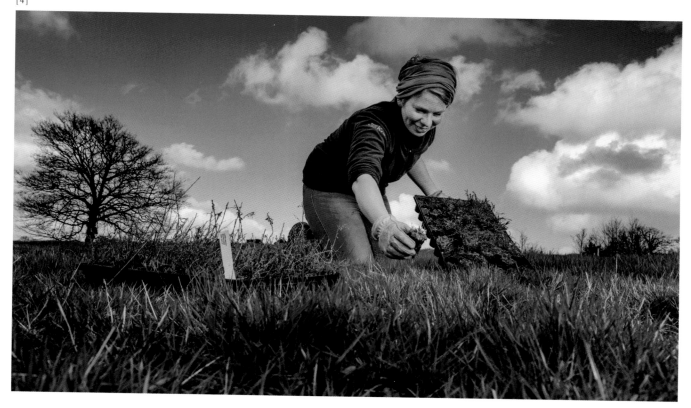

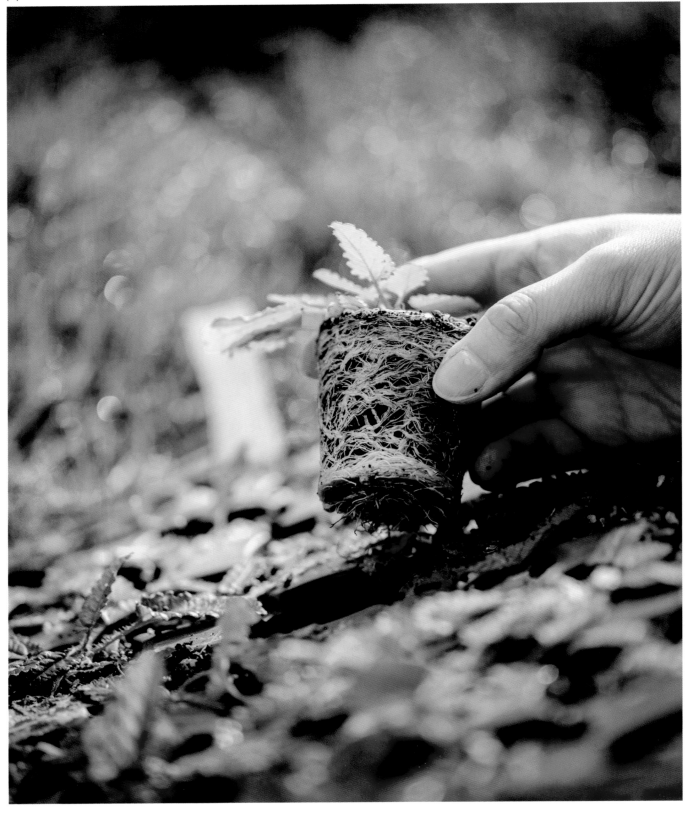

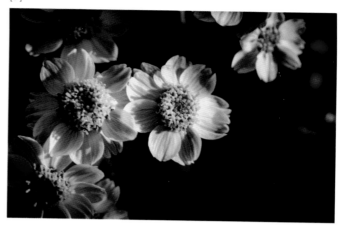

site only to find the plants are lying scattered on the surface and have long since perished.

In the same way that it is best practice not to plant a tree too deeply, it is also important to get the depth right for plug plants. Too deep and the plant will struggle to find its niche; if planted too high the roots will be exposed and become vulnerable to drying out. I like to keep a watchful eye on the wildflowers that I have placed in the meadow. Even after the passage of time I still recognise each one, although many of course are now surrounded by their offspring.

I find planting in early autumn the best time of year, when the soil still has some warmth to it. This allows the roots time to settle in, and, there is always plenty of moisture in the ground. In spring the plants are ready to hit the ground running. Having said that, planting in spring is also acceptable, although the risk of a prolonged dry period can be a concern.

Over the years I have planted tens of thousands of wildflower plug plants, and each one is placed into the ground with care, attention and a wheelbarrow full of affection. It may seem over-sentimental to some people, but each flower becomes a friend to me and hopefully a friend to the pollinating insects that feed on the nectar and pollen they produce. My work is a balance between conservation and enthusing other people about the urgency of caring more for the environment. I try to make sure that visitors leave my meadow with a lasting impression of not only the beautiful colours and textures of native wildflowers, but also the inspiration to plant some for themselves. ❧

[1] Betony (*Stachys officinalis*) is a long-lived and slow-growing perennial which is a welcome and beautiful addition to any meadow.

[2] Expensive plug-planting tools are available, but an old scaffold pole is more than suitable.

[3 AND 4] Planting wildflower plugs in autumn allows the plants to settle in and hit the ground running in spring.

[5] A healthy root system is key to establishing wildflower plug plants. These young betony (*Stachys officinalis*) plugs have every chance of successful establishment in the meadow.

[6] Establishing sneezewort (*Achillea ptarmica*) into a meadow by seed is not always successful, but a healthy plug plant has a much better chance of survival.

[7] Sneezewort (*Achillea ptarmica*) is an attractive perennial plant that thrives on clay and tolerates acidic soils. The roots of the plant were traditionally used to induce sneezing – not to cure it.

A meadow appeals mostly to our sense of sight, so I try to make sure that the colour palette and pattern of planting catches the eye.

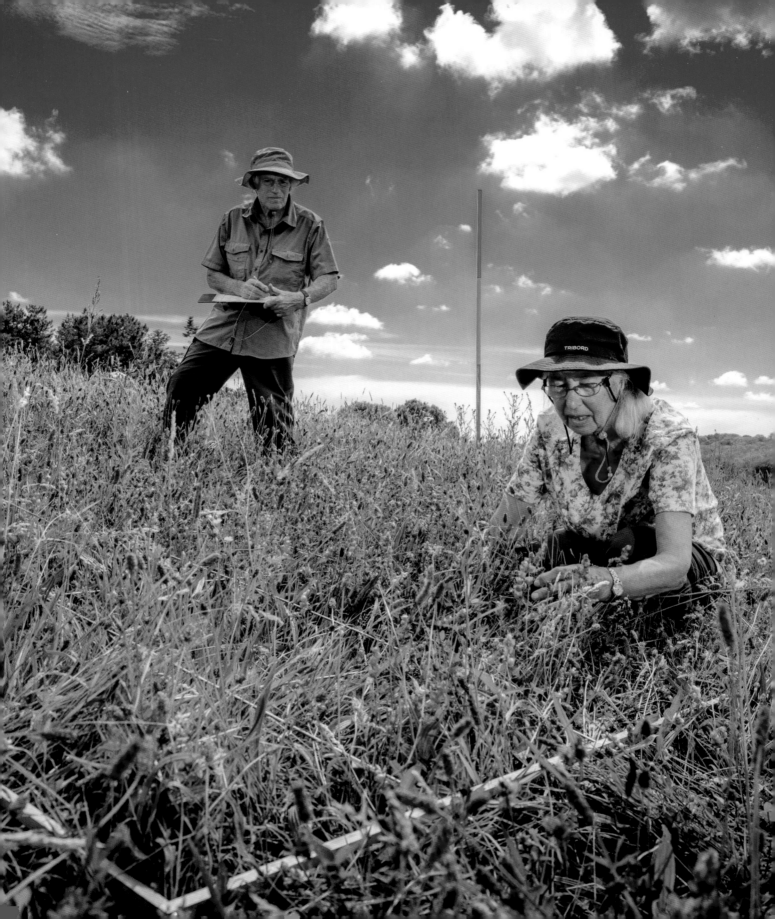

Monitoring performance

DR MARGARET PILKINGTON
EMERITUS SENIOR LECTURER (UNIVERSITY OF SUSSEX)
BOTANICAL HORTICULTURIST

Science-based monitoring is an important element of grassland restoration. There is still much to learn about the best way to manage and restore species-rich grassland. By gathering evidence, we can evaluate the effectiveness of different restoration techniques and assess whether changes are required in the way the grassland is managed. Monitoring serves an important scientific role by showing long-term trends that can lead to a greater understanding of the complex ecological functions at play. The more detailed and accurate the monitoring is, the more confidence can be placed in the reliability of the results.

Fortunately, my team of expert volunteers are all experienced botanists with a good grasp of the grassland sections of the National Vegetation Classification (NVC). Widely acknowledged as the common language of plant classification, the NVC survey method is a descriptive system for categorising plant communities within certain habitats, such as species-rich grassland. Each plant community has key players or constant species that you would expect to find in most examples, and this determines how the meadow is characterised.

Over the years our group has carried out monitoring and surveys at restoration sites all over Sussex. Most recently we have been working with the team at Wakehurst, Kew's wild botanic garden, to monitor a five-hectare meadow restoration project. The project is very personal to me, as it has been restored using wild harvested seed collected from Valebridge Common, a very special local meadow that I have been studying for the past 30 years. I have spent many happy times there with our volunteers recording the plant communities, which include interesting plants such as grass vetchling (*Lathyrus nissolia*), common spotted orchid (*Dactylorhiza fuchsii*) and, one of my favourites, dyer's greenweed (*Genista tinctoria*).

I thought it very appropriate that seed from Valebridge Common was used to create another meadow at Wakehurst with the potential to include many of the same plant species. Both are meadows of the Weald of Sussex and share many of the same environmental conditions. With the seed coming from

[1]

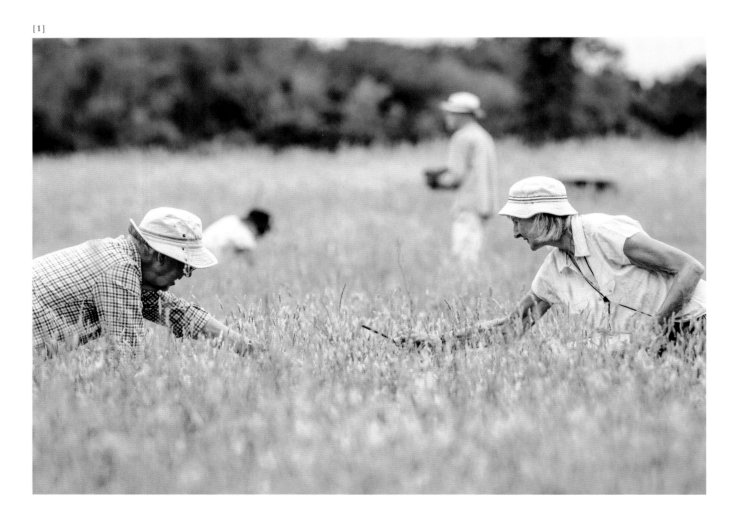

Monitoring serves an important scientific role by showing long-term trends that can lead to a greater understanding of the complex ecological functions at play.

a meadow a few miles away, it is of a local provenance source – such an important consideration in meadow restoration – and will be able to adapt to the local heavy clay soils and climate.

We began our monitoring with a baseline survey, which helps to establish the ecological value of the grassland by identifying the species and abundance of plants that are present. The survey acts as a benchmark and provides a set of data against which future surveys can be compared. I remember that we worked in tall grass with only the tops of our heads showing. It proved to be very species-poor, but in one sample plot we recorded adder's tongue fern (*Ophioglossum vulgatum*), an ancient grassland indicator plant, which suggested that all was well with the soil.

[2]

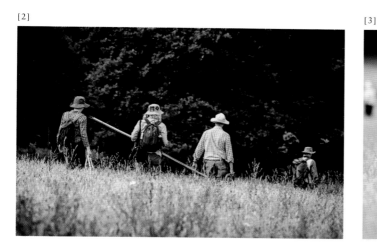

[3]

[4]

[5]

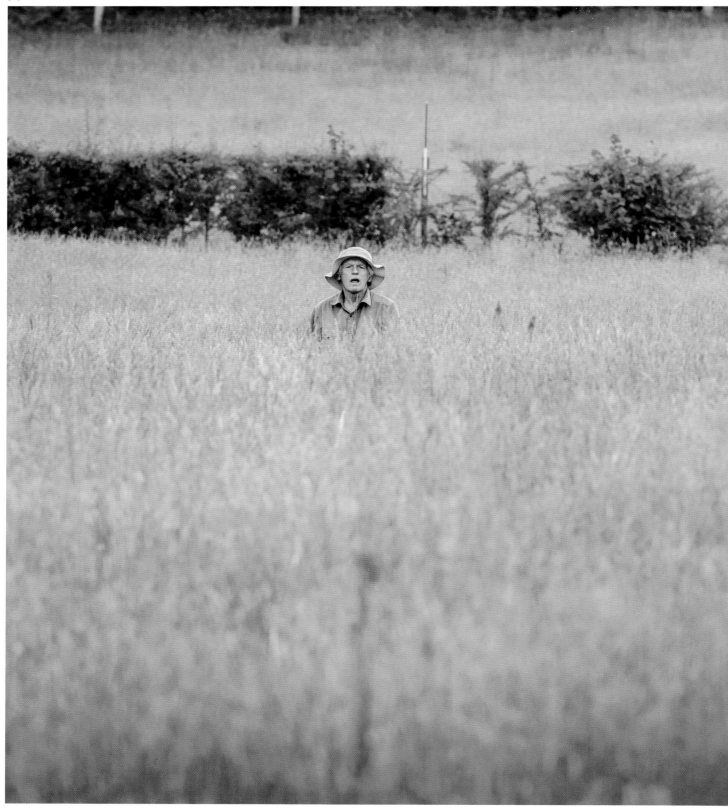

The following summer, after restoration treatment, almost all the hay meadow constants were present. It is exciting to go back each year to see the meadow developing a beautiful, flower-rich character. Every visit we make to monitor the meadow's flora is a voyage of botanical discovery. What makes the monitoring process such a wonderful experience is that it involves people and plants – the two most important ingredients that underpin any self-respecting meadow. ଔ

[1] There are a number of essential tools of the trade for monitoring grasslands, but, as every botanist knows, the most important is a wide-brimmed hat.

[2] The conservation sector relies increasingly on the expertise of volunteers for carrying out monitoring and recording of species-rich grasslands.

[3] Carrying out grassland monitoring requires a keen eye for botanical detail.

[4] The striking crimson pink flowers of grass vetchling (*Lathyrus nissolia*) are born on long stalks and appear in mid-June. This charming annual plant is occasionally found in MG5 lowland grassland.

[5] Dyer's greenweed (*Genista tinctoria*) is an attractive perennial of hay meadows, but the value of this plant is more than skin deep; it is also an important foodplant for a range of scarce moths and other insects.

[6] Margaret and her husband John have inspired many 'meadow folk' over the years, including the author of this book.

What makes the monitoring process such a wonderful experience is that it involves people and plants – the two most important ingredients that underpin any self-respecting meadow.

'Landscape is composed not only of what lies before our eyes but what lies within our heads.'

D W MEINIG

Character

The British Isles have a wonderfully rich and varied landscape, from dramatic mountain ranges and sea-swept cliffs to a gentle patchwork of woods, hedgerows and fields. In spring and early summer hay meadows take centre stage, transforming parts of the countryside with trademark tapestries of colour and sound. At a glance, the individual character of one meadow appears much the same as another, but closer inspection at a species-level reveals countless expressions of regional identity. The surprising levels of botanical variation found in the composition of meadow plant communities reflect subtle differences in the nature of their underlying geology, soils and hydrology, alongside changing patterns of landform and climate.

The well-drained soils of upland hay meadows, for example, support a unique flora, including a number of rare and threatened plants such as wood crane's-bill, globeflower and lady's mantle. In contrast, the flower-rich swards of the central floodplains favour the growth of

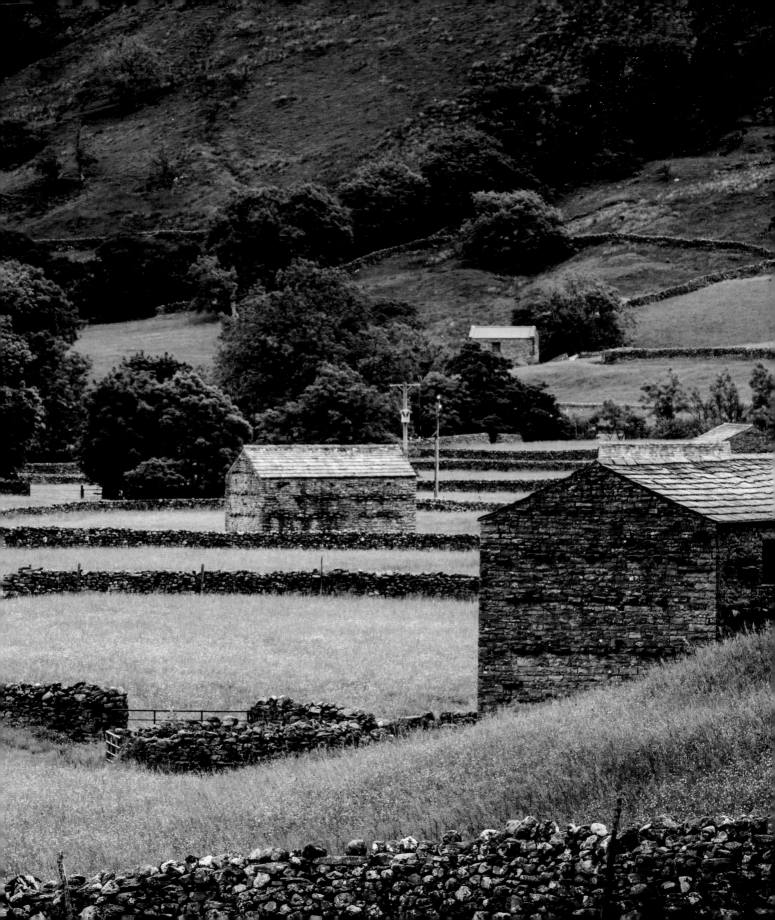

moisture-loving plants, which have evolved sophisticated strategies to cope with seasonal flooding. Similarly, water meadows offer a range of niche habitats for species of damp grassland which take advantage of the complex networks of carefully graded channels. Most remarkable of all though are the meadows of the machair, where a highly specialised flora has adapted to life growing on lime-rich shell sands typically found on the coastlines of the Western Isles.

Wildflowers can often be found masquerading as meadow in rural churchyards and city cemeteries or alongside our highways and byways. Traces of ancient grassland such as these are valuable on many different levels. Most importantly they act as reservoirs for biodiversity, providing habitat for wildlife and a home for many rare and threatened plants. Wherever a meadow chooses to put down its roots, over the passage of time, each one develops a unique personality. This strong sense of place is not just shaped by the physical characteristics of the landscape, but also embodies a layer of human perception, reflecting the emotive bonds that people have developed with these special places.

At a glance, the individual character of one meadow appears much the same as another, but closer inspection at a species-level reveals countless expressions of regional identity.

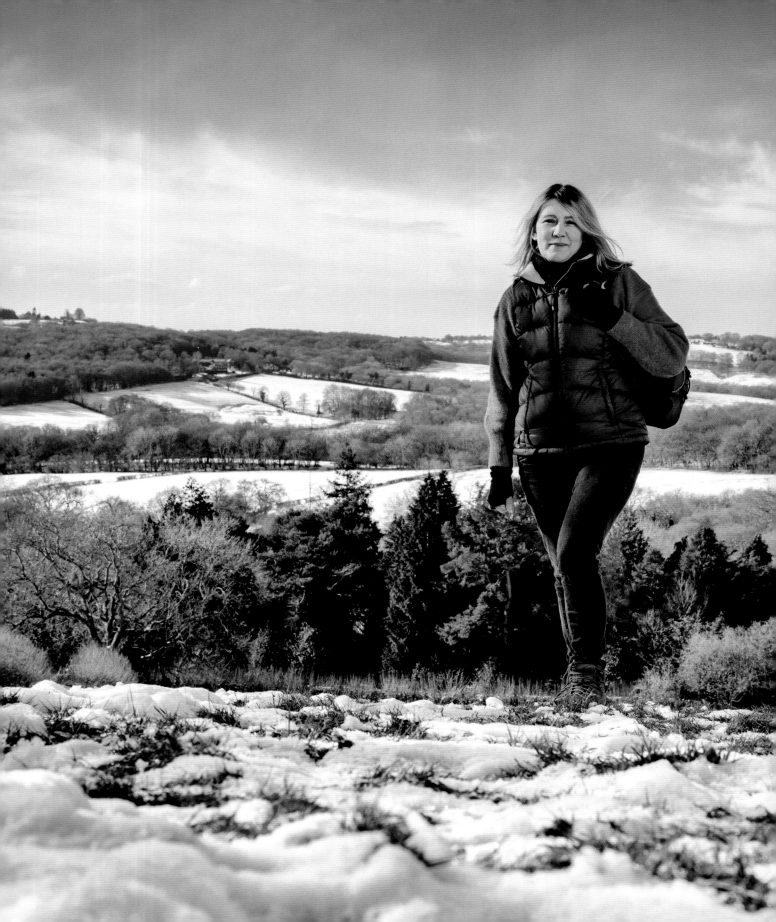

Lowland layers

GERRY SHERWIN
LANDSCAPE SPECIALIST

Navigating an icy tread, I pause as I step over the stile to scan the view ahead. To the right I can see fields swathed in a uniform emerald green, to the left fields of earthy green and yellows. The former are typical of re-seeded grassland, while the latter hint at older grassland. Stepping down, I turn left. It is winter, it has been raining, and I know from experience that the fields in this direction are less likely to be waterlogged and slippery underfoot, thanks to their undisturbed soils. But my main mission is to find a new cluster of fields with a strong sense of place: grasslands which, alone or together, are unique and oozing with long-standing human attachment.

I am walking through the High Weald Area of Outstanding Natural Beauty, a cultural landscape covering 1460 sq km at the heart of South East England. Its rolling hills are clothed with woods (over 30 per cent of the area), small, irregular-shaped fields and scattered farmsteads. These features are connected by a rich network of characterful hedges, ancient routeways and a myriad of streams, largely found at the bottom of wooded, deep-sided ravines, known locally as gills. Archaeological features, many a legacy of the area's Tudor iron industry, abound. Unsurprisingly Historic England consider it to be one of the best-preserved medieval landscapes in Northern Europe.

And within this landscape wildflower meadows and pastures can still be found, tucked away within the woods, often protected from change because they are hard to reach. At this time of year, I will not find flowering plants, chirping grasshoppers or the myriad shapes and colours of waxcap fungi which emerge in the autumn. I might, if I am lucky, see a barn owl (*Tyto alba*) hunting close to the ground; now the leaves have fallen it is easy to spot the artificial nesting boxes that are crucial to their survival.

Without these wildlife distractions, it is other elements of the field that I find beautiful. I take in the frame that surround the meadows: sinuous boundary hedges of hornbeam (*Carpinus betulus*), hazel (*Corylus avellana*), holly (*Ilex aquifolium*), hawthorn (*Crataegus monogyna*) and blackthorn (*Prunus spinosa*), some on old earth banks topped by gnarled veteran trees.

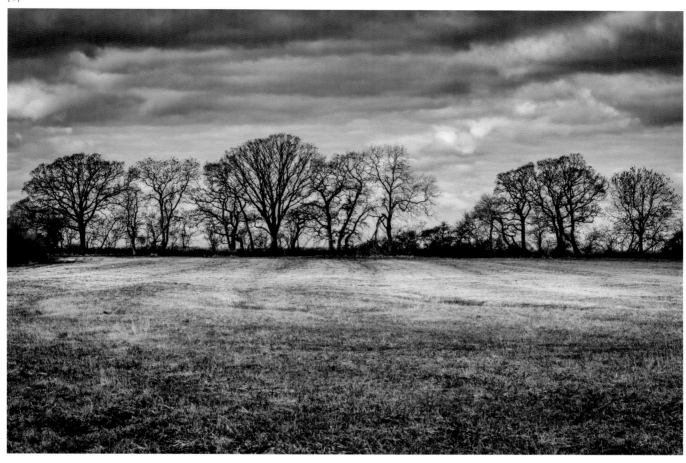

I never take these meadows for granted. I have seen too many of these tiny, precious, beautiful jewels disappear, and I still feel a sense of loss.

Looking down the slope, I absorb the canvas. There are subtle undulations (or rumples) that suggest a meeting of the underlying geologies of sandstones and clay. The wet flushes are probably caused by a natural spring close to the field's surface, but the pond in the corner is a water-filled quarry, a legacy of human endeavours to mine iron, stone and perhaps marl. I scour for lynchets – subtle ridges and furrows formed by the movement and build-up of soil after ploughing on sloping land. There is tussocky grass here and there, a perfect home for field voles and shrews. Seed heads that have been missed by the hay cut or munching livestock hint at the flowery meadow to come in summer. And I spot anthills. An unappreciated wonder of their natural world with their surreal form and intricate network of internal channels.

Created by tiny yellow ants over many decades, these microhabitats support many species of wildflowers and animals. They are 'housed' on a steep bank where machinery that would flatten them dare not go. Varied vegetation structure is important to wildlife, the more of it the better, and this field offers it in bucketloads.

I move on. The average size of field in the High Weald is very small, so it is not long before I am in the next field. The beauty of a meadow is found in its subtle character or personality. It is the small changes and lack of uniformity that breathe significance into meadows. At the next stile I perch on the top and muse about the people who have been here before me. Meadows are a conspiracy of nature and culture, and their sense of place includes the invisible as well as the visible.

Meadows harbour hundreds of stories that have never been written down. Many people toiled to carve these fields from the Weald's woodland, creating their distinctive shapes, and worked to plough, graze and hay them over centuries. I wonder who was the first person to coin the phrase 'moon penny' as a word for ox-eye daisy (*Leucanthemum vulgare*) or 'eggs and bacon' for common bird's-foot-trefoil (*Lotus corniculatus*). Even the stile, with its hand-sawn timber struts, has escaped conformity and has been crafted by someone.

These fields are not mine, but through a 30-year journey I feel attached to them. That journey has involved den-building with cut hay in the school playing field, a lot of time on hands and knees peering into plant quadrats and, more recently, turning my eyes to the historic environment and the story behind the area's many 'lumps and bumps'. And I am still learning. Discovering what is happening below the ground's surface is a new dimension; the importance of healthy soils, particularly the role of fungi, is a revelation. It is astonishing that there are more soil microorganisms in the form of fungi, bacteria and soil

[3]

[4]

It is the small changes and lack of uniformity that breathe significance into meadows.

Meadows are a conspiracy of nature and culture, and their sense of place includes the invisible as well as the visible.

microbes living in a teaspoon of healthy soil than there are people on the earth.

For centuries these fields, and many like them in the High Weald, have remained relatively unchanged, but will they stay that way? Elsewhere changes to farming systems over the last 50 years have created bland, unfriendly landscapes. It feels as though farming systems are on the cusp of rapid change again; that could enrich but may deplete – again. After surviving for hundreds of years, including the last 50, the subtleties of these fields (and the story they tell) can still be eroded by one afternoon of ploughing. I never take these meadows for granted. I have seen too many of these tiny, precious, beautiful jewels disappear, and I still feel a sense of loss.

Despite worthwhile efforts to create flower-rich meadows, these ancient fields are masterpieces that cannot be recreated. I think about the current custodian; will they be able to carry on the traditional farming that

[5]

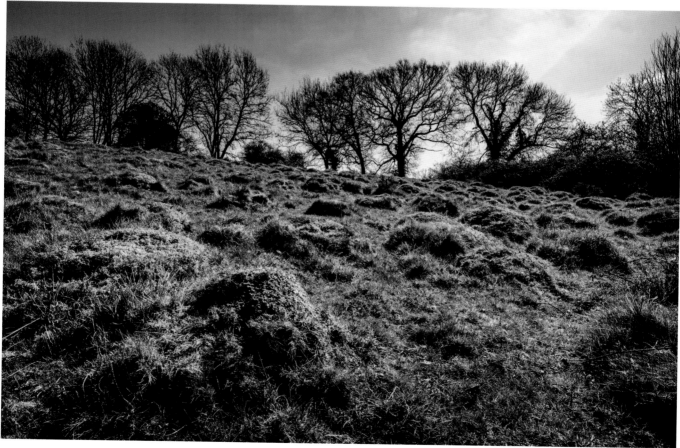

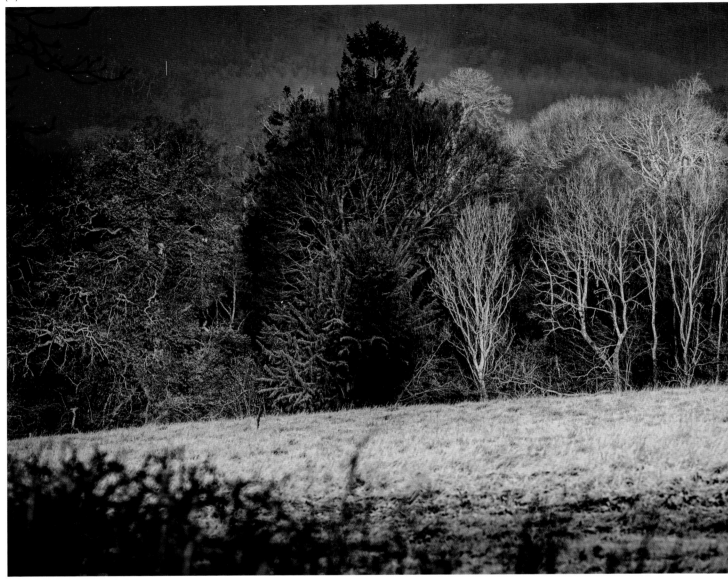

ensures these meadows' survival? Will a new custodian realise what they have or will they embark on damaging 'improvements'? I hope that next time I visit this field will not have become woodland – either through abandonment or tree planting – or worse, have been ploughed, sprayed and reseeded. Preservation is not about the status quo, but I wonder how we can maintain these masterpieces and create new ones with the same rich patina.

The snorting of a group of conker-coloured Sussex cattle with stubby legs and steamy breath wake me from my reverie and make me smile. These animals are a valued local breed, important for meadow management. With the right conditions and management, they are happy to stay outside all winter.

Heading home, I end my walk in the heart of the village, passing roadside verges which, protected by

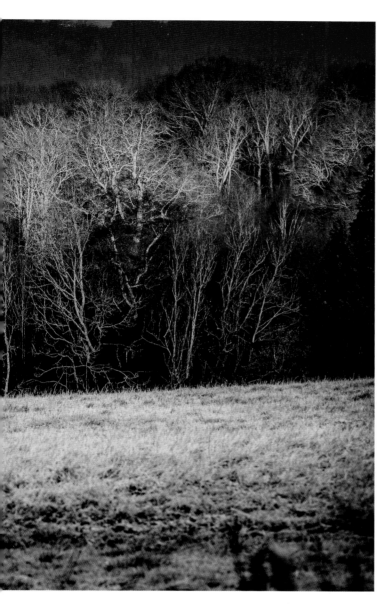

the steep banks on which they are located, are refuges for ancient grassland. In winter, to most, they are 'just green grass', but from May I know they will be naturally beautiful, a pastel firework display of early purple orchids (*Orchis mascula*), knapweed (*Centaurea nigra*) and swaying ox-eye daisies (*Leucanthemum vulgare*). Mini-meadows on the doorstep. ❧

[1] Lowland meadows often occur on shallow slopes or level ground with relatively deep soils that are neither strongly acidic nor rich in lime.

[2] Even in winter it is possible to identify a meadow by the muted colours of the sward, which provide a stark contrast to the emerald-green leys of intensively managed fields.

[3] Common bird's-foot-trefoil (*Lotus corniculatus*) is a ubiquitous species of lowland meadows.

[4] The large flowerheads of ox-eye daisy (*Leucanthemum vulgare*) are so bright that they seem to 'glow' in the evening – hence their other common name of 'moon daisy'.

[5] A moonscape of large round mounds provides evidence of the activities of yellow meadow ants (*Lasius flavus*) over many decades.

[6] Winter exposes the stripped-back beauty of lowland grasslands, allowing other elements of the landscape to draw the eye.

[7 AND 8] As grassland fungi are extremely sensitive to agricultural intensification, their presence in a meadow is a sign that the grassland has ancient and undisturbed soils.

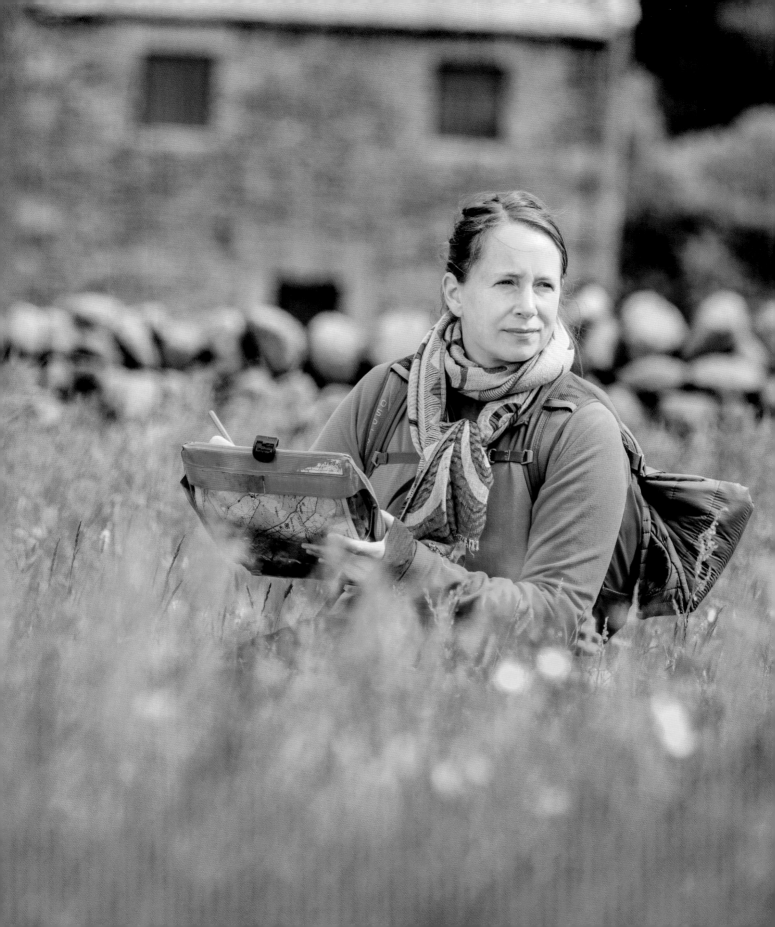

Upland heritage

DR RUTH STARR-KEDDLE
TEES-SWALE FARMING AND NATURE OFFICER

My enduring love affair with upland hay meadows began on a bright sunny day one June over 11 years ago when I started undertaking botanical surveys in the North Pennines Area of Outstanding Natural Beauty (AONB). The day was framed by a clear blue sky; overhead the raucous calls of lapwing (*Vanellus vanellus*), curlew (*Numenius arquata*), redshank (*Tringa totanus*) and snipe (*Gallinago gallinago*) rang out loud and a slight breeze blew over the grasses to form ripples of green waves. A bumblebee buzzed past my ear. The yellows of meadow buttercup (*Ranunculus acris*), yellow rattle (*Rhinanthus minor*) and rough hawkbit (*Leontodon hispidus*), the reds of red clover (*Trifolium pratense*) and the whites of eyebright (*Euphrasia officinalis*) and pignut (*Conopodium majus*) painted a vivid picture.

Over the years my connection to the landscape and the cultural heritage of upland hay meadows has deepened. The mesmerising ecological diversity and species richness of upland hay meadows has been brought about by centuries of traditional farming management. The meadows are grazed with sheep during the spring and autumn, with a brief period of cattle grazing after the summer hay cut. During the summer the vegetation flourishes into a beautiful, colourful and diverse sward. Every year the meadows are cut by the farmers in mid- to late July. The crop vegetation is turned, dried and baled into hay. The musty, sweet smell of the hay produced from a species-rich meadow is unforgettable – thanks, in part, to the presence of the aromatic sweet vernal grass (*Anthoxanthum odoratum*). Each year there will be an application of farmyard manure; this is the only form of applied nutrient in this non-intensive system of farming management.

However, these traditional farming systems are changing, replaced by more intensive farming practices. We have lost 98 per cent of our species-rich grasslands over the last 60 years, leaving us with only 950 hectares of species-rich upland hay meadows in the UK. Some meadows have been ploughed and reseeded to allow for more livestock. There has been a move away from haymaking to silage production, with the addition of chemical fertilisers and an earlier cut date. These approaches encourage the faster-growing grasses, which outcompete the later-flowering wildflowers. The meadows that I have become so attached to are fast disappearing, and I have watched the botanical diversity of meadows vanishing before my eyes.

A traditionally managed upland hay meadow is visually stunning, with a vast display of different grasses and wildflowers. My personal favourite is wood crane's-bill (*Geranium sylvaticum*), because it is the classic upland hay meadow plant – if you stumble upon it in a meadow, you will know that the grassland is ancient. To highlight a number of important plants found in upland hay meadows I have coined the term 'The Big Five'; these include wood crane's bill, great burnet (*Sanguisorba officinalis*), melancholy thistle (*Cirsium heterophyllum*), lady's mantle (*Alchemilla mollis*) and globeflower (*Trollius europaeu*s). These are the iconic

[1]

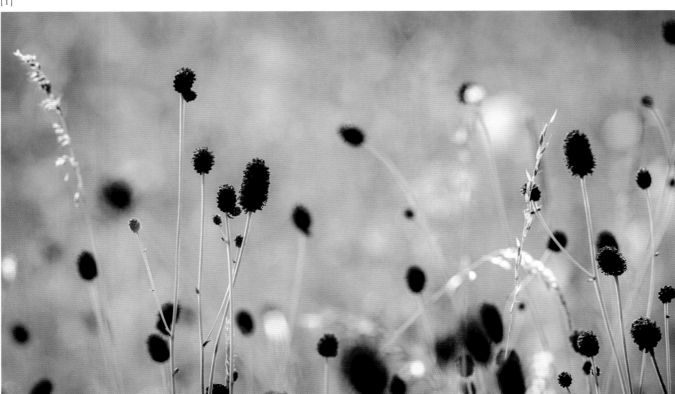

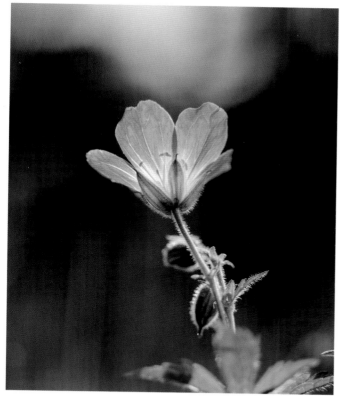

[5]

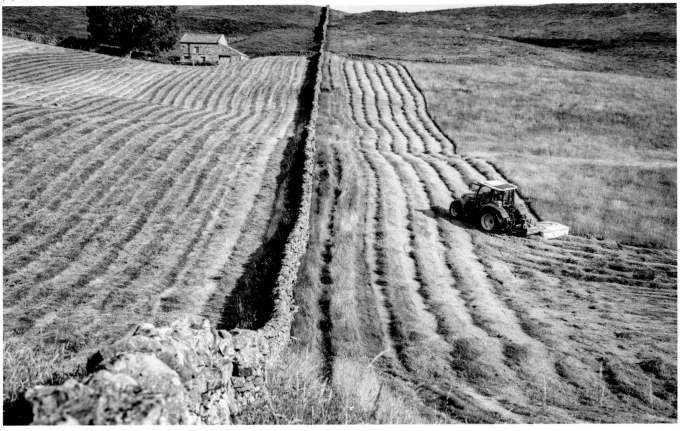

plants found in species-rich upland hay meadows. They are either late flowering or require low fertility; consequently they have been declining from the meadows due to the changes in management.

Upland hay meadows are delightful places for a range of rare and threatened bumblebees and other pollinators. Many of the plants, such as yellow rattle, eyebright, red clover, lesser trefoil (*Trifolium dubium*) and bush vetch (*Vicia sepium*), are excellent sources of nectar and pollen. Yellow rattle is a hemiparasite which attaches its tiny root system to nearby grasses, reducing their vigour. The farmers call this little plant 'poverty' because it lowers the yield of the hay crop. Yellow rattle is a 'facilitator of restoration' as it reduces the volume of grasses to enable other wildflowers to establish. The legumes are needed not only for the pollinator populations but also to fix nitrogen and promote a healthy soil too, increasing fungi to bacterial ratios.

I have a wonderful job at the North Pennines AONB Partnership and have worked on various projects including Hay Time, Nectarworks and Plugging the Gaps, all of which aim to restore upland hay meadows. During August each year I work with local contractors who undertake upland hay meadow restoration with specialist machinery. We use a large forage harvester to cut and collect green hay from species-rich donor meadows when the flowers have set seed. In partnership with the contractors, farmers, landowners and Natural England, we harvest this green hay and spread the seeds onto nearby meadows. We have reintroduced yellow rattle, red clover, eyebright, lesser trefoil, pignut, ribwort plantain (*Plantago lanceolata*) and selfheal (*Prunella vulgaris*) into 147 meadows using this restoration method.

The success of restoration is an encouraging story, but there are limits to such work. We have been unable to reintroduce plants such as wood crane's-bill and

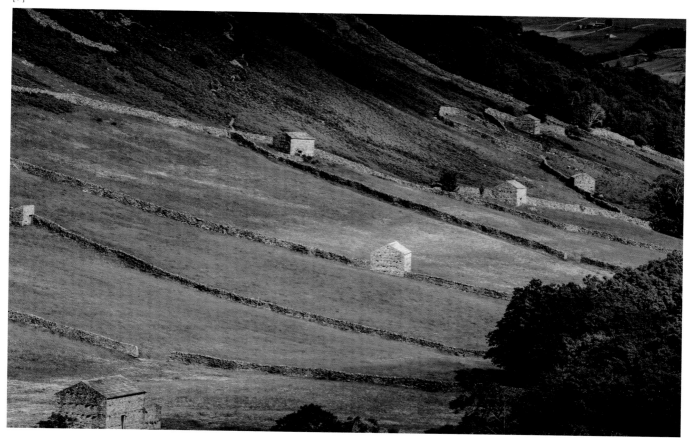

globeflower into the meadows by using the green hay method. It is clear that 'The Big Five' have specific seed germination and growing requirements. Over the years numerous volunteers and I have learned how to hand-collect wildflower seeds, sow seeds into pots and germinate seedlings, taking a great deal of time and effort to establish difficult plants. We have planted thousands of wildflower plants into meadows grown from hand-collected local seeds.

Restoration is expensive and requires experts on the ground working directly with land managers to organise the work. The challenges of ecological restoration emphasise the urgent need to protect the existing upland hay meadows from further damaging changes in farming practices. It is far easier to maintain than to restore lost habitats. This is a journey that requires collaboration with the farming communities to prevent upland hay meadows from disappearing from our landscapes and lives forever. ❧

[1] The oval-shaped, crimson flower heads of great burnet (*Sanguisorba officinalis*) can be seen in damp grasslands from June to September.

[2] Wood crane's-bill (*Geranium sylvaticum*) is a defining species of upland hay meadows.

[3] The globeflower (*Trollius europaeus*) creates a wonderful splash of colour in early summer.

[4] As the name suggests, melancholy thistle (*Cirsium heterophyllum*) was traditionally used as a potion to prevent 'melancholia' – a form of depression.

[5] It was thought in the past that the water droplets that formed on the leaves of lady's mantle (*Alchemilla* spp) were the purest form of water and might turn base metals into gold.

[6] Recent estimates indicatet that less than 1,000 hectares of upland meadows still survive.

[7] The patchwork pattern of drystone walls give upland hay meadows a strong sense of place.

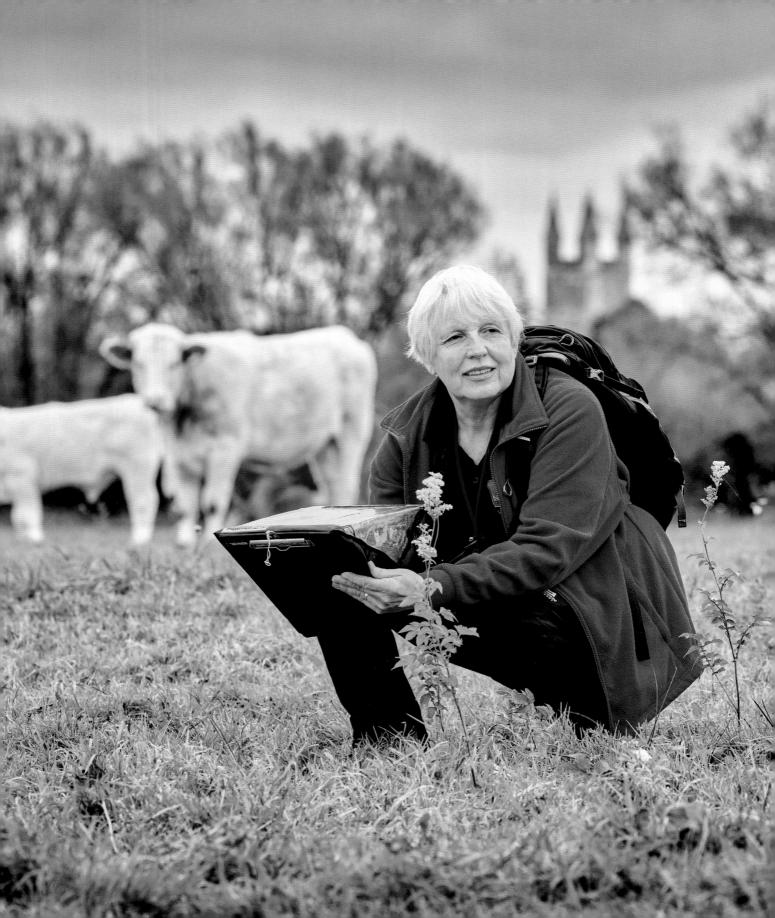

Flowery floodplains

ANITA BARRATT
VOLUNTEER WARDEN

Ancient lowland hay meadows hold a wealth of secrets. No more so than the 45 ha in North Meadow National Nature Reserve, situated on the northern edge of Cricklade, a small town in North Wiltshire. This land is a floodplain meadow that has been managed in the same way since medieval times, resulting in rich sward of some 250 plant species. North Meadow is woven into the fabric of the community, its secrets handed down through the centuries by families who still live in the locality.

It has been my constant pleasure for the past 45 years to visit and marvel at the flora and fauna which produce fascinating seasonal changes in this meadow - firstly with our three children and now with three grandchildren. Initially I went as a volunteer, then seasonal warden and finally as the Reserve Manager; now retired, I am again a volunteer warden. I grew up in Lincolnshire from a farming background. This was to my advantage, as it was a useful anecdote to gain the trust of farmers who later in my professional life I had to engage in conservation.

The hard-working farmers began to tell me stories of how the community had managed this meadow and surrounding historic landholdings. How whole families would help with the hay harvest to sustain their animals over the winter months. The farmers seemed keen to reminisce about the changes they had witnessed, from horse-drawn machinery to the first tractors with mowers, tedding machines and bailers. Anyone who has managed a meadow over a period of time will notice changes, from the ephemeral vagaries of the seasonal climate to advancements in farming technology. Meadows are products of evolution; if we are to maintain their integrity, we have to learn to move with the times.

North Meadow is managed as a 'Lammas' meadow, owned mainly by Natural England apart from 2.2 ha belonging to Cricklade Court Leet, an ancient judicial court that still sits today. The Court oversees the grazing after Lammas Day (1 August). In the spring and early summer a hay crop is grown which is sold to local farmers. Hay is cut after 1 July when the wildflowers and grasses have set seed; the crop must be removed before Lammas Day. An ancient document states that

Bowing down to the majesty of a meadow is something I have always encouraged; there is no better way to experience the wealth and beauty of flora and fauna than by lowering yourself down to their level.

those who have the right to take the hay should 'only take that which falls beneath the sweep of the scythe'. Stock can stay on until Candlemas Day (2 February), but as a precaution are usually moved off earlier as the meadow often floods from the rivers Thames and Churn, which form its boundaries.

North Meadow attracts a great many visitors, mainly in April and May when the meadow puts on a spectacular display of the snake's head fritillary (*Fritillaria meleagris*), triggering an annual pilgrimage to both professional and the often-underestimated so-called 'amateur' botanists. As Reserve Manager and Court Waywarden, I have given hundreds of guided walks during this season. One special memory is etched into my mind. An elderly lady, who was blind, joined a guided walk with her mindful carer; after a short while her carer laid a rug on the ground among the sward,

where the blind lady sat and touched and smelt the plants and grasses around her. We watched as she identified various species by touch and smell, an amazing experience for both her and the others on the guided walk.

Bowing down to the majesty of a meadow is something I have always encouraged; there is no better way to experience the wealth and beauty of flora and fauna than by lowering yourself down to their level. Meadows will unveil different secrets for each individual: some will identify only with a green field, others will experience the beauty of wildflowers and the resonance of the variety of wildlife, while others will explore the history and inner meaning of the meadow. Ultimately each person will end up asking themselves the question as to why a particular meadow still exists, and hopefully they will also ask themselves what it is that they can do to help protect and champion other meadows. I do hope this is the result of all my labours and hopes and dreams. ❧

[1] Species-rich floodplain meadows evolved under a pattern of seasonal winter flooding, hay cutting and regular grazing.

[2] Some floodplain meadows can support up to 40 plant species per square metre, as well as providing a habitat for many rare species.

[3] North Meadow in Cricklade, Wiltshire is one of only a few sites in the UK considered to hold wild populations of snake's head fritillary (*Fritillaria meleagris*).

[4] Of all the rare and threatened plants that occur in floodplain meadows, the snake's head fritillary (*Fritillaria meleagris*) is the most iconic.

[5] Research suggests that populations of devil's-bit scabious (*Succisa pratensis*) in floodplain meadows flower and set seed much earlier than the same species in other habitats due to the plant adapting to centuries of hay cutting

[6] Ancient boundary stones indicate the allocation of hay strips to members of the local parish.

[3]

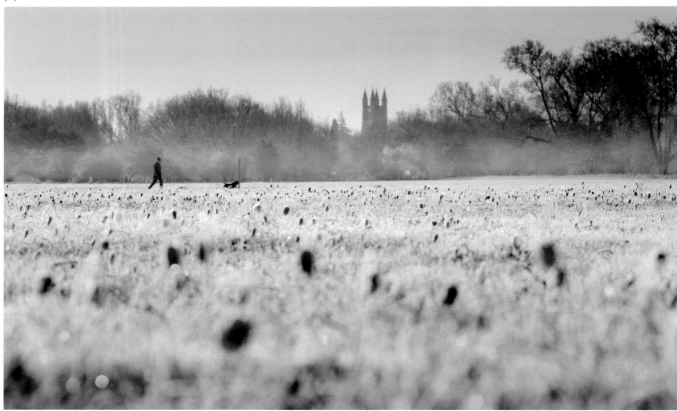

[4]

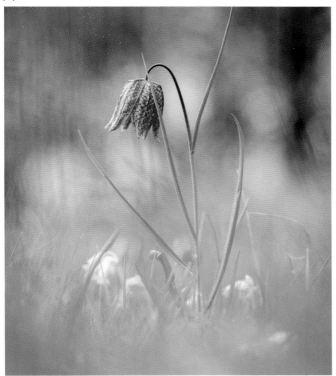

[5]

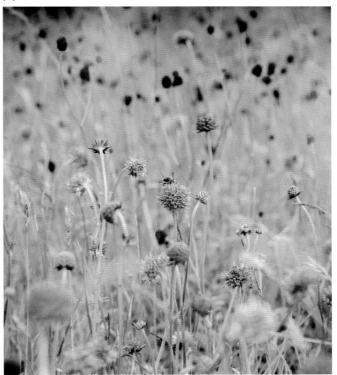

[6]

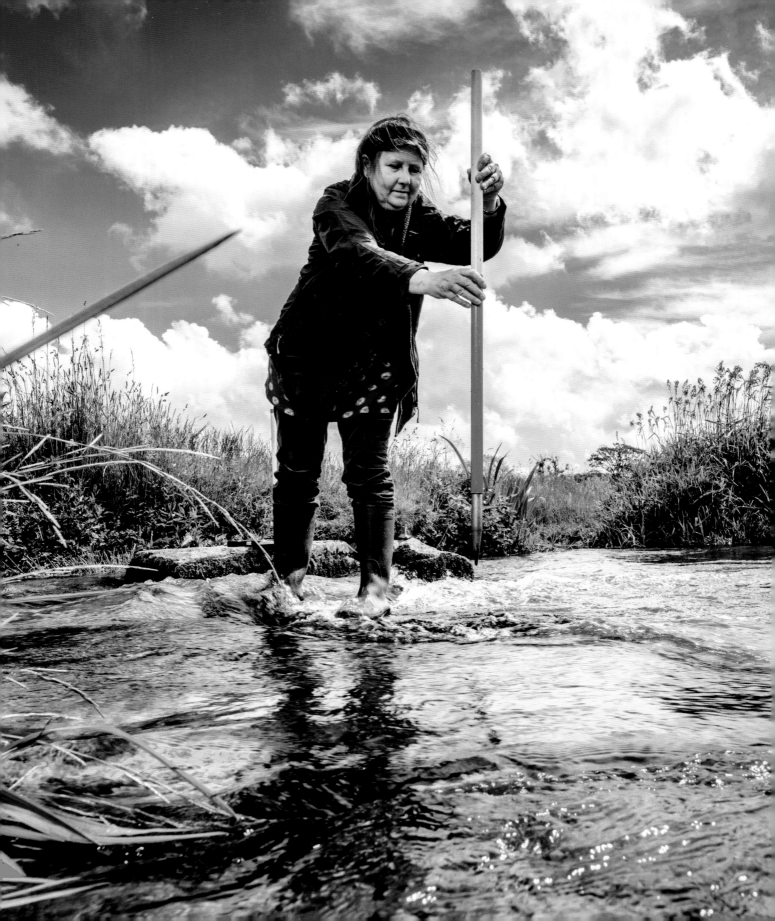

Water meadows

NICKY SMITH
ARCHAEOLOGICAL INVESTIGATOR

Water meadows evoke a strong sense of the past and bygone ways of life lost within living memory. Although working examples are a rare sight today, the presence of the old 'drowners' who skilfully tended them can still be sensed in their silted channels, trampled ridges and jammed sluices. Their understanding of the meadows and how to care for them was second to none, handed down from generation to generation for hundreds of years. Sadly it is now a lost art, but the meadows remain a part of the intricate historic fabric of the English countryside, the story of centuries of interaction between people and nature.

History is written in the landscape all around us, from patchwork fields and meandering lanes punctuated by ancient sites to towns, villages and cities, each with their own unique patterns. As a child these were a source of wonder to me. Why were the fields certain shapes and sizes, and to what mysterious lost places did roads now leading nowhere once go? My first jobs, with the Ordnance Survey and then the Royal Commission on Historical Monuments, introduced me to the world of landscape archaeology and exciting ways to unravel the layers of time.

Sixteen years ago, working as an archaeologist for English Heritage, I found myself scouring the fields and hedgerows around Turnastone Court in Herefordshire, home of Rowland Vaughan, the alleged 16th-century 'inventor' of water meadows, for remnants of his illustrious 'water works'. His reputation seems to have been based on theory rather than practice, but this set me on journey of discovery in search of water meadows. It was fascinating to learn about the reasons why they were made and the way in which they worked. I was lucky enough to see traditional watering at some of the few restored meadows, a wonderful sight when hatches are lifted and water fills the channels, bringing them back to life.

Before cheap fodder crops and chemical fertilisers were introduced, shortage of feed limited how many animals could be kept through the winter. Sporadic meadow irrigation, known as 'floating', 'watering' or 'drowning', was one of the earliest solutions to the problem. It warmed the soil and improved it with nutrient-rich deposits. In winter it protected the ground from frost, bringing grass growth forward by several weeks to bridge the 'hungry gap' in March and April. Repeated in late spring and summer, it boosted hay crops, particularly if lime and manure were added. In

[1]

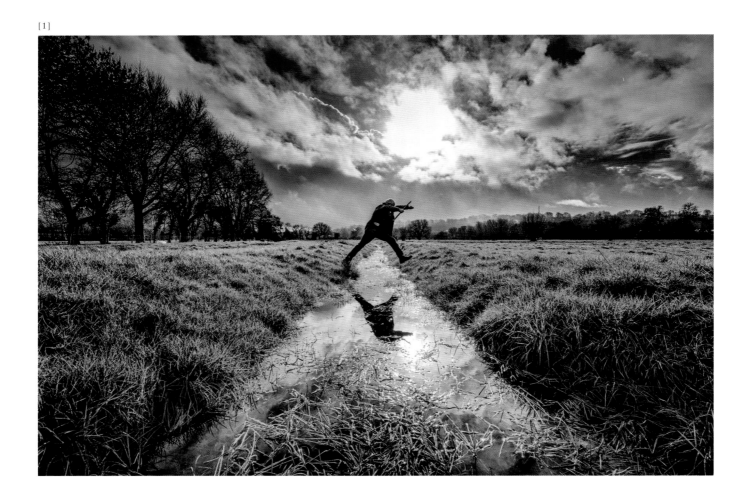

What distinguished water meadows from other wet meadows were their special systems to keep strict control over the water flow.

Water meadows are rich habitats, alive with insects, plants and animals.

places where mixed husbandry was practised, more animals, in turn, meant more manure to help grow more crops.

What distinguished water meadows from other wet meadows were their special systems to keep strict control over the water flow. It had to be kept moving across the ground, ideally as a thin sheet about 2.5 cm deep, and was drained away promptly to prevent any waterlogging. It was said that water should flow 'on a trot and off at a gallop'. To achieve this, natural slopes were put to good use, along with specially constructed channels, ridges, sluices, hatches and even aqueducts. Keeping all these in good repair, as well as continually adjusting the flow of water, was very labour-intensive.

Once chemical fertilisers were introduced they were more economical, so many water meadows were abandoned before the 20th century. Swathes of their remains have been ploughed up or built on, mostly since

[2]

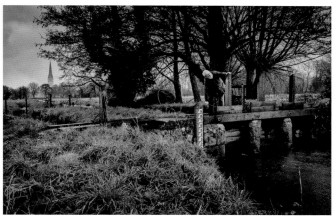

[3]

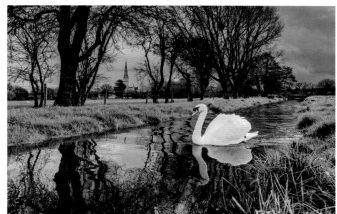

[4]

[5]

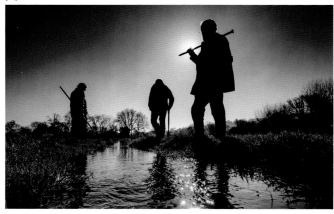

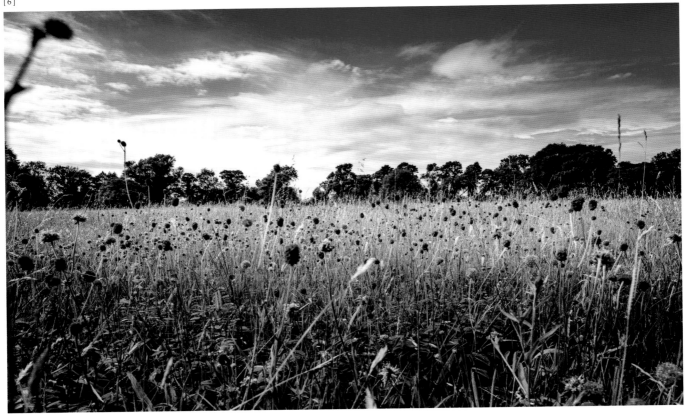

the Second World War, and those that survive are often unrecognised and unrecorded. An important step in protecting them is identifying their remains and adding them to historic environment records.

Two main types of water meadow are found in England: 'catchworks' and 'bedworks'. Catchworks are simple contour-following channels that were often used by hill farmers to improve sloping pastures. Fed with water from high level springs or leats, often passing through a farmyard to wash out manure, these overflowed onto the meadow below. Catchworks may have been known in medieval times and some continued well into the 20th century.

Bedworks became popular from the 17th century onwards for tackling flat river valleys where water would not flow naturally. Their complex 'beds', resembling ridge and furrow, provided artificial gradients carefully planned by surveyors and maintained by professional drowners. They were expensive to create and operate, but they doubled the value of a dry meadow. Wealthy landowners interested in fashionable agricultural innovation commissioned interconnected systems covering long lengths of river valleys. This removed a lot of water, affecting river levels downstream, so negotiation with neighbours was important, especially if they were mill owners.

Water meadows are rich habitats, alive with insects, plants and animals. Their wet and dry cycles of floating, combined with grazing and hay cutting, favoured certain species over others, creating a distinctive type of grassland that persists even on redundant sites. They were designed to make pasture more productive and some were said to produce grass up to 5 m long. Their ability to 'kyll, drowne and dryve away the moldy warpes' (moles) was praised, but allegedly they also damaged the cowslips.

Modern experiments on working water meadows have confirmed that they increase vegetation growth, particularly grasses. As well as hay meadow species, wetland plants such as rushes (*Juncus* species), marsh

marigolds (*Caltha palustris*) and creeping buttercup (*Ranunculus repens*) flourish in their wet areas. They make ideal over-wintering spots for wading birds, while songbirds such as warblers, finches and buntings feast on their insects and seeds. In summer their swaying grasses make perfect nesting places for harvest mice and other small mammals. ❧

Water meadows evoke a strong sense of the past and bygone ways of life lost within living memory.

[1] The person who looks after the meadows and maintains the water systems is referred to as the 'drowner', or in some cases 'meadman' or 'waterman'.

[2] Bedwork water meadows are suited to valley bottoms where irrigation water can be diverted from nearby rivers via sluice gates.

[3] A main 'carriage' carries the irrigation water to a network of shallow trenches or furrows, where it overflows and soaks into the grass roots.

[4] The thin layer of moving water carried oxygen across the surface of the meadow and into the soil to prevent the root zone from stagnating.

[5] The presence of the 'drowners' hard at work tending to their sluices, channels and hatches can still be felt today.

[6] Water meadows have evolved a rich and varied flora and are now home to some of our rarest and most threatened wild plants.

[7] The shallow trenches that are usually hard to distinguish take on new significance when the sluices are opened.

[8] Water meadows differ from floodplain meadows, grazing marshes or other naturally flooded areas in that the meadow is deliberately irrigated at the discretion of the 'drowner' in charge.

Ancient patterns

DEBBIE LEWIS
ECOLOGY MANAGER
WILDLIFE TRUST

Ridge and furrow earthworks, the rippled fields created by medieval farming practices, were once a familiar sight across many parts of the countryside, but they now represent a unique archaeological feature that is becoming rarer as each year passes. The rise and fall of ridge and furrow follows an all-too-familiar pattern of decline, but some still survive today, where the arable land was turned over to grazing. This is the case for the wonderful Woodsides Meadow in Oxfordshire, which now provides a niche habitat for many rare and threatened wild plants.

The meadow at Woodsides is draped over the ancient pattern of ridge and furrow which is still visible today, particularly in winter when the sun is low and the sward has been grazed short. These changes in topography are a result of medieval farming practices, ghosts from a time long ago when the area was extensively and contiguously cultivated. By the 13th century this type of cultivation covered the vast majority of the eastern Midlands. Ploughs of this period always turned the soil over in one direction and could not return along the same furrow. As a result, ploughing was carried out in a clockwise direction around long rectangular strips, thus creating ridges in the centre and associated furrows round the edge.

These strips demarcated land managed by different farmers and in many cases were also used for drainage.

Widespread enclosure of this open field system took place in the Tudor period, when arable fields were converted to pasture for sheep and the associated wool trade. It is impossible to know exactly when the land stopped being cultivated at Woodsides, but it is likely that it was at some point during this period.

Following the enclosure, for the subsequent five hundred or so years, a meadow has always been present at Woodsides. This continuous land use with little or no addition of herbicides or fertilisers is one of the reasons why wildflowers flourish here in such profusion, while elsewhere they have been lost from the landscape.

Meadows are also floristically diverse because the herbs that thrive there have evolved to cope with very precise hydrological conditions. While some species

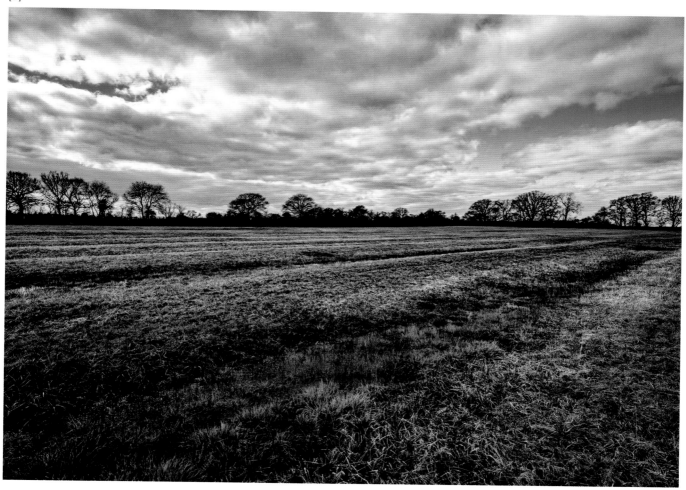

The meadow at Woodsides is draped over the ancient pattern of ridge and furrow, which is still visible today, particularly in winter when the sun is low and the sward has been grazed short.

can survive with being in damp soil all season round, others do better where the soil is drier. This difference is dramatically picked out by the ancient ridges and furrows. Plants such as brown sedge (*Carex disticha*) and creeping buttercup (*Ranunculus repens*) dominate the damper furrows. The higher and drier reaches support drifts of yellow lady's bedstraw (*Galium verum*) while the deep purples and magenta reds of great burnet (*Sanguisorba officinalis*), common knapweed (*Centaurea nigra*), betony (*Stachys officinalis*) and saw-wort (*Serratula tinctoria*) are interspersed with white patches of fluffy meadow rue (*Thalictrum aquilegiifolium*) and dropwort (*Filipendula vulgaris*).

The continuation of traditional management practices, experienced at Woodsides Meadow for hundreds of years, is essential in order to maintain the

hay meadow community. In a nutshell, this is a hay cut in early July followed by an 'aftermath' graze by cattle. Both of these activities remove nutrients from the system and thus reduce the dominance of coarse grasses, allowing the finer grasses and wildflowers to grow in profusion.

As an ecologist, meadows are deeply special for me – not only because they are home to a dazzling array of wildflowers, many of which are rare and under threat, but also because they create an uninterrupted link to our ancestors. Our forebears would recognise Woodsides Meadow and understand the importance of its management to ensure the long-term survival of both the habitat, their livestock and ultimately themselves. People were intimately connected to meadows in the past, so much so that Shakespeare noted:

The even mead, that erst brought sweetly forth
The frecked cowslip, burnet and green clover,
Wanting the scythe, all uncorrected, rank,
Conceives by idleness and nothing teems
But hateful docks, rough thistles, kecksies, burs
Losing both beauty and utility.
Henry V, Act 5, Scene 2

[3]

[4]

It is this link to the natural world around them that is critically missing for so many people today and is something that meadows can help to mend. I am lucky enough to be able to take my daughter to these amazing places and help her learn to love and understand the world in which she lives. But perhaps meadows can help all of us, by giving us the opportunity to immerse ourselves in a habitat so full of sounds, smells and colours that we can recharge our batteries and find inspiration for a nature-rich future. ❧

[1] Ridge and furrow grassland provides a range of niche habitats which at certain times become noticeable due to the different types of plant that take advantage of the conditions.

[2] The shallow furrows hold water during the winter. Although these channels are similar to those found in water meadow systems, they have been shaped by entirely different forces.

[3] Betony (*Stachys officinalis*) prefers to grow in dryish, light soils so is very at home on the well-drained ridges.

[4] The low-lying furrows provide an ideal habitat for plants that enjoy wetter, heavier soils, such as dyer's greenweed (*Genista tinctoria*).

[5] Speckled through the meadow in early summer are the charming jewel-like buds of saw-wort (*Serratula tinctoria*).

[6] Bird's-foot-trefoil (*Lotus corniculatus*) is the larval food plant for the common blue (*Polyommatus icarus*), green hairstreak (*Callophrys rubi*) and dingy skipper (*Erynnis tages*) butterflies.

[5]

[6]

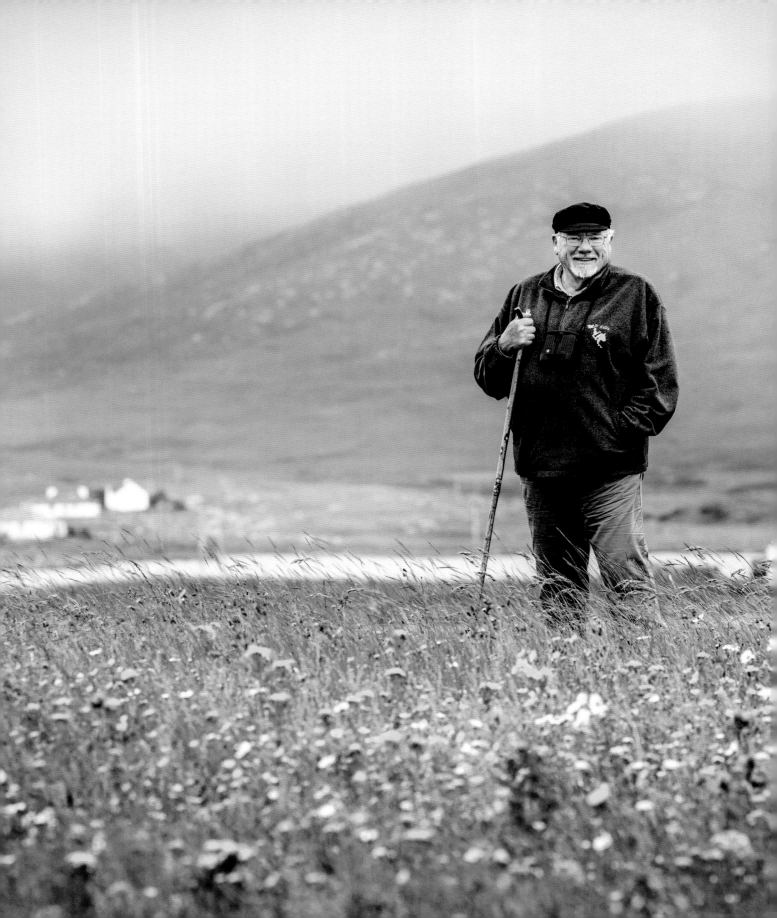

Magical machair

JOHN A LOVE
NATURALIST

When I came to Uist late in 1992 to work as Area Officer for what was then Scottish Natural Heritage, I began what was to become a lifetime's love affair with machair. I have lived beside it ever since. Generations of Gaelic bards have been celebrating the beauty of machair in their poetry. For example, John MacCodrum, who lived and worked in North Uist around 1750, composed *Smeorach Chlann Domhnaill*:

S I `n tir sgiamhach tir a`machair, tir nan dithean miogach daithe . . .

'Tis a beautiful land, the land of the machair, the land of the smiling coloured flowers . . .

But what exactly is machair? Reference to Edward Dwelly's classic Gaelic dictionary (1911) describes it perfectly – 'an extensive, low-lying fertile plain', expanding on this with:

> 'a long range of sandy plains fringing the Atlantic side of the Outer Hebrides. They are closely covered with short green grass, thickly studded with herbs of fragrant odours and plants of lovely hues.'

Machair is not just confined to the Outer Hebrides, of course, with other fine examples on the inner islands (especially Colonsay, Coll and Tiree), parts of the nearby mainland and places in Orkney, Shetland and the west of Ireland. Some has been recognised in the south of New Zealand and I have seen what might also be machair in the Falkland Islands.

In truth, we should not think of it as a single habitat. Many areas of machair might be damper, with some marshes, ditches and small lochans scattered throughout, not to mention the sand dune systems along the shore, perhaps even the sandy beaches too. But what makes the Uist machair extra special is perhaps the human contribution – crofting. Rotational cultivation of 'corn' (a mixture of small oats, rye and the old bere barley) adds to the mix – both by cropping (with all that it involves) and as fallow, even small potato patches. So perhaps it is better to think of 'machair' as not so much a single habitat, but as a mosaic of habitats.

[1]

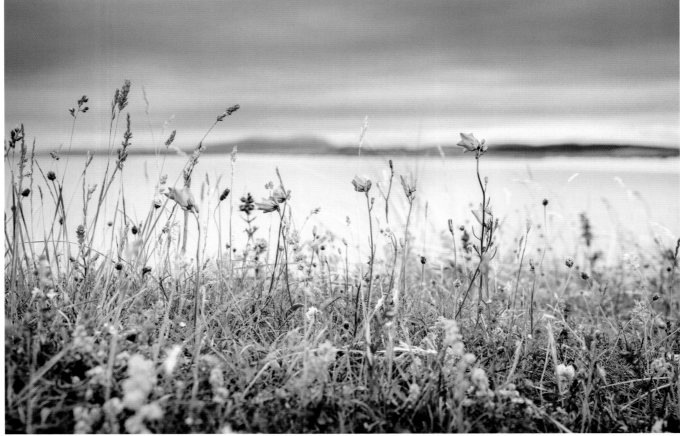

What excited me about machair from the outset was this interplay between generations of crofting and crofters with the flat, windswept landscape around them. The sand blown inland from the beaches and dunes is composed of crushed seashells and therefore rich in calcium. But the lime-rich sandy soils drain readily, lacking much humus, and are deficient in certain trace elements which modern cereals demand. So, in order to produce produce good crops, seaweed cast upon the shore in winter storms is applied before ploughing and sowing. Shallow, Cockshutt ploughs are best. The traditional corn mix grows short and stiff to withstand the winds and salt spray, so was harvested by hand or binders. Being grown largely as animal fodder, largely for cattle, what modern farmers might consider 'weeds' can be tolerated. Hence the flower-rich sward, ideal for a host of insects and nesting birds, producing a machair high in conservation value.

For a long time this ancient land use was low intensity and effectively organic. Even when I arrived in the early 90s this remarkable system was being encouraged (with payments for the continued application of seaweed for cultivation, altered mowing techniques and late cutting to encourage the disappearing corncrake, *Crex crex*). Crofters signed up for government subsidies in the form of a targeted Environmentally Sensitive Area Scheme. Some maintained that without it crofting would not have survived much longer. Uptake was high, while wildlife (and conservationists) continued to benefit too.

But times are changing. Sadly nowadays agricultural support seems to be nudging machair crofters into becoming farmers. Even the demand for beef and for cattle is declining, thus also their manuring effect that adds flower seeds and organic matter to the machair in winter. In too many places, perhaps, modern heavy

The machair has been retreating for centuries yet it still presents an astonishing spectacle, providing us with an amazingly rich and diverse ecosystem of high conservation value.

[3]

[2]

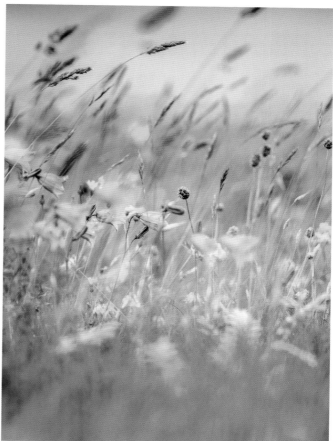

machines plough deeper, compacting the soil and restricting drainage; mineral fertilisers are replacing seaweed, even sprays are sometimes applied to clean out the weeds. Black plastic bags wrap the silage, cut earlier to the detriment of our corncrakes, corn buntings, skylarks, etc.

Where the islands once lacked ground predators – hedgehogs, American mink and ferrets, for example – these have been introduced and have prospered; as a result, the abundant ground-nesting waders, terns and wildfowl have declined. A notable exception is perhaps the resident greylag geese, once scarce and of great conservation interest but now, unfortunately, thriving on the crofters' corn, threatening continued cultivation. In nearly 30 years of living beside the machair, I have seen its conservation resource diminish.

And now there is the threat of climate change, increasing the frequency of storms and sea level rise, both promoting coastal erosion. Offshore kelp beds have long offered protection for the soft, sandy Atlantic shores and provide fertiliser for machair cultivation. As long ago as 1830 the distinguished naturalist and Aberdeen zoology professor William MacGillivray (brought up on Harris machair) recognised how marram (*Ammophila arenaria*) 'is the natural inmate of a sandy soil . . . [and] is therefore obviously the best

that could be selected for the purpose of fixing loose sand.' But it will be a losing battle, for the machair edge in Uist has long been in retreat. In 1756 houses in Baleshare, North Uist, were buried in blown sand up to their roofs. Indeed, the name Baile Sear means 'eastern town', which implies that there must once have been a western town, Baile Siar. The village of Hussabost mentioned in 1389 was said to have been washed away in the 15th century and is remembered only as a reef offshore, just west of Baleshare, called Sgeir Husabost. Local folk memory maintained that it was once possible to journey across to Heisgeir, the Monach Isles, by horse and cart.

The machair has been retreating for centuries yet it still presents an astonishing spectacle, providing us with an amazingly rich and diverse ecosystem of high conservation value. Much of it has been designated a Site of Special Scientific Interest (SSSI), Special Protection Area (SPA) and Special Area of Conservation (SAC), and a few as nature reserves. Not only that, crofting, and especially machair, has helped to sustain a successful, sympathetic and thriving rural population whose first language has always been Gaelic, which in turn is so rich in oral tradition, poetry, music and song. But maybe we should not ask 'What can the machair be?' but 'Where will it be in the future?' ❧

[1] The low-lying, fertile grassy plains of the 'machair' are a unique habitat that is one of the rarest in Europe; only occurring on the exposed, west-facing shores of Scotland and Ireland.

[2] The machair habitat is formed from lime-rich shell sand washed up thousands of years ago by the sea and blown inland by strong westerly winds.

[3] The machair is home to common flowers such as red clover (*Trifolium pratense*), thyme (*Thymus*), yarrow (*Achillea millefolium*) and harebell (*Campanula rotundifolia*).

[4] Machair is dominated by crofting, a traditional family farming practice carried out on small areas of land.

[5 AND 6] The machair is a windswept and hauntingly beautiful landscape.

[4]

For a long time this ancient land use was low intensity and effectively organic.

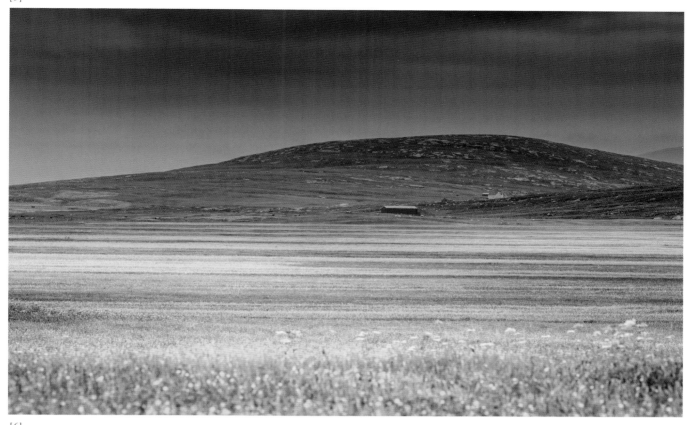

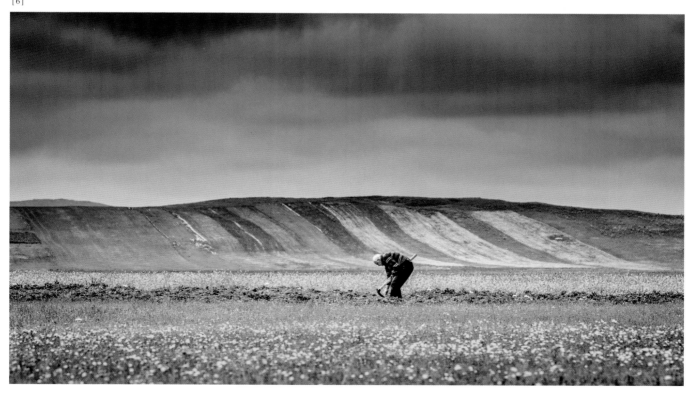

Nectar networks

KEITH DATCHLER, OBE
RETIRED FARMER

Having spent my working life in farming, several decades of it meadow-orientated, I did not think roadside verges would become a part of my life, but they have. I am a meadow nut – my wife says if I were cut in half, I would have 'Meadows' written through me like a stick of rock. Increasingly the push to save existing meadows, and create more species-rich, biodiverse grassland, has gathered pace. Thank heavens – they are basic in the story of human life, in ways people are only beginning to understand. We are a grassland species, still largely dependent on grasses of various types. Wheat (*Triticum* species), barley (Hordeum vulgare), oats (*Avena sativa*), rye (*Secale cereale*), rice (*Oryza sativa*) and maize (*Zea mays*), all staples to our existence still, and all types of grass. That said, we need to feed ourselves, and farms and farmers always rise to that challenge.

As a generalisation, not all farms can turn over large areas of land to conservation alone, although a sympathetic approach that touches our planet more gently is rising in popularity. Thankfully there are schemes that come and go, offering support to farmers if they embrace conservation within their farming practices. With this in mind, and the realisation that the surviving pockets of intense biodiverse value grassland are by design fragmented, what to do?

Obviously, look to the future and at land capable of supplying, or that might already be supplying, natural diversity. What is this and where is it? Parks, gardens, churchyards and other public green spaces are an obvious place to start – and roadside verges: all 200,000 hectares of them. Roadsides, although mostly little strips of grass, are everywhere. They are in the public view, by design linear and connective throughout the nation. I can hear the thinking, 'But they are individually so small there's nothing of them.' However, collectively they represent a simply massive land holding, and not a hectare of it used for food production. Therefore the impact on our agroeconomy is zero, the potential to increase diversity gigantic. All in the public domain.

Roadside verges are connective in the public eye and representative of every local soil type, geology and elevation. Plus, as they have always sat outside of agriculture, many represent fragments of meadow or the last stronghold of a species – be that plant or insect. The majority view is that short green grass is neat and tidy, a reflection of civic pride and care. Oh dear me, 'tidy' is a curse of nature. What is wrong with 'beautiful'? Long grass blowing in the wind, the tapestry of colour, banks alive with ox-eye daisy (*Leucanthemum vulgare*) and knapweed (*Centaurea nigra*) or even buttercup (*Ranunculus acris*). Even in winter, brown grass stalks covered in hoar frost or dripping with morning dew… it is a question of perception.

Until councils had flail mowers and all imaginable sizes and types of strimmers and petrol-driven mowers, we had free natural roadsides. These produced an abundance of insects, because left to grow to live its annual cycle of life, the grasses and other plants host

[1]

[2]

[3]

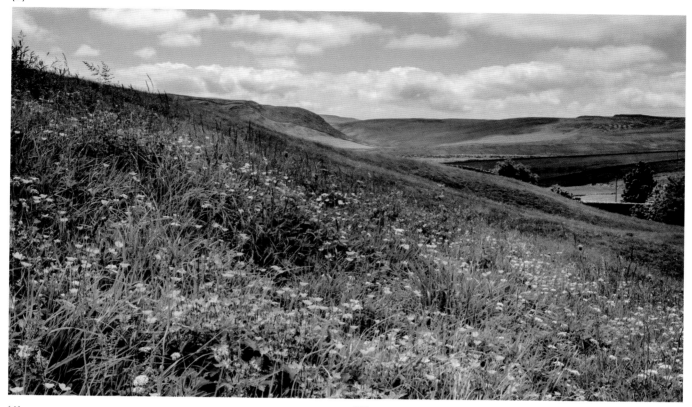

[4]

[5]

a myriad of insects that can also complete their life cycles; it is so obvious. All we have to do is stop mowing – please! An eye to safety must take precedence with junctions and sightlines maintained, but otherwise let it go, leave it free to nurture nature.

That is a basic first step. Opportunities exist for enhancing some verges where diversity has been lost. The introduction of good local provenance wildflower seed, for instance. Every species of plant is a host, often to a specific insect – the more variety of plants, the more variety of insects. Roadsides are also excellent sanctuaries for rare plants. One of our rarest plants, spiked rampion (*Phyteuma spicatum*), has a stronghold on a verge. Where safer for a rare plant than on the verges of the 'here to stay' M25? I would love to see more roadside verges designated reserves for wildlife.

There are many valiant local volunteer groups now adopting verges, applying good management and setting about enhancing where possible. Local authorities are listening and adopting better wildlife management strategies, as are highways regions. So take time to sit on your coat with a flask of tea and wonder at a verge full of early purple orchids (*Orchis mascula*) in spring. Lean on a betony bank in late summer, listen to the insect buzz. Lanes, by-ways and highways thread throughout the land; they are beautiful places and provide a 'side-drop' to our daily lives. So please join me in my quest to protect, conserve, enhance and celebrate this untapped grassland resource; there is much biodiversity to be extracted here. ❧

Roadside verges are connective in the public eye and representative of every local soil type, geology and elevation.

[1] Many local authorities designate roadside verges as special conservation areas. In East Sussex the areas are identified with a small yellow flower sign, which earmarks these areas for special conservation management.

[2] We are starting to see a resurgence of wildflowers on our roadsides as local authorities adopt a more sensitive management regime.

[3] Upland roadside verges hold a profusion of widespread species that are supplemented by a number of specialist plants including wood crane's-bill (*Geranium sylvaticum*) and globeflower (*Trollius europaeus*).

[4] Roadside verges are under considerable pressure due to priorities for road safety and budget constraints.

[5] Species-rich verges can bring the colour and character of the countryside back into our daily commute.

[6] Road verges support an amazing diversity of wild plants and animals. They often have archaeologically important old banks, ditches, hedgerows and ancient trees associated with them.

[7] Roadside verges are some of the UK's richest habitats, supporting over 700 species of wildflower – nearly half of our total flora.

[8] Flower-rich roadside verges are not only important for wildlife, but they also act as a beautiful 'side drop' to our everyday lives.

[8]

[7]

Living sanctuaries

HELEN PROCTOR
BOTANICAL ECOLOGIST

There are numerous burial grounds up and down the country, ranging from small village churchyards to large city cemeteries. For many communities, these wonderful havens for our native flora and fauna provide locally accessible green spaces to enjoy. Flower-filled meadows transform God's Acres into living sanctuaries. Bees buzz while seeking nectar from a myriad of colourful native wildflowers. Butterflies and many other insects and amphibians seek refuge in tall herbage. Burial grounds that have never been ploughed, chemically fertilised or drained offer the ideal opportunity to bring meadows into the heart of our communities.

From 2016, members of the Sussex Botanical Recording Society recorded plants in over 400 churchyards and cemeteries throughout East and West Sussex. An average of 104 native or established non-native species per site was recorded and sent to the Sussex Biological Record Centre.

I devised a list of species indicative of the unimproved grassland of traditional meadows, scoring them 1 to 3, with orchids scoring 3 as the most habitat-sensitive. The few churchyards showing high scores originated from hay meadow management in the Victorian era. Some medieval churchyards may have originated similarly, but traces of unimproved grassland rarely remain.

Some burial grounds have flowerless 'lawns'. Others have frequently strimmed grassland, where the mulched arisings (grass cuttings) enrich the soil as compost for vigorous plants to dominate. Some sites have so-called 'conservation areas', where lack of any management encourages tussocky grass with few flowers.

Intensive farming has led to the demise of traditional meadows. However, I believe that meadows in burial grounds can be restored or created to reverse the loss. Burial grounds commemorate the deceased, but can also celebrate life. With open access, close to communities, anyone can find solace and experience the natural world in churchyards and cemeteries, as well as helping our beleaguered pollinators.

A meadow can simply define an area where plants are allowed to flower and set seed. Ox-eye daisies (*Leucanthemum vulgare*) and meadow buttercups (*Ranunculus acris*) will abound even in fertile soil. How much more rewarding, though, to create a meadow that mimics a traditional hay meadow or chalk downland with diverse flowers and insects.

The challenge is to maintain low soil fertility by removing the growth following late summer cutting. Limited space and uneven ground renders farm machinery and domestic lawn mowers unsuitable. The cost of removing the vegetation by contractors may be prohibitive. However, churchyard management provides a perfect opportunity for volunteer involvement.

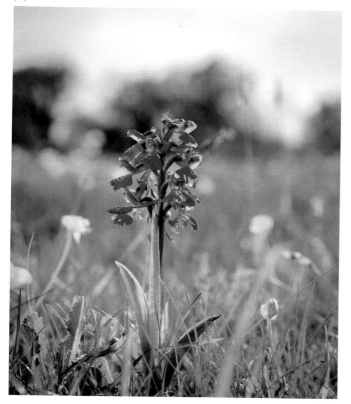

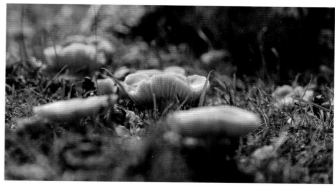

Burial grounds that have never been ploughed, chemically fertilised or drained offer the ideal opportunity to bring meadows into the heart of our communities.

Burial grounds can be 'green deserts' or oases of colour and aerial activity.

I have experienced conservation management in various sites. The vicar of a medieval church asked me to write and present a management plan to the church's Friends group. Following local consultation, plants were allowed to flower and set seed before cutting in late July or September. Local residents came, armed with scythes, strimmers and rakes. Surplus hogweed (*Heracleum sphondylium*), docks (*Rumex*) and stinging nettles (*Urtica dioica*) on the enriched soil were controlled. When blackthorn (*Prunus spinosa*) was dug out, the soil disturbance prompted a profusion of ox-eye daisies to germinate. Burnet saxifrage (*Pimpinella saxifraga*), meadow vetchling (*Lathyrus pratensis*) and bird's-foot-trefoil (*Lotus corniculatus*) followed. Locally sourced yellow rattle (*Rhinanthus minor*) has reduced grass height. Long grass left elsewhere shelters amphibians and overwintering invertebrates.

Some parishioners disliked seeing tall plants in seed, perceiving the appearance as 'untidy'. Compromises were made, such as maintaining short grass by the main path and visited graves. Ongoing publicity in the village

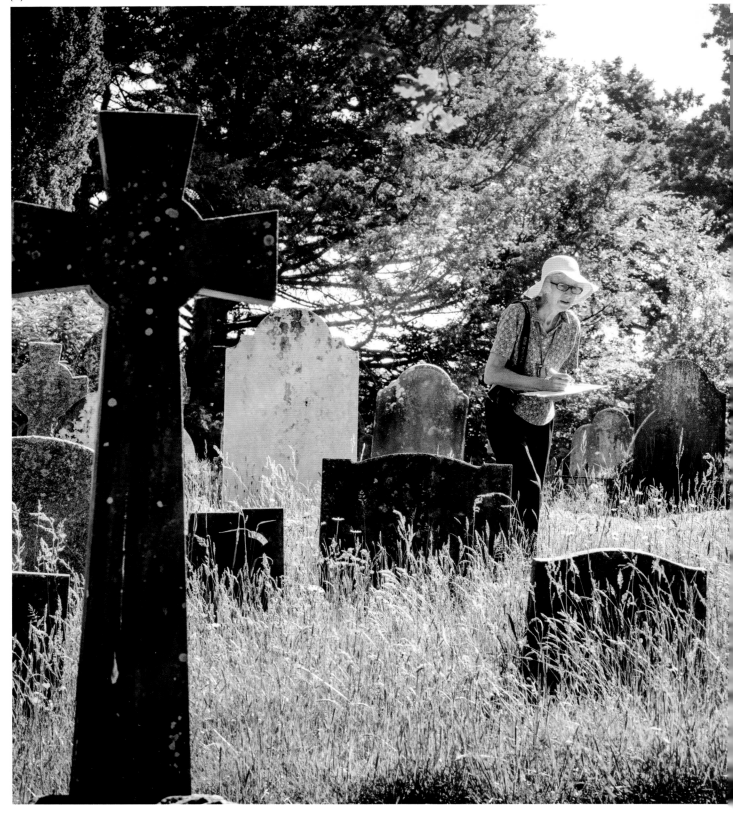

magazine has expelled opposition. Moth trapping events have involved parishioners, who heard a turtle dove (*Streptopelia turtur*) churring on one occasion.

Meadows in burial grounds, nationwide, bring the natural world closer to communities. Engagement with the creatures that share our planet can bring greater understanding of their value. Flower-filled meadows support pollinating insects and provide solace for us. The initiative and commitment of clergy and parishioners who support nature conservation make all this possible. Burial grounds can be 'green deserts' or oases of colour and aerial activity.

[1] Churchyards are home to an abundance of wildflowers, including the ubiquitous ox-eye daisy (*Leucanthemum vulgare*).

[2] Avoiding the use of chemical fertilisers or pesticides has enabled the ancient swards of burial grounds to evolve a rich and varied flora.

[3] Burial grounds provide a refuge for many rare and threatened species, including the jewel-like green winged orchid (*Orchis morio*).

[4 AND 5] In autumn churchyards and cemeteries are speckled with the vibrant colours of bizarre, beautiful and seldom seen wild fungi, including waxcaps (*Hygrocybe*), fairy clubs, spindles (*Clavaria*) and earthtongues (Geoglossaceae).

[6] Monitoring and recording the changes in species diversity in churchyards and cemeteries can inform local management decisions in how the grassland flora is conserved.

[7] It is sometimes difficult to cut and remove the annual growth within burial grounds, so the addition of yellow rattle (*Rhinanthus minor*), a semi-parasitic grassland annual plant, helps to keep many of the more dominant grasses in check.

[7]

'Art is the Flower – Life is the Green Leaf. Let every artist strive to make his flower a beautiful living thing, something that will convince the world that there may be, there are, things more precious more beautiful – more lasting than life itself.'

CHARLES RENNIE MACKINTOSH

Inspire

Meadows have long whispered inspiration into the hearts and minds of painters, poets and other discerning artists. Over the centuries portraits of haymaking and scenes of scything have been committed to canvas, woven into great tapestries and celebrated in prose, song and dance. With people placed prominently in the picture, such musings illustrate the value that artists attached to meadows as communal spaces where rural folk gathered to work, rest and play. Cultural observations portrayed in paintings from yesteryear provide an interesting comparison with the more environmentally focused artwork of today. Inevitably this subtle shift in creative emphasis prompts reflections on the changing relationship between people and their local landscape.

Meadows manifest a beauty of colour and form that artists find appealing on many different levels. Botanical illustrators, for example, are drawn to the small-scale world of wildflowers. By using the power of observation, these highly skilled artists blend elements of art and

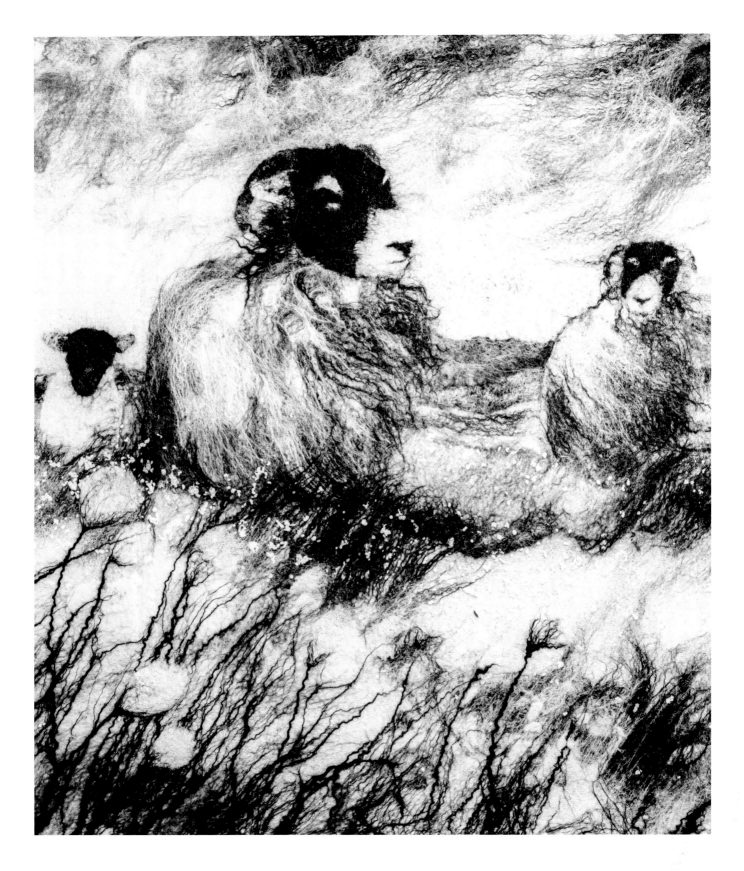

science in order to magnify the intricate details of plant morphology. Other artists find the art of foraging provides a constant source of inspiration. In the right hands, natural materials found in the meadow sward, such as sheep fleece and plant fibre, can be used to fashion craftwork that interweaves beauty with utility.

There are many wonders of the natural world, but few landscapes inspire more artistry than the beautiful design of a classic hay meadow. In the fight to save the significance of our ancient grasslands, art has an increasingly important role to play. The power of art can help to open our hearts and minds to new ways of tackling biodiversity loss by turning reflection into action. By working together, artists can harness the force of creative expression to help us imagine a more colourful future for our wildflower grasslands.

Meadows have long whispered inspiration into the hearts and minds of painters, poets and other discerning artists.

Observational art

ANITA BARLEY
BOTANICAL ILLUSTRATOR

Am I a botanical artist or a botanical illustrator? The body of my work would suggest both. While I have sometimes blurred the boundaries, all of my works share an emphasis on careful observation and a faithful depiction of form and detail so that a plant can be identifiable to species level. That said, throughout my career, whenever the opportunity has arisen, I have always aimed to produce 'artful' illustrations that present an approach that balances aesthetic interest with scientific accuracy.

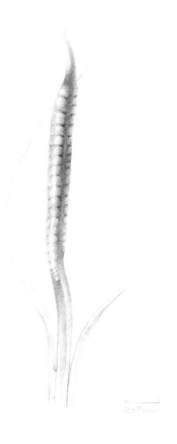

My illustrative approach, gained through decades of working alongside scientists within herbaria, requires a constant process of comparison and contrast (Are the leaves bigger? Are the stems hairier?). I came to settle in the UK from Australia nearly eight years ago, and from the standpoint of being a 'newly introduced variety' I am continuing the process of comparison – observing the British flora, the landscape the weather, the culture, the language and so forth.

Botanical illustration is a universal language by virtue of its conventions: the use of a pale coloured and generally empty background, the single light source casting no shadows and, most commonly, the use of pen and ink or watercolour. However, on closer inspection the works always reflect the social, cultural and historic sources from the artists' origins. Conventions used in scientific documentation have acted to distance the artist from a personal engagement with the subject matter by frequently removing it from its natural context.

In scientific environments, the botanical illustrator works from a dried and flattened herbarium specimen not of their own choosing, most often to produce a plate to accompany and support a scientific paper. However, painting the adder's tongue fern (*Ophioglossum vulgatum*) from the meadowlands in the High Weald of Sussex where I could walk, experience the environment sensorially, make drawings and colour notes and see the subject in situ allowed a level of personal engagement

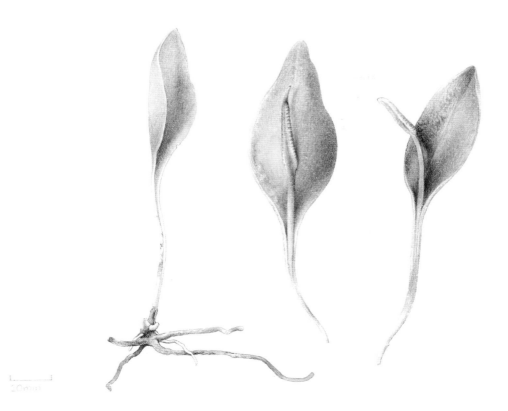

Botanical illustration is a universal language by virtue of its conventions.

The emphasis of botanical illustration is on science rather than visual art.

not often afforded people working in my professional field. I have been able to become involved with the subject matter in a relationship that defies the usual requirement of scientific detachment.

As an 'outsider' I have limited experience of the flora and ecology of the meadows of the British Isles, but in my depictions of the Australian flora I became familiar with its counterpart in the grasslands and open woodland of the south-east of that continent. These environments had been 'managed' for around 60,000 years by Australia's indigenous peoples; they used low-intensity fires in a technique now labelled 'fire-stick farming'. The purpose was to encourage new growth of food plants and for forage plants to sustain

native animals that also formed part of their diet. In these meadowland equivalents, the Australian species of adder's tongue ferns are distributed widely, and it was there that I portrayed them for the *Flora of Victoria* in 1990. It is serendipitous to meet its British cousin in the meadowlands of the High Weald, and to understand that meadows in this country have also been managed over many centuries to sustain their species-rich diversity and habitat value.

From a personal story of lifelong inspiration and creative fulfilment, I am increasingly aware that plant-based art forms have become more widely relevant as humanity feels the urgent need to address human–plant relationships in light of threats to ecosystems. The evolution of new philosophical perspectives and research is interwoven with changes in the botanical illustration world; where once they recorded the taming, naming and utilisation of nature, an illustration now may record and preserve the image of an endangered species in perpetuity. A professional passion has become a responsibility, and empathy for the subject matter – in this instance the adder's tongue fern – is important not only on a personal level, but also as a way to increase awareness of the importance and fragility of the meadowland habitat. ❧

[1] The skill of a botanical illustrator is not just to look, but also closely to observe and then to translate accurately what they see and feel onto canvas.

[2 AND 4] The emphasis of botanical illustration is on science rather than visual art, although most illustrations, particularly these, are pleasing to the eye.

[3] The handling and use of colour helps to draw attention to important taxonomic detail, aiding study and identification.

[5 AND 6] The striking appearance of adder's tongue fern (*Ophioglossum vulgatum*) makes it an interesting muse for a botanical illustrator to paint.

I am increasingly aware that plant-based art forms have become more widely relevant as humanity feels the urgent need to address human–plant relationships in light of threats to ecosystems.

Anita Barley 2021

Heartfelt landscapes

ANDREA HUNTER
FELT ARTIST

I am privileged to live and work in our beautiful upland landscape of meadowlands, fells, hay barns and drystone walls. I suppose one could say I have imbibed my surroundings. Meadowland is a particular and precious imaginative resource, and I feel that living within this colourful landscape has given depth and authenticity to my artwork. My experiences of local meadows help me to conjure their distinctive botanical character in my work – swathes of mown meadow grass scenting the air, a myriad of nutritious grasses and an abundance of wildflowers, such as yellow rattle (*Rhinanthus minor*), clover (*Trifolium* species), meadow buttercup (*Ranunculus acris*), ox-eye daisy (*Leucanthemum vulgare*) and knapweed (*Centaurea nigra*) and meadowsweet (*Filipendula species*), as well as numerous species of orchid growing on the sides of uncut riverbanks.

Meadows embody the passage of time; wistful in nature, they serve to keep the memory of the people who toiled in their productive swards alive. A rich community of life ran alongside 'hay time' involving people from the local villages, including their relations, who often provided a welcome helping hand. This historical context provides an emotional dimension to the landscapes that surround me and consequently influences my creative direction. The vagaries of the weather were always an important consideration when deciding when to cut the hay and this is still the case, although to a lesser extent in our mechanised world. The warm sun and a good breeze made nutritious sage-green hay – dry with much goodness – but rain and gloomy skies were cause for concern. I find that the weather in all its variety feeds the creation of atmosphere in my artwork, as I observe the sky and the clouds.

My depiction of Swaledale sheep in the landscape is inspired by knowledge of their hardiness and observing how the elements – rain, snow, sun, wind – affect their behaviour, posture and appearance; to me they embody a resilience drawn from the meadowlands and fells where they live. While the passage of time inevitably brings change, much of the meadowland in the upland valleys remains unyielding. Farming practices may well have moved on, and as a result meadows have lost some of their botanical variety, but recent conservation schemes have started to reverse this trend, ensuring that these enigmatic grasslands retain the power to whisper their stories of the past and to shout out for the future. ✑

[1] By skilfully applying the principles of drawing and painting to fine layers of wool, Andrea captures subtle tones and colours in a meadow of extraordinary light and depth.

[2] Felt is a malleable and durable material that in the right hands can be transformed and manipulated into three-dimensional shapes with an organic form. Applying vigorous rolling to the wool image results in it being permanently bound and transformed into a durable felt picture.

[3, 4 AND 6] The alchemy of Andrea's felt making brings together traditional techniques with a contemporary style that captures the authentic nature of meadowland.

[5] Andrea's journey is ongoing, winding through new ways of seeing and old ways of understanding, but will always engage with the wild and beautiful places of her home.

While the passage of time inevitably brings change, much of the meadowland in the upland valleys remains unyielding.

[3]

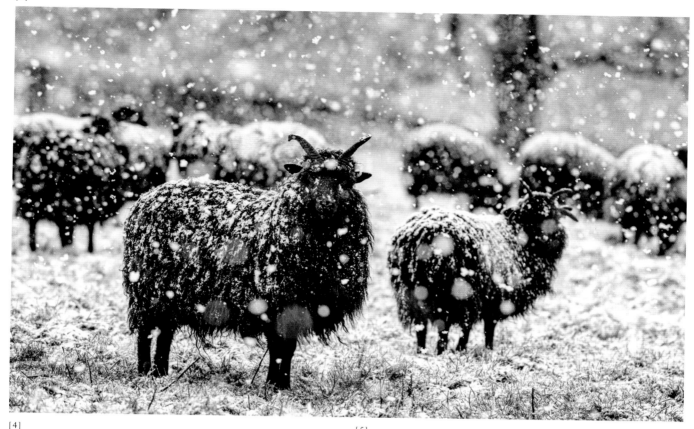

[4]

[5]

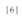

[6]

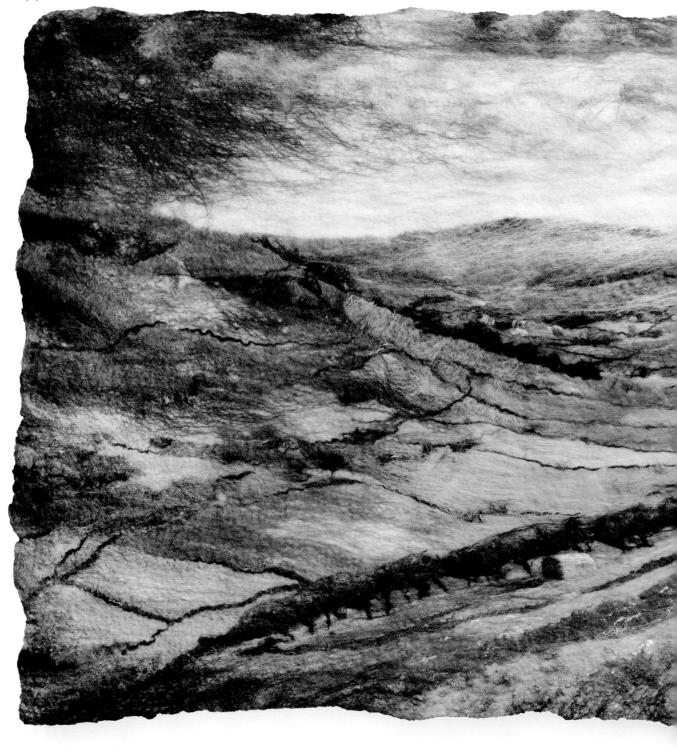

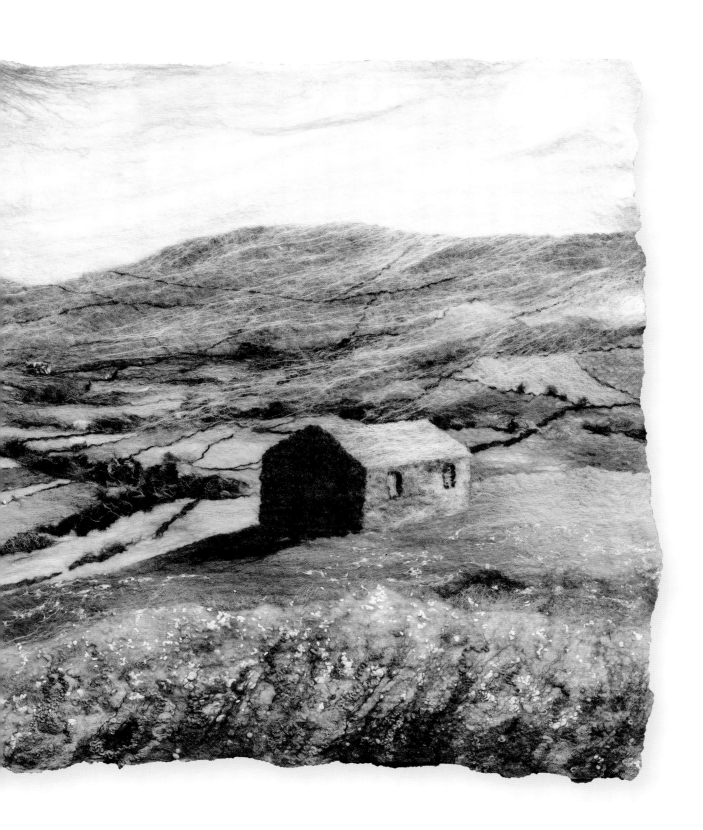

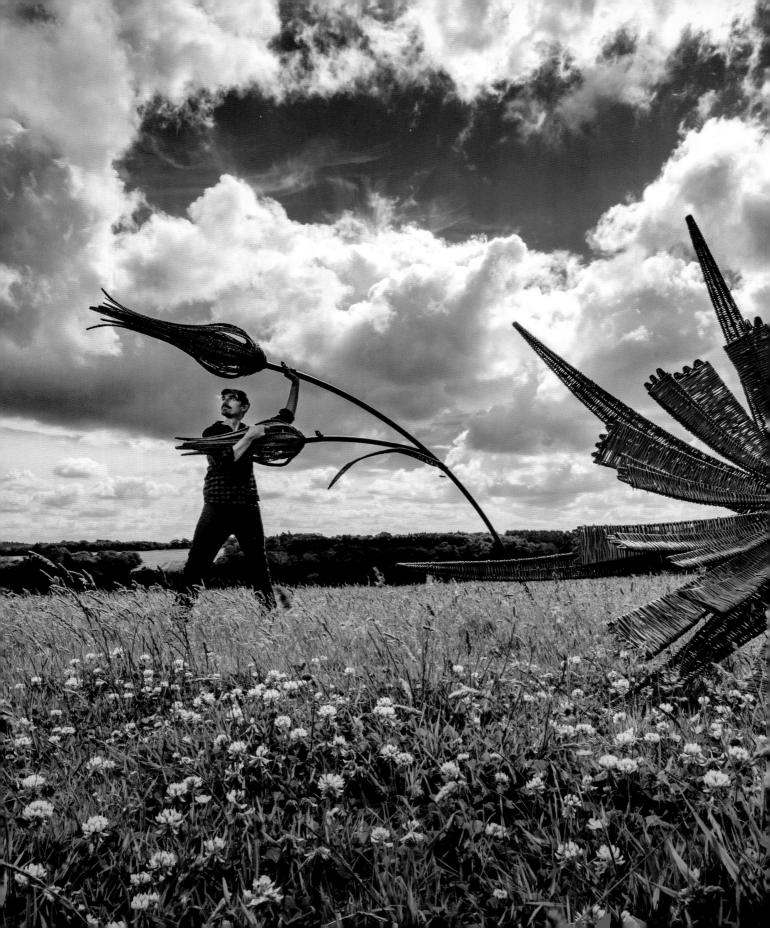

Weaving inspiration

TOM HARE
WILLOW ARTIST

I was first drawn to willow as a creative material for its spontaneity. The ability to manipulate its long slender stems into all manner of shapes and forms, with instant results, contrasted to my earlier experiences, when I used other mediums to express my creative thoughts. Some years on, the scent of drying willow fills the workshop each spring to punctuate the year, as the stems season from their winter cut green state. Willow is a truly remarkable plant, a perfect example of a sustainable material.

My current practice includes sketching with pen and ink, making marks and teasing out a sense of the chosen study. From here, I move to model making, specifically for any large armatures that then will require problem-solving and fabricating. The final skin and texture of the sculpture is woven onto a steel frame, often one stem at time, suggesting the movement and sinuous lines of the original sketch.

This process is almost meditative and very time-consuming, selecting the appropriate stems and intuitively creating tension in the form – techniques that I have developed over the last 20 years. Willow has its own character with evocative qualities. Through time an understanding of this develops which, together with a bundle of patience, is woven into the final creation.

My sculptures have been described as 'woven observations', largely scaling and magnifying details found in the natural landscape. Wildflowers are a wonderful source of inspiration, each with their own unique character. From stem and leaf to flower, then finally seed head and dispersal, they are often identified by common names and referred to in folklore with a hint of magic. Goat's beard (*Tragopogon pratensis*) has all these qualities; to witness this in a meadow at eye level is spectacular, and yet often overlooked. So a sculpture scaled 15 times larger in willow can draw attention and celebrate these smaller details.

Goat's beard is a very attractive wildflower – it has a wonderfully fluid form that lends itself to the malleable qualities of willow. While researching this plant before starting to sketch, I found that it has a very unusual trait of opening its flowers at daybreak but quickly closing them again before noon, giving rise to its other common name of 'jack-go-to-bed-at-noon'. Goat's beard is a classic biennial plant; it produces only a rosette in the first growing year and completes its life cycle by flowering and setting seed in the second – the stunning seed 'clock' is well worth the wait. Once the sculpture has settled into the landscape it will mellow over time, reflecting the ephemeral nature of this charming little plant. ❧

[1] The flower head of goat's beard is surrounded by very distinctive bracts, but it can still elude sleepy-headed botanists because it only blooms in the early morning.

[2] Goat's beard is also called 'shepherd's clock', a reference to its remarkable seed head.

[3] The malleable nature of willow presents an artist with endless opportunities.

[4] The finished sculpture challenges our perception of scale in the landscape.

Wildflowers are a wonderful source of inspiration, each with their own unique character.

At Beauty's glance

ALUN HESLOP
ARTIST/DESIGNER

It is one thing to have an idea in one's mind of a form through a sense of movement; it is another thing altogether to be able to translate that concept into a manifest reality. Where do you begin? It is always a journey when you attempt to stitch the threads of interconnectivity together. Sometimes this process can feel obvious, rich and varied, at other times much more subtle and yet still far reaching. Within the landscape of invention, one is always aware that change is the only constant.

I am an artist and designer and have principally specialised in the design and creation of sculptural chairs and seating that sit perfectly within their surroundings. I was asked to create the seating scheme for the Coronation Meadow at Wakehurst, Kew's wild botanic garden. The design aimed to allow pause for thought, a place to rest and perhaps contemplate the wonder and interconnectedness of the surrounding meadow. A journey of seven seating pods flows down through the meadow into the valley below, each carrying the rhyming couplets of the poem 'Leisure' by W.H. Davies, a favourite of former Director of Wakehurst, and inspiration to all, Andy Jackson.

The poem read through the meadow landscape helps us to carry that thought and create a space to reflect upon our own curiosity and the importance of our interactions. We may perhaps reflect on the vibrant richness and diversity woven within the geographic microclimate of the location, allowing appreciation of what is within and around us, each a ripple of space and time in gentle contemplation and joy, as we travel through our lives without moving.

The placement of each pod allows a dialogue with others or offers a space just to sit and to be in the moment. Created from oak wood for its naturally durable longevity, weathering to harmonious silver grey through the seasons, each pod has carefully carved fluid waveform seating hollows for comfort; each also has gap set joints, allowing rainfall to easily drain off. Much of the wood was sourced directly from the Wakehurst woodlands, which appear almost in touching distance across the valley and adjacent hill line.

We are of course part of the nature around us. It is not something separate from us to merely gaze upon, tread or thrust unwittingly within. We create it through our own conscious being, and in order to thrive we must balance and harmonise within our own local and wider reaching environments. The life of a meadow is an example of the web and threads of mutual dependence as time runs through the ever-changing seasons. ଔ

[1]

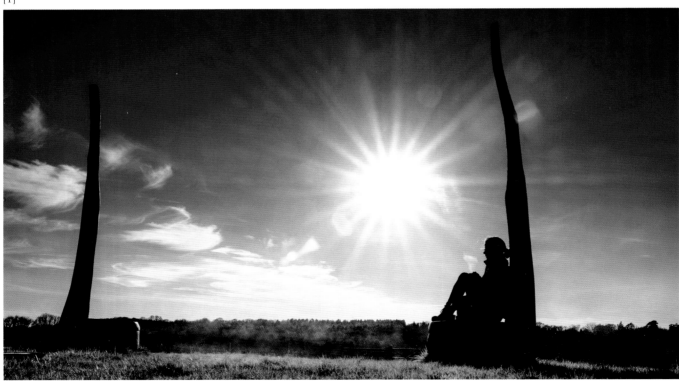

Within the landscape of invention, one is always aware that change is the only constant.

The life of a meadow is an example of the web and threads of mutual dependence as time runs through the ever-changing seasons.

[1] The seating pods provide a perfect resting point from which to admire the beauty of the meadow landscape.

[2] In skilled hands a spokeshave is the ideal tool for shaping and smoothing wood.

[3] The words of the poet W.H. Davies provide a salutary reminder of the importance of living in the moment and slowing down to appreciate natural beauty.

[4] In the past, shave horses were used by basket weavers, chair makers and coopers as a form of clamp to firmly hold pieces of wood.

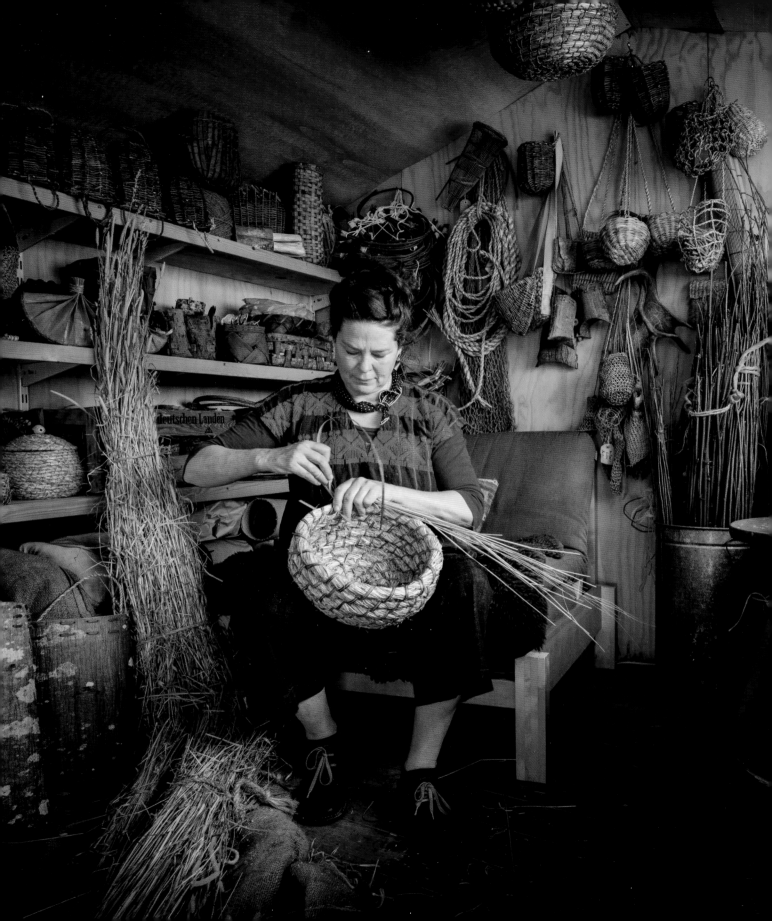

Threads of connectivity

RUBY TAYLOR
NATIVE HANDS

My studio smells like a hay meadow after rain.
I am making a series of grass baskets, and the
dampened material lies wrapped in hessian on
my workbench. I am thinking about the field
margin under the ancient oak near where I
live in Sussex, on chalk, where I foraged these
grasses. It is a favourite place for harvesting
because it is so species-rich. It has probably
never been cultivated and the grasses grow tall,
which is what I need. Like the haymaker, I time
my harvest of grasses to the rain, sun, wind and
the setting of the seed.

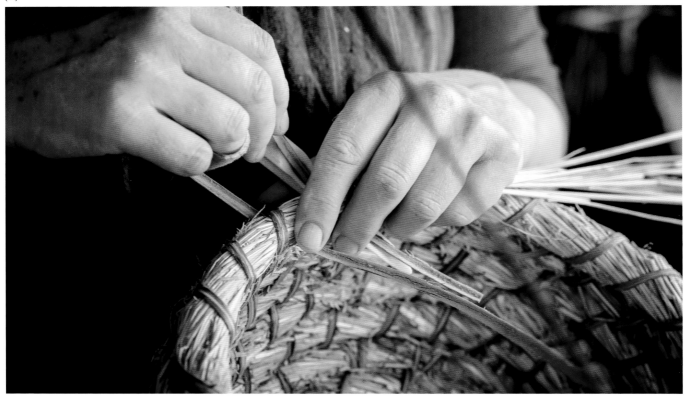

My father tells me about the permanent, uncultivated meadows on the family farm in South Oxfordshire, and how in the late 1940s only about 50 acres were left after the compulsory ploughing up and draining of land for food production during the Second World War. He describes wandering through the remaining meadows with his sister, my aunt, identifying many wildflowers, and recalls the hares, lapwings, plovers, larks and partridges that all relied on the meadows.

The armfuls of grass I cut give off a sweet scent. I have found my preferred ones, Timothy grass (*Phleum pratense*) and red fescue (*Festuca rubra*), although I cut others as well and a few meadow flowers are in among them: purple milk vetch (*Astragalus danicus*), knapweed (*Centaurea nigra*) and black medick (*Medicago lupulina*). It has taken time to discover which grasses yield useful fibres and to find places where they grow abundantly. Over time, on regular routes of travel and wanderings near where I live, I have developed a mind map of the places I harvest from, a map that continues to evolve.

Somewhat like the basket making itself, foraging the plant materials is an activity that has its own rhythm.

You cannot be in a rush. It is a relationship that evolves: observing which grasses grow where; recognising the various soil and weather conditions that influence this; noting growth varies year to year. I notice what else grows nearby, becoming familiar with the communities of plants.

There are often times when I cannot harvest what I went out for. Sometimes the plants in a particular place have not flourished, so I do not take them. Sometimes landowners change how they manage the area, cutting grasses early, and there is nothing there for me to gather.

In the studio I bind these grasses into baskets in the traditional way, with split bramble fibres and a tool called a fid. Settling into the rhythm of making that my hands know well, I remember the meadow I sat in last summer, the insects and flowers, the call of raven and buzzard overhead. The old oak under which these grasses grew comes to mind; and a hay meadow at dusk from my teenage years, with pale moths and the sweet scent of dew-damp grass. I always harvest with sustainability in mind; cutting after the seed has set, never clear-cutting an area. Always considering future years and other creatures, always with gratitude. ❧

[2]

[3]

[4]

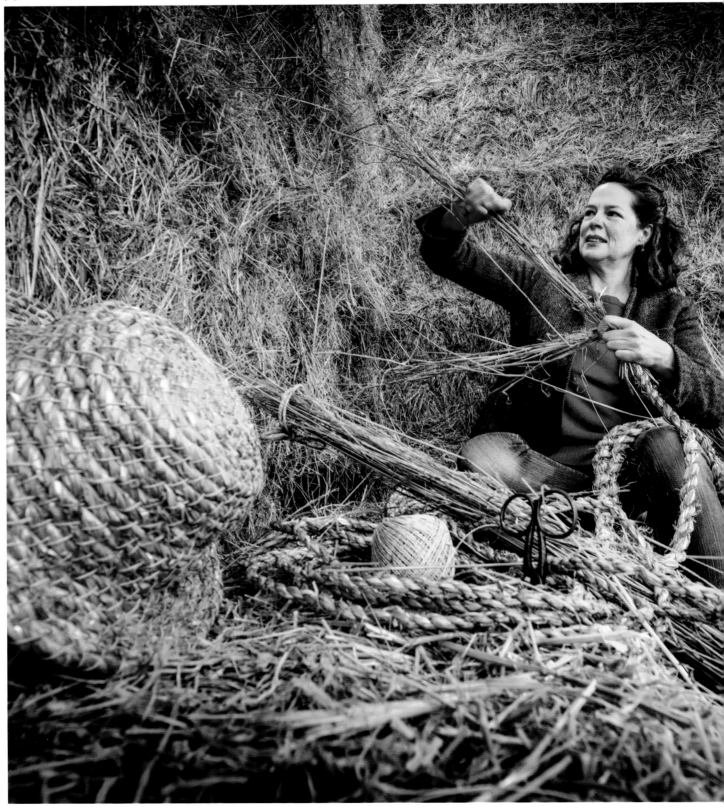

[1] Twisting and binding the long, strong and flexible plant fibres.

[2] A pair of scissors and a 'fid': the only tools needed for this type of basket making.

[3] The origins of basket making are entirely rooted in place, the techniques developed from local plants and their characteristics.

[4] Plant fibres offer a wide range of possibilities for basket making.

[5] Dried grass cut from the meadow gives flexible fibres; the baskets made from it are tactile and fragrant.

Like the haymaker, I time my harvest of grasses to the rain, sun, wind and the setting of the seed.

Somewhat like the basket making itself, foraging the plant materials is an activity that has its own rhythm.

'Study Nature, love Nature,
stay close to Nature.
It will never fail you.'

FRANK LLOYD WRIGHT

Value

Meadows underpin our lives in more ways than at first you might imagine. Recent studies, for example, reveal the essential role they play in capturing carbon and providing naturally engineered solutions to the threat of seasonal flooding. Meadows also provide us with healthy soils, fresh air to breathe, clean water to drink and open green spaces for relaxation and exercise. Moreover, the myriad insects they support help to pollinate wild plant populations and agricultural crops, as well as providing a natural pest regulation service.

Whether we recognise it or not, we all profit from the ecosystems of sustainably managed grasslands. Being invisible to the naked eye, however, the flow of services they provide can appear abstract and far removed from our daily lives. Fortunately, grasslands go beyond just providing products and helping to regulate natural processes. They are also rich sources of inspiration and can help to keep us happy and healthy. Spending time in the company of wildflowers is not only a proven remedy to

counter the stresses and strains of modern life, but also has the power to stimulate the senses and soothe the soul.

Meadows are generous in the rewards they make to society, yet in spite of their obvious beauty and utility we continue to take them for granted. While considerable controversy surrounds the merits of placing a monetary value on nature, if we want to reverse biodiversity loss then business as usual is not an option. By calculating the financial benefits that nature provides, we can better argue the case for investing in a more sustainable future. With meadows and the wildlife they support fast disappearing from the landscape, it is more important than ever for us to appreciate the value they bring to our lives before we start paying the price.

Meadows are generous in the rewards they make to society, yet in spite of their obvious beauty and utility we continue to take them for granted.

Water regimes

PROFESSOR DAVID GOWING
PROJECT DIRECTOR
FLOODPLAIN MEADOWS PARTNERSHIP

Water is a key factor in shaping the character of meadow plant communities. Fluctuations in water level through the year influence both the vegetation and its management. Floodplain meadows, for example, usually flood in the winter and spring, giving us beautiful 'silver meadows' covered in shallow water. The timing, frequency, depth and duration of flooding varies from year to year, as does the depth to the water table in summer, when evaporative losses dominate. The water regime changes constantly, sometimes subtly, sometimes dramatically; however, the characteristic plant communities of floodplain meadows are beautifully adapted to their dynamic environment.

Meadows lie dormant under winter floods, conserving resources for when the flood recedes, while their deep roots allow them to sustain growth even during periods of drought. Each species has its own strategy to cope, every one of which is slightly different. The random variability of the water regime from year to year regulates competition between species and thus promotes the amazing diversity of the meadows. Farming communities have carefully husbanded floodplain meadows for centuries, as they were often the most productive land on the farm. Ditches and gutters were created and regularly maintained to convey floodwaters rapidly back to the river; this is because prolonged flooding in summer leads to a lack of oxygen in the soil, killing the finer grasses on which a good hay crop depends.

Plants need water to grow, but their roots also need oxygen. Good meadows require a well-structured soil whose pores can hold both air and water simultaneously and allow these resources to flow. In shallow systems fed by groundwater, water moves up from the aquifer below during summer to replenish water lost by evaporation,

then drains back downwards in winter following rainfall. Water can also move sideways into the meadow, flowing between river and ditches. In these situations water movement is determined by the height of water in the river, while its speed is controlled by the permeability of the alluvial soils. The snake's head fritillary (*Fritillaria meleagris*) thrives in such situations. It requires periods of winter flooding followed by rapid drainage in spring. The seeds can even germinate on water, helping to spread the plant around floodplains. There are still lovely examples of such meadows at Oxford on the Thames and Huntingdon on the Great Ouse.

Ditch-drained systems such as Pevensey and Gwent Levels, as well as the Somerset Levels and Moors, are common on peat soils. In winter and spring water drains to the ditches, while in summer and autumn, with ditches held high to act as wet fences, water flows back to the fields. These systems rely on the soil being open and porous, so damage from compaction or over-draining must be avoided. Ridge and furrow meadows tend to have free-draining soils over impermeable

[1]

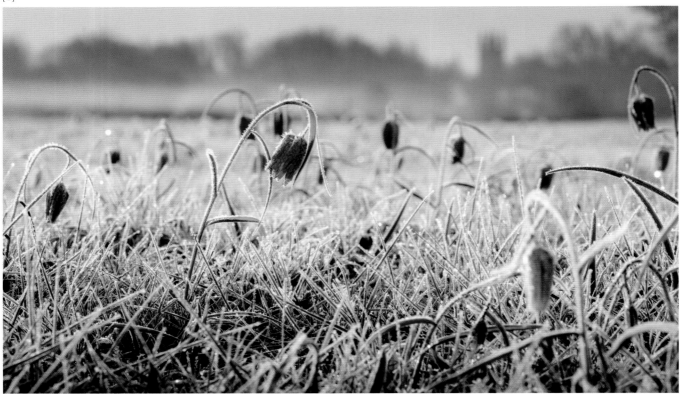

Water is a key factor in shaping the character of meadow plant communities.

Good meadows require a well-structured soil whose pores can hold both air and water simultaneously and allow these resources to flow.

subsoil. Small differences in topography, for example a 20-cm difference between the top of a ridge and the bottom of a furrow, can sustain very different plant communities. Cowslips (*Primula veris*) and green-winged orchids (*Anacamptis morio*) flourish on ridge tops, while marsh orchids (*Dactylorhiza incarnata*) and lady's smock (*Cardamine pratensis*) thrive in the wetter furrows. Examples occur on the River Ray in Buckinghamshire and the River Wampool in Cumbria.

Water meadows also have a ridge-and-furrow structure, but the engineering of their hydrology has been taken further. They were created in the 17th and 18th centuries to promote the productivity of floodplains. Water was deliberately diverted from rivers to flow through the meadows in small channels along the ridge tops, cascading down the ridge sides, or panes, to be collected in the furrows and efficiently returned to the river downstream. The timing of these artificial flood events allowed managers to regulate the delivery of both sediment and water to the soil, boosting its productivity. Plants are fantastic indicators of soil water regime. For

example, the bulbous buttercup (*Ranunculus bulbosus*) tolerates drought, whereas the creeping buttercup (*R. repens*) copes with waterlogging and the meadow buttercup (*R. acris*) dominates the zone in which neither stress is common.

The floodplains of Britain have been greatly altered over the centuries by river engineering and water management. Few, if any, are truly natural. Many have been straightened, widened, deepened and embanked, the net effect being to disconnect the river from its floodplain. This process has led to the demise of meadows and other habitats of high nature value. Our challenge is to repurpose floodplains such that they can again support beautiful landscapes and provide useful services. Around 45 per cent of our rivers are no longer connected to their floodplain. Over 70 per cent of floodplain land is under intensive agricultural management. There is therefore enormous potential to restore these systems to produce nutritious food while regulating floods, benefiting both people and wildlife.

Growing up on a farm, I was surrounded by plants and became absorbed by them. I earned my pocket money by selling vegetables I grew in a field corner and I studied botany at university with the intention of making a career in agricultural research. I became fascinated by how sensitive plants were to the availability of water and I started my research career designing irrigation systems and considering water management. While working on a project for river engineers, I encountered floodplain meadows for the first time. Their diversity was breathtaking, nothing like the meadows at home where I had learned to make hay. My academic interest was piqued by how so many species can coexist when ecological theory suggests the species best adapted to the conditions should be able to exclude competitors. ଔ

[3]

[4]

[5]

[6]

[1] Floodplain meadows are home to a variety of moisture-loving plants such as great burnet, the nationally scarce narrow leaved water-dropwort and the iconic snakeshead fritillary.

[2] Meadows lie dormant under winter floods, conserving resources for when the flood recedes.

[3] When a floodplain meadow is in full flower, it is hard to imagine that just a few months before it was in full flood.

[4] The many benefits we get from floodplain meadows include storing floodwaters, keeping soil and nutrients out of rivers and helping to protect water quality.

[5] The precisely engineered channels of water meadows carry a thin sheet of water containing nutrient-rich silt across the meadow surface to increase agricultural productivity.

[6] The frothy clusters of cream-coloured and sweet-smelling flowers of meadowsweet can be found in damp meadows, ditches and riverbanks.

[7] The study of hydrologic processes in floodplain meadows can help to inform practical management practices and enable us better to understand the complex interactions that underpin these fascinating grasslands.

[8] The pincushion lilac-blue flower heads of devil's-bit scabious attract a wide variety of butterflies, including the meadow brown shown here, and bees.

Plants are fantastic indicators of soil water regime.

[7]

[8]

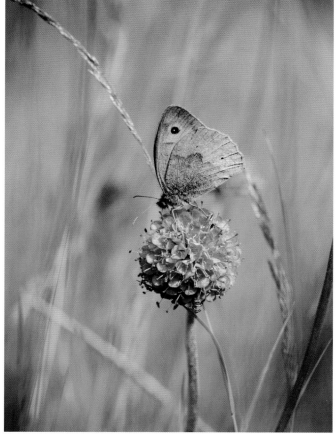

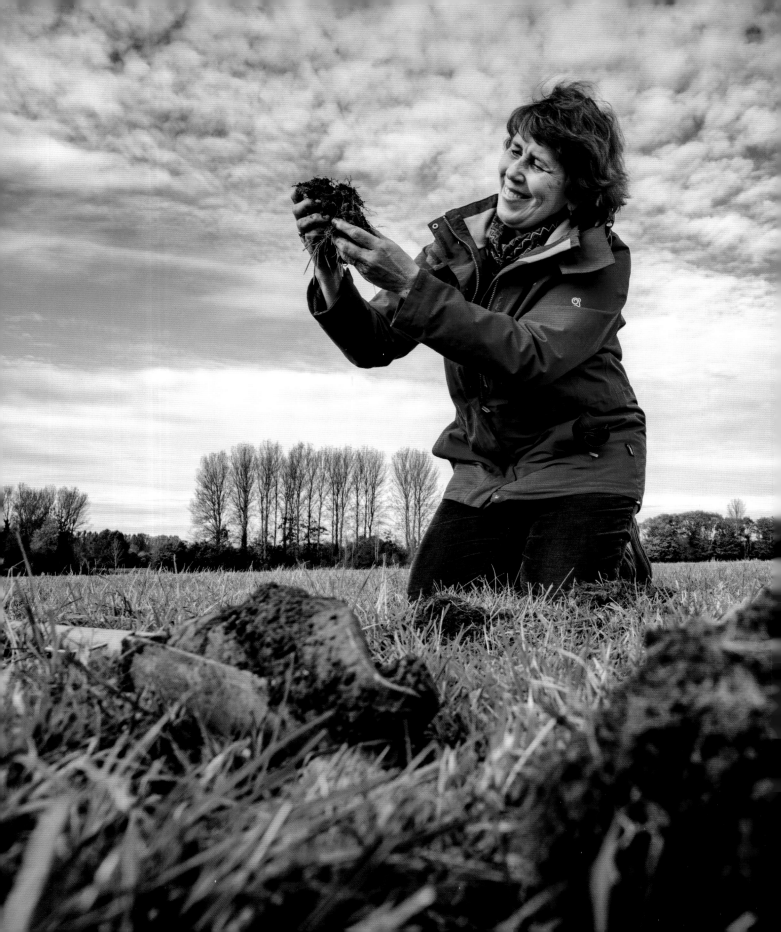

Subterranean secrets

DR IRINA TATARENKO
RESEARCH MANAGER
FLOODPLAIN MEADOWS PARTNERSHIP

The soil beneath our feet is probably easier to understand when you are a child and therefore physically much closer to the ground. I spent my early childhood in the northern village of Ed'ma in Archangel Oblast in Russia, where floodplain meadows stretched for many kilometres along the River Vaga. Hay meadow flowers waved above my head when I walked and ran through the fields from an early age. It was amazing to feel the warmth and the texture of the soil under my bare feet all summer long. At that age I had no knowledge about how coarse material was widely deposited on floodplains some 11,500 years ago, when melting snow fields and ice sheets created swollen rivers that eroded the uplands and transported sand and gravels onto lowland floodplains. However, my feet naturally knew the difference between gravel, sand, clay, silt and all types of loam.

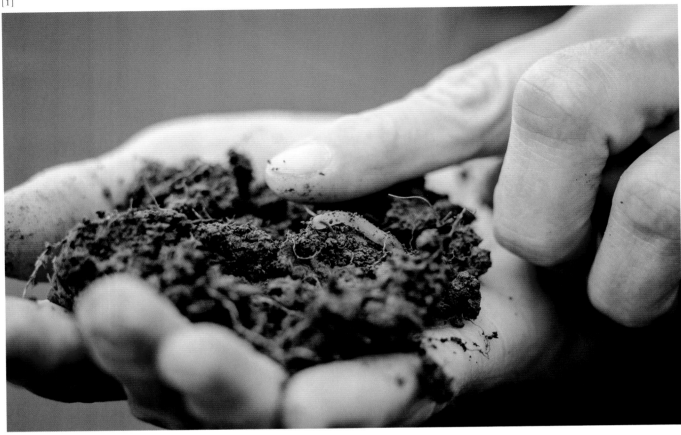

Later as a student I learned about the importance of underlying deposits allowing snow-melt, rain and floodwater to drain away rapidly, as well as soil evolution. As winters warmed, meltwater floods declined and the speed of floodwater slowed; this allowed alluvial soils to build, some up to more than 3 m deep. Soil is a complex material formed from mineral particles by air, water and living things. Soil profile grows up very slowly. At the depth of 1 m, soil carbon dates at about 7,000 years old. Floodplain meadows lie on the top of alluvial soils, built up over centuries of sediment deposited during flood events. The size of particles dropped depends on the speed of the floodwater and varies from coarse sands and gravels (forming levee and terrace deposits) to fine silts and clays known as alluvium.

The upper soil horizon is really important and is where most of the organic matter is found. My bare feet crushed plant litter, pushed seeds into the soil, tripped over rhizomes and tufts, alive and dead. Stepping on the anthills prompted chaotic movements of these little insects restoring their house. Enigmatic earthworms were mindful of my feet, stretching out and shrinking back in a bid to escape. Soil burst with life beneath my feet; life that tirelessly builds the soil. Fallen leaves and numerous plant roots, soil animals, bacteria and fungi, animal dung and debris left behind after floods are the building materials and the builders of soil organic matter. They increase soil fertility and improve soil structure, making it resilient to compaction. Old grasslands are a really important repository of carbon, as important, if not more so, than trees and woodland. Carbon as soil organic matter is protected in soil aggregates and can be stored in the deep soil for many thousands of years.

Meadow managers need to know a lot about their soil, manage water levels and decide how and when to cut and graze the meadows to keep soil in top condition.

Old grasslands are a really important repository of carbon, as important if not more so than trees and woodland.

The key features of soil are texture, structure and porosity.

The best way to investigate soils is to take a core using a device called a soil augur or to look at the profile exposed on eroding riverbanks. Alternatively, a soil pit can be dug, but only if justified, as a large hole is needed and the material must be put back just as it was found.

The different colours of the soil layers can tell you a lot about the history of a site and its management. Soil determines an extent of water table fluctuations and how quickly water can move through the profile (rapidly through sand, poorly through clay); it also reveals its suitability for restoration and vulnerability to compaction. The key features of soil are texture, structure and porosity. These are best determined by looking at and feeling the soil, rubbing it through your fingers.

The availability of water and the ease with which it drains depends on the size of the pores in the soil and the degree of saturation. This has a fundamental impact on meadow plant communities and on management. Well

structured porous soils can hold a lot of water and allow it to pass easily into the rivers and gravel below. Soils which have been compacted by driving heavy machinery on the land when wet, or through having too many animals grazing during wet weather, lack pores and store very little water. Water can be sitting on the surface for days after rain, but the soil below the compacted layer can be bone dry. In these circumstances no water penetrates to replenish the aquifers below, so vital for our drinking water supplies. Soil compaction reduces plant and insect diversity and should be avoided at all costs as, once lost, soil structure can take many decades to recover. ❧

[1] Soil is a complex mix of mineral particles, organic matter, air and water, which combine to provide a habitat for an array of living organisms.

[2] Floodplain meadows predominantly occur on alluvial soils, which are made up of sediment deposited by seasonal flooding.

[3] Soil profile, texture and structure can be examined through observation, but more detailed investigation requires laboratory analysis.

[4] One of the best ways to analyse the soil profile is to take a soil core using a hand-held auger.

[5] Conserving the structure of the soil is crucial when managing meadows. Once soil has been compacted it can take years for the structure to recover.

[5]

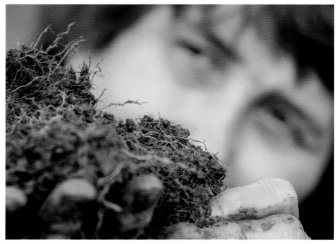

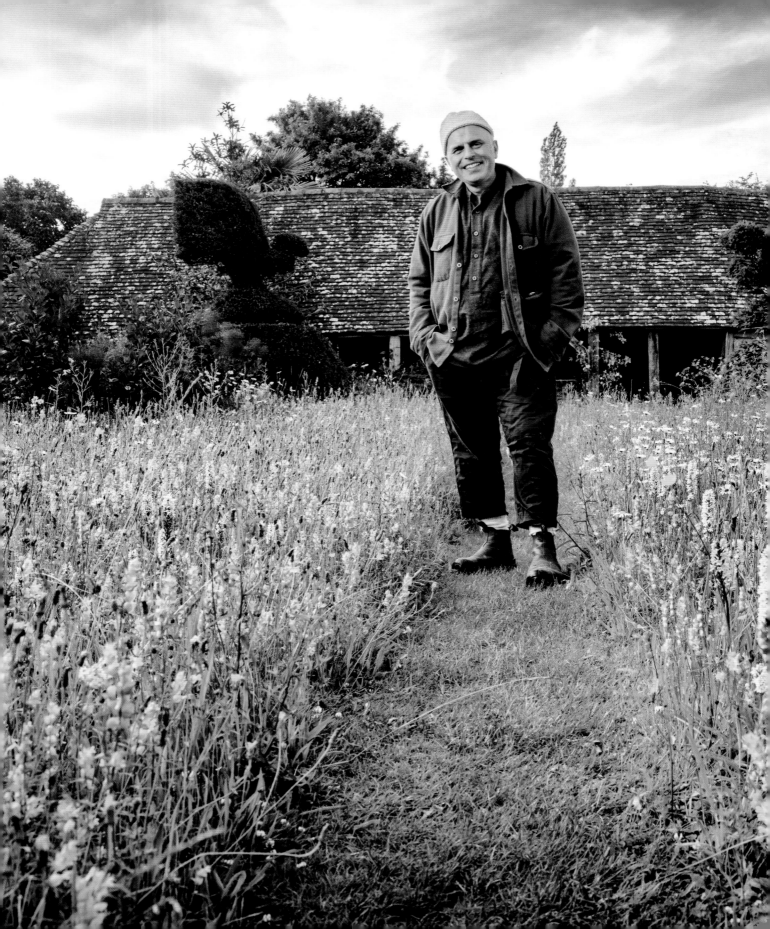

Mindful meadows

FERGUS GARRETT
GARDENER
GREAT DIXTER

Outdoor spaces enable us to breathe and have a deep and direct connection with the natural world. Grassland, in particular, gives us a place where we can sit, play and relax. It is a soothing environment where we are grounded – it inherently brings us closer to the earth beneath our feet and surrounding our being. A meadow with all its complexities and richness, with its movement, its smell and all its layers of life takes this feeling to a higher, deeper and more spiritual level. The intricate, ever-changing tapestry of species-rich grassland brings with it not only a myriad of flowers and colours, but also an ebullient microcosm of life.

Meadows are alive, vibrant, mysteriously dynamic, with an astonishing assemblage of life. They are among the very best examples of nature, but they are among the most fragile too. A meadow with its hustle and bustle is not unlike the most exciting of cities. However, the racket within a city is noise – energetic but also unsettling – whereas the sound from a meadow is a soothing, melodic, rhythmic call to nature. There is no doubt that a spiritual connection with nature is highly significant for our well-being. Unfortunately, with an increasing majority of the population living in urban environments, we continue to be physically and psychologically disconnected from the countryside and the natural world around us.

There is evidence clearly showing positive physical and mental health benefits from a close relation with wildlife-rich environments, of which meadows are an important part. Reducing stress and anger, lowering blood pressure, making you more relaxed, improving your physical health – these are all linked to an active life outdoors. Whether this is in the countryside or in villages, towns or cities, whether on roadside verges or within a sympathetically designed landscape, the benefits of what is now called ecotherapy can no longer be denied.

A meadow plant community reacts to the environment and often the unexpected happens. Repetition, movement, tapestries, sounds and scents are all a part of this response. Communities change from one year to another and from one season to another, sometimes inexplicably; it is this enigmatic characteristic, along with their unquestionable beauty, intermingling and interchanging – seemingly out of our control with a mind and a determination of their own – that makes meadows so special. Nature has a soothing quality that helps us to deal with pain and connects people with each other and to a community. Meadows and open green spaces are a vital part of life outdoors and can make a significant positive contribution to our psychotherapy; they also have a critical role in biodiversity, and yet they continue to come under pressure.

But there is hope. Meadows are now very much in vogue and, as our natural world has increasingly come under threat, there has been a welcome shift in public

[1]

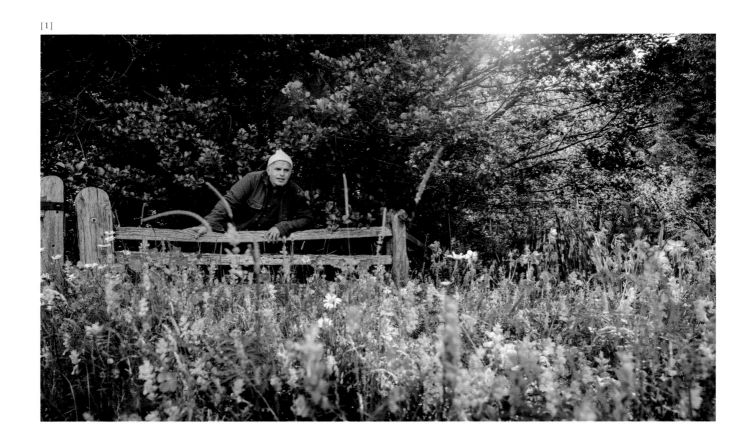

The intricate, ever-changing tapestry of species-rich grassland brings with it not only a myriad of flowers and colours, but also an ebullient microcosm of life.

There is an innately relaxing and reassuring synergy between people and grasslands.

perception. Garden designers, landscape architects, local communities, borough councils and the general public seem to be more at ease with cutting less. Certainly at Great Dixter, where my affinity with meadow grasslands has grown, the complaints about our long grass and meadow areas being unkempt and scruffy seem to be almost non-existent among our visitors. Replacing the initial scepticism is interest in how to create similar wildflower areas. There seem to be more and more meadow areas being created on village greens and in churchyards, and now quite a few public parks have sections devoted to meadow.

My own personal journey has been an interesting one. Working as a student for Brighton Parks Department in the 1980s, I had a stint cutting roadside verges leading into the city. Being on the best machinery, operating at speed and creating a neat, tightly mown verge was what interested me at the time – meadows and biodiversity did not come into my head at all. They simply were not a part of my education. On my first visit to Great Dixter Gardens I was taken

[2]

aback by the meadows, thinking they looked scruffy and should be outside the garden framework and not within. Now, 40 years on, they are my favourite part of the gardens and the part that reaches profoundly deep into my soul.

This is not because the meadows here are dripping with rarities such as the green-winged orchid (*Orchis morio*) or because we have substantial colonies of the adder's tongue fern (*Ophioglossum vulgatum*), which is indicative of ancient grassland, but rather because there is a community of rare and common rubbing shoulders and making a dynamic tapestry. There is an innately relaxing and reassuring synergy between people and grasslands. A deep connection between humans and meadows lies latent in all of us, but given the opportunity it resurfaces. The pull to nature is stronger than we give it credit for. Part of this attraction, perhaps, is the association and yearning of times gone past, when long grass surrounded us and meadow flowers were abundant, insect life was plentiful and the world seemed a better and less complex place. It could also go deeper than this; it could be that we humans were originally a grassland species – and so we feel most at home when surrounded by the prairie, savannah, steppe or meadow. ❧

[3]

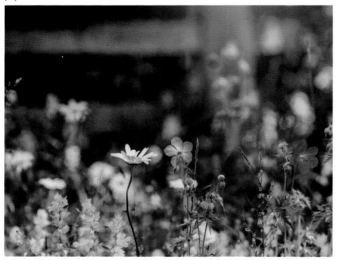

[1] Spending time in the company of wildflowers in gardens like Great Dixter can transport our spirits to a happier and healthy place.

[2] Going for a walk in open green spaces can improve cardiac risk factors such as cholesterol, blood pressure, diabetes, obesity and mental stress.

[3] Wildflowers are not just important for the health of people, but are also crucial to healthy, functioning ecosystems.

[4] The Gardens and wider landscape at Great Dixter provide spaces for quiet contemplation whatever the season.

[5] Wildflowers have an abstract beauty of colour and form that has inspired and delighted people over time.

[6] The Gardens at Great Dixter act as a haven for beauty and biodiversity.

[4]

[5]

Pollination patterns

PAULA RUDALL
RESEARCH PROFESSOR
ROYAL BOTANIC GARDENS, KEW

Insects foraging in meadows, whether they
are searching for food or for the opposite sex,
are confronted by a dazzling array of colours,
patterns, smells and textures. They react to
signals from plants that attract them to flowers
and lead them unintentionally to assist in pollen
or seed dispersal. But what do they actually
look for? To a person, colour is probably the
most obvious signal, but insects also detect
many odours in their sensitive antennae and,
unlike our simple eyes, their compound eyes
perceive colour well into the ultraviolet (UV)
spectrum. Colour contrasts and patterns become
increasingly significant as the insect approaches
the flower, while microscopic surface features
such as hairs and waxes influence its foothold
as it lands.

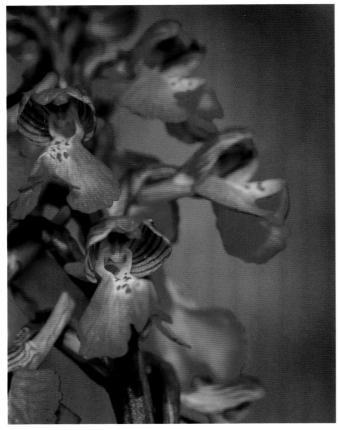

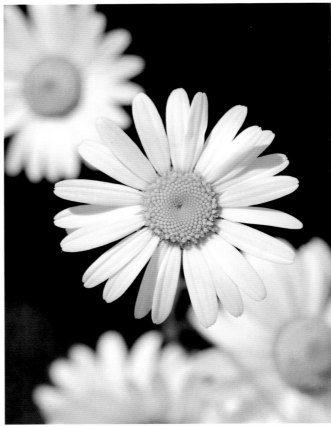

My research focuses on the anatomy and development of plant cells, tissues and organs. My work ranges from the organisation of flowers and the patterning of petal surfaces, which are so important in attracting pollinating insects, to the intricate structure and development of the stomatal pores on the surfaces of leaves. These minute openings allow essential passage of carbon dioxide and oxygen to and from the internal tissues, and therefore represent a vital interface with the natural environment.

Plant development is often governed by a set of 'rules' that are so deeply hidden that it could take a working lifetime to expose them – one of the reasons why specialist research often needs to be collaborative. Part of my work involves comparing 'typical' structures with 'misfits' that can help to understand plant evolution. For example, a plant with consistently mutant flowers can sometimes show us what forms are possible when normal development goes wrong, and hence offer potential insights into genetic controls.

Meadows contain flowers belonging to many different plant families, each with their own unique combination of features at both macroscopic and microscopic levels. For example, orchid flowers – even those of relatively small terrestrial orchids found growing in British meadows and woodlands – are highly distinctive. They display a labellum that forms an insect landing platform, located below a fertile structure composed of a pollen-producing stamen fused with the pollen-receiving stigma. On closer inspection, orchid flowers are remarkably diverse. Those of some species bear a long labellar spur that contains a nectar reward for the pollinating insect, whereas others flatter to deceive, failing to provide a reward but nonetheless enticing visitors into paying repeated visits. Daisy flowers are actually groups of numerous flowers clustered together in a condensed inflorescence. Each flower is subtly different from its neighbours, depending on the genetic and chemical signals it receives during

Meadows contain flowers belonging to many different plant families, each with their own unique combination of features at both macroscopic and microscopic levels.

development. The precise location of each tiny flower within a cluster helps to determine its shape and role, the outermost ring of flowers bearing the most prominent petals.

Petals are coloured by chemical pigments inside the cells, but this colour is often enhanced by structural features that interact with sunlight to produce signals and flashes that attract a passing insect. By contrast, in exposed meadows the green leaf surface is often more adapted to absorb light than reflect it, not only facilitating photosynthesis but also providing a useful contrasting background that highlights the meadow flowers and encourages passing insects to visit them.

My love of plant structure stems partly from being the child of artist parents who encouraged me to draw, and partly from a strong lifelong affinity with biology in general. At first I aspired to be a marine zoologist or a palaeontologist, but I soon found greater challenges in the extraordinary diversity of plant form. At university

my increasing focus on comparative plant structure led me to undertake postgraduate research in this area, and ultimately to academic employment at Kew.

Working at Kew has given me wonderful opportunities to study many different types of plant, both in their natural environments and in Kew's extensive living and preserved collections. One of the highlights has been searching for a rare and unusual plant family in Australia as part of comparative studies on ancient living flowering plants. Closer to home I study different aspects of meadow plants, such as the flower structure of orchids, the petal surfaces of poppies and the stomatal patterning of horsetails, but always in the context of comparing them with their relatives, seeking better to understand how these structures evolved. ☙

[1] Orchid flowers display a labellum that forms an insect landing platform, a fertile structure composed of a pollen-producing stamen fused with the pollen-receiving stigma.

[2] Ox-eye daisy flowers are actually groups of numerous flowers, clustered together in a condensed inflorescence.

[3] Appreciating the colour of nature is one thing, but to study why it is important is another level altogether.

[4] Studying the science of plants helps to unlock many of their secrets.

[5] Wildflowers could not flourish without their pollen being spread by bees and hundreds of species of other insects including hoverflies, wasps, moths, beetles and butterflies, including the unmistakable marbled white (*Melanargia galathea*)

[6] Flower-rich habitats, such as meadows, are vital to supporting pollinators by providing good sources of pollen and nectar throughout the summer, as well as shelter and nesting sites.

[OVERLEAF] Marden Meadow in Kent is an excellent example of an unimproved hay meadow and home to a wonderful population of green-winged orchids (*Anacamptis morio*).

[4]

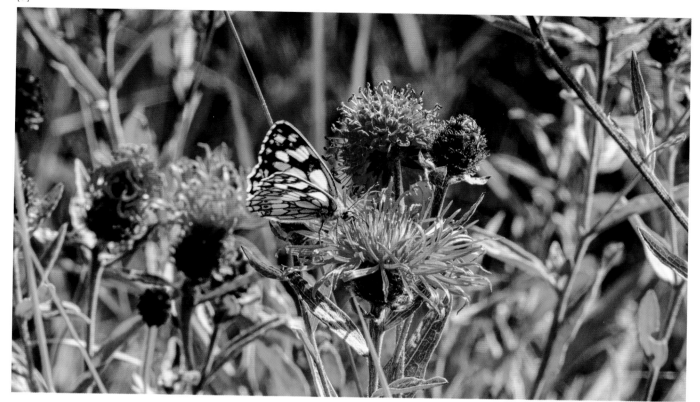

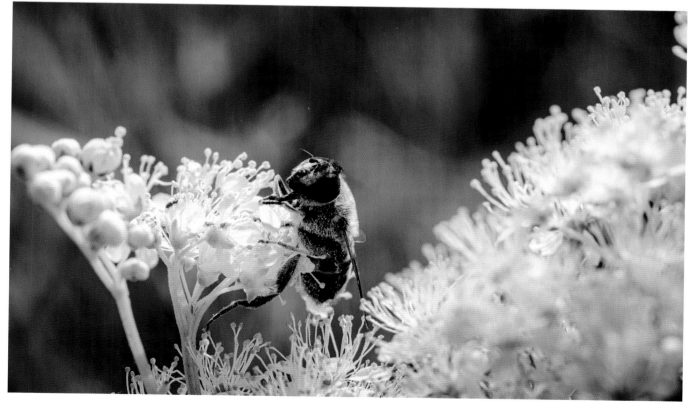

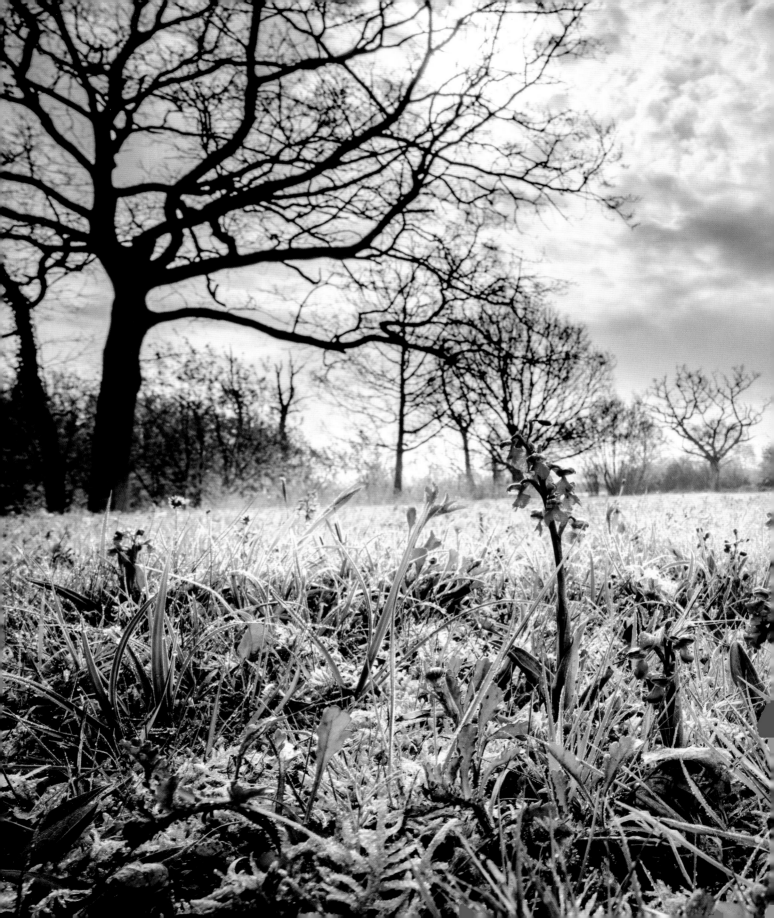

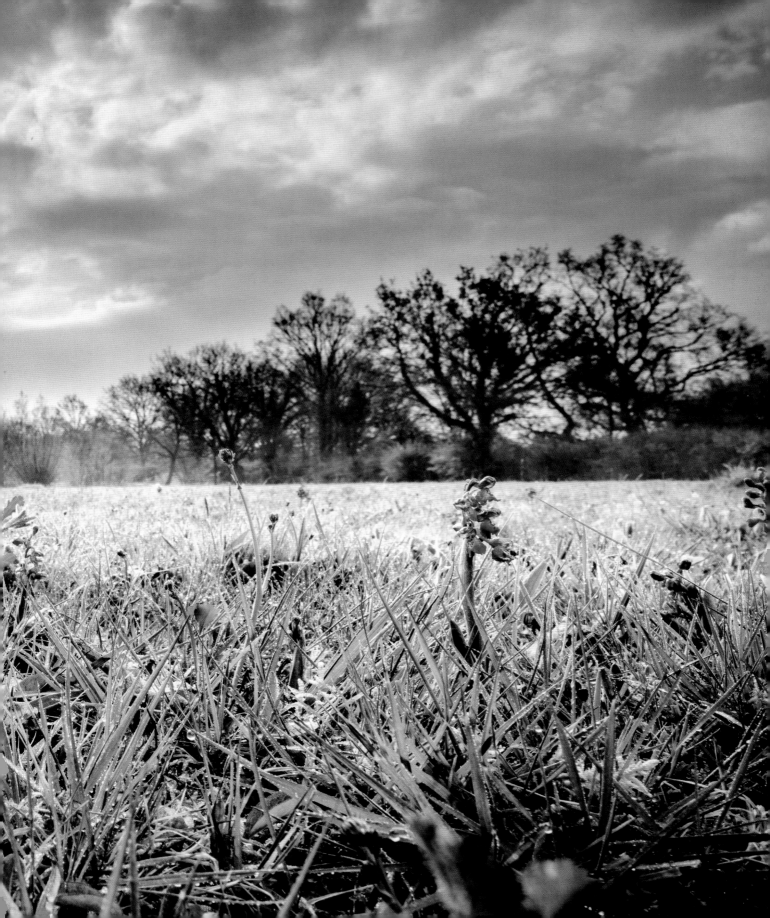

Final reflections

Iain Parkinson

There were many ways that I could have chosen to arrange the structure and content for this book but just like the meadows which are celebrated within its pages, the concept evolved slowly over time. Initially, I considered charting the secret life of a meadow through the changing seasons, then I favoured focussing specifically on the variety of different meadow types, and at one point I even explored the idea of using the five senses as chapter headings. Despite my wavering thoughts, one theme always remained clear in my mind which was a desire to involve the wide range of meadow experts who I had met over the years.

I was less sure about how to weave this idea through the book, although I wondered whether a series of case studies might be the answer. I decided to give it a try by inviting a number of my closest meadow mentors to each write an essay about an aspect of meadow life they found interesting. At the time I had no idea that this would prove to be a turning point in the journalistic road that I was travelling along.

The first few commentaries that I received were full of interesting content that I not only enjoyed reading but also found immensely informative. The narrative pattern of each essay gave the prose a charming personal touch which brought the words alive. It dawned on me that this book would be all the warmer and wiser if it was written by a plethora of authors. Suddenly, the balance of the book had tipped in the favour of people rather than plants.

I particularly liked the idea that this book would provide a platform for a range of experts to share their knowledge and expertise. This approach certainly proved to make the experience more inclusive and enjoyable for everyone involved. It also gave me the excuse to catch up with people who I had lost touch with over the years, as well as an opportunity to introduce myself to many new meadow enthusiasts. It is a strange admission to make, but I have learnt so much from reading my own book and this is why I like to refer to myself more as a curator rather than an author.

By placing people right at the heart of the narrative both Jim and I hope this book will be an interesting and slightly different addition to the many wonderful meadow books that have already been published over the years. From start to finish this has been a fascinating journey, made all the richer and more enjoyable for sharing the experience with so many fascinating people.

Jim Holden

What an adventure! To travel the length and breadth of the British Isles armed with a couple of cameras, photographing people and the meadows they watch over has been an amazing experience. Many of the meadows I have visited have been within a day's striking distance of my Sussex home, but others were found in further-flung places. My little camper van has certainly clocked up many miles in my pursuit of these enigmatic grasslands. Although the word 'meadow' conjures up thoughts of balmy, warm sunny days, the reality was every possible weather condition crossing my path. Temperatures ranged from -6°C when photographing snowy sheep to 36°C at Highgrove capturing the art of scything.

The vagaries of the British weather were always a concern, especially when I only had one chance to visit a meadow. On one such trip to the Outer Hebrides I arrived in mist, drizzle and fog and departed under the same cloud. When I arrived at each meadow with camera in hand, it was all too easy to become overwhelmed by the sheer diversity of colour, shape, pattern, sound and movement. Meadows provide an astonishing level of sensory input from all quarters. At the beginning of the project I would be seen bouncing around a meadow trying not to miss a thing – I am sure it must have looked far too energetic to some. Over time I found a far better approach, which was to find a likely spot to just stop, sit and wait. The meadow would soon find me and everything would be revealed. It was magical – I was hooked.

I have learned a great deal about meadows and their enthralling idiosyncrasies in this far too short a glimpse into the life of a meadow. A futile search one long afternoon for meadow goat's beard, *Tragopogon pratensis*, for instance, left me scratching my head until the obvious – with hindsight – significance of its common name, 'Jack-go-to-bed-at-noon', finally dawned on me. A humbling lesson learned, and I made sure to return early the next morning to capture my subject.

The considerable effort of travelling to these isolated meadows has been absolutely worth it in order to capture their changing character through the seasons. It is so important to raise awareness about the increasing pressures that meadows are under and the impact this has on the flora and fauna they support. Embarking on these mini adventures, visiting so many classic and special hay meadows has been an unforgettable experience, and meeting the people who look after them a real privilege. Being invited to help create this book, working so closely with Iain and such an eminent collection of meadow experts, has brought home to me that meadows are just as much about the people who care for them as the plants.

Index

Images are indicated by page numbers in **bold**.